FLORIDA'S WETLANDS

Volume 2 of the Three-Volume Series

Florida's Natural Ecosystems and Native Species

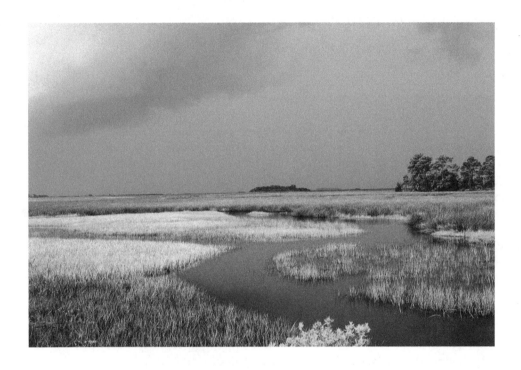

Ellie Whitney, Ph.D.

D. Bruce Means, Ph.D.

Anne Rudloe, Ph.D.

illustrated by
Eryk Jadaszewski

PINEAPPLE PRESS, INC.
PALM BEACH, FLORIDA

DEDICATIONS

*To the memory of my husband, Jack Yaeger, whose love for wild Florida
I now carry forward.*

—Ellie Whitney

*To all the animals, plants, and ecosystems that have gone extinct because
of mankind, and to those we are now threatening.*

—Bruce Means

*To all the kids now playing on the beach, who will continue this work
in the next generation.*

—Anne Rudloe

Distributed by NATIONAL BOOK NETWORK

www.pineapplepress.com

Library of Congress Cataloging-in-Publication Data

Whitney, Eleanor Noss.
 Florida's wetlands / Ellie Whitney, Ph.D., D. Bruce Means, Ph.D. ; illustrated by Eryk Jadaszewski.
 pages cm. — (Florida's natural ecosystems and native species ; volume 2)
 Revision of a section of: Priceless Florida / Ellie Whitney, D. Bruce Means, Anne Rudloe. c2004.
 Includes bibliographical references and index.
 ISBN 978-1-56164-687-6 (pbk.)

1. Wetlands—Florida. 2. Wetland ecology—Florida. 3. Biotic communities—Florida. I. Means, D. Bruce. II. Whitney, Eleanor Noss.
 Priceless Florida. III. Title.
QH105.F6W457 2014
577.6809759—dc23

 2014005829

Design by Ellie Whitney

CONTENTS

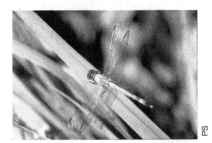

Eastern pondhawk (*Erythemis simplicicollis*), a dragonfly native to the eastern two-thirds of the United States and to Ontario, Canada.

ACKNOWLEDGMENTS

Anne Rudloe, Ph.D. was our coauthor on *Priceless Florida*, from which this book was adapted. She died in April, 2012, leaving behind many beautifully written publications and countless children and adults who learned from her to love the plants and animals of Florida's coastal wetlands and waters. We are grateful to her for her contributions to this book.

We are also indebted to many people for their contributions of expert knowledge and sound counsel: biologists Wilson Baker and Susan Cerulean; naturalist Giff Beaton; botanists Andre Clewell, Angus Gholson, and Roger Hammer; environmental specialist Rosalyn Kilcollins; educator Jim Lewis; geologists Harley Means and Tom Scott; meteorologist John Hope; and paleontologist S. David Webb.

Our associates at Pineapple Press have been wonderfully supportive: June and David Cussen and Shé Hicks.

The photographers who have contributed images to these pages are listed on page 156. Every one of them has been cooperative and we sincerely thank them all.

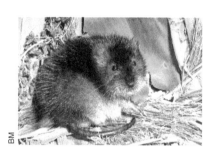

Round-tailed muskrat (*Neofiber alleni*). This rare animal is found naturally only in Florida and southeastern Georgia. It occurs in colonies in marshes.

TITLE PAGE PHOTOGRAPH

Tidal marsh. The plants of tidal marshes capture the energy of sunlight, grow, and become food for vast quantities of fish, shellfish, and other marine life. Photograph by Bruce Colin

FOREWORD

Priceless Florida was first published in 2004 as a 423-page book that presented all of Florida's upland, wetland, and aquatic ecosystems. Welcomed by a reading public eager to learn about natural Florida, it was widely shared and appreciated among visitors to the state as well as by year-round residents. Victoria Tschinkel, state director of The Nature Conservancy, Florida Chapter, wrote high praise into the Foreword:

> Priceless Florida *is one of the most important books ever crafted about Florida's natural history. . . . The scientific and educational lessons within these pages are simply astounding. Collected within this marvelous book are detailed natural histories of the native species and communities that comprise Florida. . . . Florida's inhabitants, human and other, depend on the state's fragile environment for survival, but the challenges ahead are enormous. Rapid growth drives the need to secure a system of parks, forests, and wildlife management lands. Without a core system of conservation lands to sustain the ecosystem functions and services up on which all life depends, the quality of life for every Floridian will suffer. Humans also need open space for recreation, water supply, rejuvenation of spirit, and reconnection with nature. I have no doubt that the readers of this book will become ardent proponents of this message, and most importantly, will love wild Florida even more.*

Lizard's tail (*Saururus cernuus*). This native plant is common in freshwater marshes and swamps throughout interior Florida.

It is now time for a second edition—but because the original book was a large volume, we decided to split it into three smaller books this time: *Florida's Uplands, Florida's Wetlands,* and *Florida's Waters.* These are true derivatives of the earlier book. We have brought forward many of its beautiful photographs and much of the original text, updating it where necessary to keep it current.

It has been a pleasure to revisit Florida's natural ecosystems and to know that they still remain beautiful examples of what nature has wrought in this topographically diverse state. We hope that these books will bring pleasure and useful knowledge to readers today as before.

PREFACE

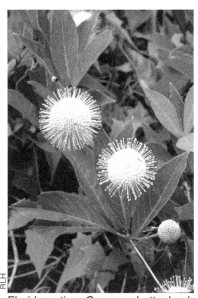

Florida native: Common buttonbush (*Cephalanthus occidentalis*). This native wetland shrub is common in swamps and around the margins of water bodies nearly throughout Florida.

Florida's landscape is much more varied than most people realize, and it supports a surprisingly diverse array of wetlands. And in each wetland, a tremendous number of plant and animal species thrive and interact in webs of life that inspire wonder in the lucky few who learn about them. They are extraordinarily complex, intricate, ancient, and full of secrets. The more we learn about them, the greater our pleasure, sense of awe, and feeling of connectedness. They are ours, both to enjoy and to protect.

This book is primarily about *natural* wetlands in healthy ecological condition, as far as scientific studies have determined. Many books present short descriptions of natural systems and then devote most of their space to the damage that has been inflicted on them. Those books serve a useful purpose, but in this one, natural wetlands are given all the space available.

Similarly, *native* species are in the spotlight throughout. They are fascinating, because they are adapted so beautifully to Florida environments. How is it that cypress trees grow so well in deep water, where other trees die out? How can some animals live inside of carnivorous plants where others are killed and digested? How in the world do animals survive and even benefit from repeated inundation by oncoming waves on the beach? And how are the plants and animals of an ecosystem woven together in the web of life?

In this book, every photo of a plant, animal, or other living thing is of a Florida native species, unless otherwise noted. Only those that are identified as "nonnative," "alien," "invasive," or "exotic" are not native to Florida.

This book's chapters name hundreds of Florida's native species, but those named represent only a few of the total that are out there. Each is a masterpiece of biological adaptation evolved over eons of time, and as a consequence, it is far beyond our scope to present a complete inventory of the native plants and animals in every wetland. Rather, one or more groups

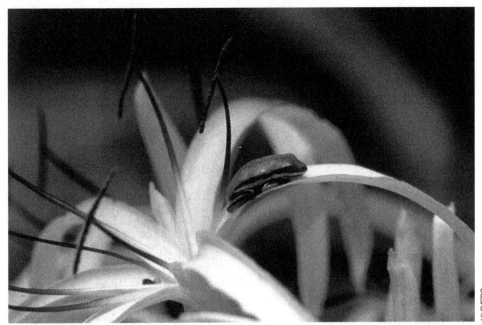

KLP/FPS

Florida natives: Green treefrog (*Hyla cinerea*) and string lily (*Crinum americanum*). The treefrog ranges east from Texas across the Gulf coast to Delaware, typically living in floating vegetation and among cattails and grasses around marshes and ponds. Active at night when it is relatively safe from predators, it calls throughout the summer, "advertising" for a mate. Its well-being depends strongly on environmental temperature and rainfall.

are singled out for special notice in each chapter. The chapter on seepage wetlands focuses on their carnivorous plants; the chapter on marshes provides a sampling of Florida's dragonflies; the chapter on interior swamps gives special attention to bromeliads and orchids; the chapter on beach and marsh intertidal zones features salt marsh plants; while the chapter on mangrove swamps zeroes in on the microscopic life. This mode of treatment is as fair as we can make it; even so, many groups have been left out altogether. Lists and photos of some of the plant and animal species in each ecosystem accompany the text to remind the reader of their diversity.

About the lists: They are not intended to provide exhaustive information (encyclopedic references do that), but to illustrate, in various ways, the specificity with which many plants and animals are adapted to their environments—and even to particular parts of their environments. On seepage slopes, some plants grow on higher, drier areas, some in lower, wetter places. In coastal marshes, different species are adapted to grow where different tide patterns prevail, and so forth. A reader who does no more than simply scan the lists will readily see that an immense amount of scholarship has gone into characterizing Florida's wetlands, from their physical characteristics to their inhabitants.

About the names of species, most readers doubtless are more comfortable

Florida native: Green arrow arum (*Peltandra virginica*). This water-loving Florida native grows best in swamps and hydric hammocks.

with common names such as "lizard's tail," whereas other readers prefer the precise scientific name, "*Saururus cernuus*." To accommodate both preferences, the common names are given for all, but those depicted in photos are identified both ways, and the Index to Species presents all of the scientific names.

A warning is in order. A welter of terminology attends wetland classification. We have referred here to bogs, marshes, and swamps, but other authorities use other terms such as wet prairies and seepage slopes. In fact, wetland ecosystems defy classification: no two are exactly alike and rigid descriptions fail to capture their diversity. In any case, for our purposes it is more important to understand what wetlands consist of and how they function than it is to adhere to a strict classification scheme.

Of the many organization schemes available, we rely most heavily on the system developed by The Nature Conservancy for the ecosystems of Florida. Beginning in 1981, the Nature Conservancy helped the state to establish the Florida Natural Areas Inventory (FNAI) to identify the state's natural communities, to single out noteworthy examples of each, and to locate populations of rare and endangered plant and animal species. The resulting *Guide to the Natural Communities of Florida* was released in 1990.

FNAI later revised its scheme and published an updated *Guide* in 2010, which has proven invaluable in providing species inventories for Florida's wetlands. Our own scheme differs somewhat, and to ease comparison, the Appendix shows how our classifications correspond with those used by FNAI. FNAI also provides, for every ecosystem, references to half a dozen or so other classification schemes used by other authorities.

This volume presents only Florida's wetland ecosystems. (Volumes 1 and 3 present the upland and aquatic systems.) In this book, the Introduction presents an overview, makes clear what is meant by "natural" ecosystems and "native" species, and displays the climate, land, soils, and waters to which every creature native to Florida's wetlands is adapted. The next six chapters display the ecosystems; and finally to put them in perspective, the concluding chapter tells the amazing story of how they came to be here, a history that can never be repeated. The book ends with a review of the values of natural ecosystems and native species.

We hope this book will lead to a better understanding of natural Florida than most people enjoy at present. Ecology is not often taught in school and natural Florida is remote from many people's lives today. Most of us see more cars, roads, and shopping malls than bogs, marshes, and swamps. Some 90-plus percent of Floridians live in urban areas: Florida is the nation's sixth most-urban state. Frog calls and bird songs are less and less frequently heard. But the natural ecosystems and their resident plants

and animals are still out there, beyond the city limits, and they are all the more precious because they are so much diminished in area and number.

Only when one understands something, can one come to love and cherish it. We hope this book leads to greater appreciation of natural Florida's wetlands.

Florida native: Pine woods treefrog (*Hyla femoralis*) tadpole, looking deceptively (and protectively) like a floating leaf. Florida's natural wetland waters swarm with astronomical numbers of these and other frog, salamander, and fish fry.

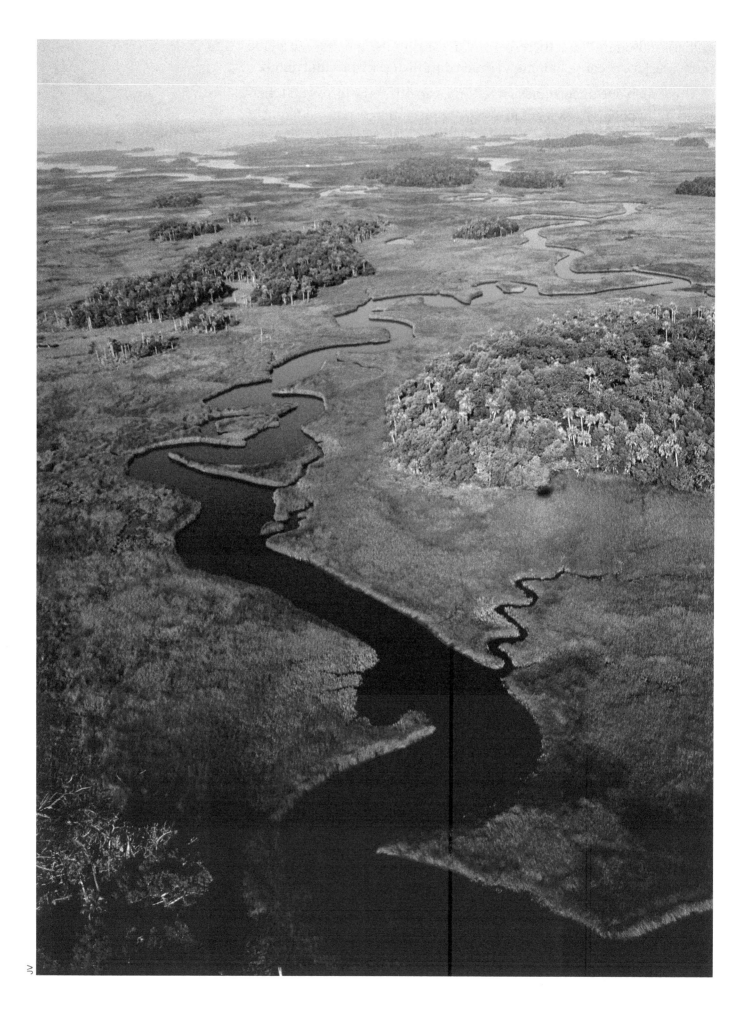

CHAPTER ONE

NATURAL ECOSYSTEMS AND NATIVE SPECIES

Florida's landscape supports upwards of 50,000 square miles of diverse natural areas including forests, flatwoods, prairies, swamps, marshes, and water bodies. It has more than 7,700 named lakes greater than 20 acres in area, and countless ponds of one to 20 acres. It has 1,700 rivers and streams, and more than 600 clear-water springs. It has a 1,300-mile shoreline of beaches, tidal marshes, swamps, and estuaries, and its offshore seafloors hold seagrass beds and coral reefs.

In this series of three volumes, Florida's natural upland, wetland, and aquatic systems are treated separately, but all three share many characteristics. They occur naturally on the landscape in mosaic-like patterns, as shown in the photograph opposite. There are upland areas (such as the hammocks in the photo, which are forested), wetland areas (such as the extensive marshes within which the hammocks stand), and aquatic areas (notably the stream that meanders across the landscape and the estuary into which it flows). This book's focus is on the wetlands.

All natural areas also support populations of native species of plants, animals, and other living things. (Depending on the classification scheme being used, these others include fungi, bacteria, and others, less well known but important in the functioning of natural communities.) Some of these populations inhabit single areas, some occupy several neighboring areas, some move from one to another with the seasons, and some migrate through at particular times of year. They also offer indispensable environmental services such as purifying water, controlling floods, yielding products of natural and economic value, and maintaining themselves without inputs of fertilizer or food from outside the system.

Burrmarigold (*Bidens laevis*). This flower grows in freshwater marshes over much of mainland Florida.

Wetlands are intermediate between upland and aquatic systems in both wetness and position on the land. Chapter 2 elaborates on this theme.

OPPOSITE: Natural ecosystems on Florida's landscape. A meandering stream flows to the Gulf of Mexico through several natural ecosystems on the Big Bend coast. Shown are pine-palmetto hammocks (uplands), tidal marshes (wetlands), a stream with several smaller tributaries flowing into it, and at the shore, the stream's estuary (aquatic systems).

Natural and Nonnatural Ecosystems

To place Florida's wetlands in context, this chapter first describes natural ecosystems in general and offers definitions of the terms *natural* and *native*. It then goes on to describe the environmental context that supports these systems: the climate, soils, topography, and waters.

An ecosystem, by definition, is a complex consisting of a community of organisms and their environment. Each influences the other. The environment imposes certain adaptations on its residents and the residents act upon the environment, altering some of its features. Not all ecosystems are natural. A glass-enclosed terrarium is an ecosystem and so is a coastal marsh.

Natural Ecosystems. The term *natural ecosystem* has the same meaning as *natural community*, the phrase coined by the Florida Natural Areas Inventory (FNAI) as described in the Preface.[*1] These communities are considered natural because they are relatively undisturbed by human influence and still function largely as they did in preColumbian times. Even before Columbus, the native people who inhabited Florida altered the land somewhat: They cleared some areas, burned them, and planted them, but not to nearly the same extent as the Europeans and Africans who succeeded them. *Natural* is therefore an approximate term that represents a range of values.[2]

Altered Ecosystems. Today, many wetlands lie downslope from uplands that have been impacted by human use: uplands such as agricultural lands, planted pine forests, orchards, ranches, golf courses, and the like. Such wetlands, although usually degraded by polluted runoff, invasive plants, and logging, still may help to purify the water that runs through them, abate floods, stabilize land contours, clean the air, moderate the local climate, and provide habitat for populations of native plant and animal species.

Other alterations of lands upslope from wetlands are more disruptive. Many very impaired wetlands lie downslope from intense human land uses such as highways, roads, parking lots, and urban development. Yet even these wetlands can perform some of the environmental services just mentioned.

Artificial Ecosystems. Perhaps the contrast of unnatural with natural wetlands is best illustrated by theme parks and zoos. These establishments are important to Florida's economy. The tourists who flock to them enjoy superb entertainment and some of the highest-quality imitation nature in the world. Some of these places also help teach people to care about

> A **natural area, natural ecosystem,** or **natural community** has the following characteristics: It is inhabited by a distinct assemblage of populations of living things.
>
> It occurs naturally on the landscape wherever certain physical conditions occur.
>
> It is inhabited by a distinct assemblage of populations of living things.
>
> Its resident populations are naturally associated with each other.

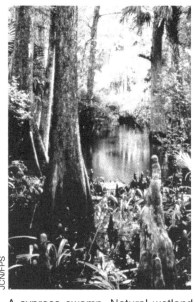

JCN/FPS

A cypress swamp. Natural wetland communities such as this support numerous native species and retain rainwater, thereby moderating the oscillations between floods and droughts.

*Reference notes follow the last chapter.

Atamasco lily (*Zephyranthes atamasca*). Native to the southeastern United States including Florida, this lily grows in swampy forests and coastal prairies.

parts of the natural world. Many a visitor who has never before thought about protecting wetland habitats has become a dedicated conservationist after encountering wetland plants and animals up close and personal in Florida's parks and zoos.

Beneath the surface, though, artificial wetlands are but high-maintenance versions of the real thing. Many require heat, air conditioning, piped-in water, mowing, weeding, trash pickup, and artificial light. They can barely tolerate normal local weather conditions, much less weather extremes. If damaged, they may be unable to recover without help. If the walls are breached, disaster follows—either the alligators eat the flamingos or the flamingos fly away. In short, such systems depend on people for their maintenance; we have to fight nature to keep them going. Stop the pumps or cut the power, and the water goes bad. Filth piles up. Plants and animals die.

Ironically, keeping these exhibits going is hard on the natural environment, too. They produce no resources, they consume them. To meet the demands of these operations, millions of gallons of water are pumped from aquifers, depleting local groundwater reserves. For power, quantities of coal, oil, and gas are burned, which pollute the region's air. Tons of human and animal waste must be transported, treated, and dumped somewhere. Truckloads of trash are hauled away to landfills.

Chinese tallowtree (*Sapium sebiferum*). This is an exotic pest plant that invades natural areas, reproduces prolifically, crowds out native trees, and drops litter that is toxic to native amphibians and fish.

Natural wetlands contrast dramatically with articificial ones in all of these respects. They cost the environment much less, and contribute far more. They require little or no maintenance, so long as their terrain and surroundings have not been altered. No fossil fuels are needed to supply their energy; no pipes or pumps must deliver their water; no trucks must deliver their fertilizer or food. They clean themselves up; they generate no wastes for processing plants to dispose of because they recycle their materials. They run on renewable resources: sunlight, soil, air, water, and the work of living things. And for as long as they are allowed to exist, natural ecosystems produce diverse plants and animals, feed and house them, and enable them to reproduce, as well as rendering many services to the environment and humankind.

How do natural wetlands manage to do so much with so little? If they owe their success to any single secret, it is that their resident populations are genetically adapted to grow and reproduce in local settings. They have evolved in these or similar environments over hundreds or thousands of generations and they are equipped to cope with both normal conditions and normal extremes. In short, the resident populations are the native species referred to earlier: they have "local know-how."

Near the extremes to which they are adapted, the living members of natural wetlands may be stressed, but they rebound at the first opportunity, provided only that invasive exotics are kept out and that repeated injuries are prevented. Often they can even recover after natural "disasters" such as hurricanes, floods, and fires, which may appear to overwhelm them temporarily. Some ecosystems promptly reassemble in the same places where they grew before. Some may recover after floods or fires appear to have wiped them out: For example, lakeside vegetation regrows after flood waters recede. Others may regroup elsewhere as suitable new places become available: For example, a hurricane may erode a coastal wetland with all its vegetation, but the same species of plants will grow again on substrate washed away and deposited elsewhere. In short, natural wetlands tend to persist, provided that the physical stresses they encounter are within the bounds to which they are adapted.

Degraded Wetlands. These exist in all settings. Familiar to all are drained and developed former wetland areas, wetlands from which the vegetation has been dredged away, wetlands polluted by spilled oil or industrial waste, and wetlands that have been completely overwhelmed by invasive, nonnative species. Even worse, many former wetlands are invisible to us because they have been filled in with dirt to accommodate housing tracts, parking lots, road rights-of-way, and other constructs of man.

At the coast, much of the shoreline, especially along bays, is today so densely populated that the natural coastal marshes and swamps have

largely broken down. Although living communities may still grow in them, they are severely impoverished in numbers of native species and may hold none at all. To regain natural function these need more than management; they require restoration.

In summary, although few of Florida's wetland areas are wholly natural any longer, some can be maintained in near-natural condition. Environmental benefits can be reaped by supporting and mimicking natural processes. Even small areas can help, especially if many are added together. There is, however, one facet of natural ecosystems already mentioned, which no other lands and waters can quite match. Natural ecosystems consist of, and support, native species.

NATIVE AND INTRODUCED SPECIES

Importantly, natural ecosystems all consist of populations of *native* plants, animals, and other living things. Like *natural*, *native* means that the population is adapted to local conditions, including the presence of other native species, has existed there for a long time, and is contributing services of ecological value. Provided that its environment does not change greatly, a native species population can also perpetuate itself without elaborate management efforts.

In contrast to natives, other species have been introduced into Florida from other parts of the world. Two introduced ("exotic") species are featured on these pages. One, the Chinese tallowtree, is an aggressive pest plant that crowds out native trees; the other, the sacred lotus, is less invasive but still disruptive in natural wetlands. Other introduced species are relatively benign in local settings such as parks and gardens, where they are used as ornamental plants. Either they do not reproduce at all, or they reproduce at a modest rate and it is easy to keep them from spreading into natural areas.

Invasive exotic species pose a real hazard to wetlands: They tend to multiply out of control, taking over the territories of native species and disrupting their webs of relationships. They are so destructive that concerned citizens maintain an Exotic Pest Plant Council to identify, monitor, and help state agencies control them.

There are also some "weeds" that are natives—that is, native plants that seed in readily wherever space becomes available and then grow rapidly. Native weeds appear promptly where erosion occurs, where trees fall, fields are plowed, forests are cut, or land is cleared for roads or construction. However, unlike nonnative plants, native weeds may make important contributions to many ecosystems in transition times. The first plants to move in, they provide habitat and plant food for insects and other small organisms, and they stabilize the soil while slower-growing native plants

A **species** is a distinct group of organisms that reproduces its own kind.

A **native species** is one whose presence in an ecosystem is the result of only natural processes, with no human intervention.

An **introduced** or **exotic species** is one whose presence in an ecosystem is the result of intentional or accidental human intervention.

Some nonnative species are **invasive**: once introduced, they tend to multiply out of control and overwhelm native species populations.

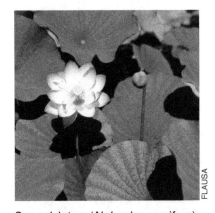

Sacred lotus (*Nelumbo nucifera*). This is an imported exotic from the Old World that can escape into the wild and grow in wetlands. Its relative, the American lotus (*Nelumbo lutea*, which is white), is native to the United States and Canada, including Florida.

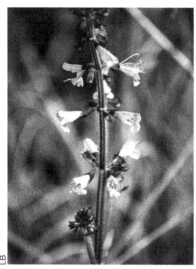

Lyreleaf sage (*Salvia lyrata*). This noninvasive native weed grows freely over most of Florida and is especially common on disturbed sites, but readily gives way to other native plants.

are becoming established. Native weeds are normally somewhat controlled by their own natural enemies and are succeeded by other native plants over time.

The photos on these pages display native, introduced, and invasive flowering plants that grow in Florida's wetlands. Animals and other living things fall into the same three categories.

Among animals, one other important category exists: migratory species that pass through, or reside in, Florida's wetlands in certain seasons. Migratory birds may use them as feeding grounds, breeding grounds, or nurseries for their young. Some birds pass through in spring and fall; some are winter residents that fly north in summer to breed; and some breed in Florida during summers and spend winters farther south.

Notes on Species. As mentioned, a species is a distinct group of organisms that reproduces its own kind. A species may exist as several populations occupying separated habitats, but for as long as the individuals readily breed with one another, they are considered to be members of one species. If two populations of organisms are similar but display no tendency to interbreed when brought together, they are distinct species. (Under abnormal circumstances, members of two different species may mate and produce hybrids, but usually the hybrids are sterile.)

A species breeds true because every individual receives the same basic genetic blueprint. For example, every Pine Barrens treefrog inherits the information necessary to make a black eye mask, to utter a nasal call, to breed in acidic 68- to 72-degree water, and to keep on reproducing new Pine Barrens treefrogs. The inherited traits may vary a little in detail due to genetic diversity, but the basic structures and functions are the same in all.

In these times of severe disruptions of natural ecosystems all over the planet, it is important to understand two other things about native species: that they did not arrive here overnight and that once extinct, they cannot be replaced. Except under extraordinary circumstances (such as laboratory manipulation), new species arise only by way of a process known as speciation, a process that in nature is usually slow. It begins with reproductive isolation. A single population may be split geographically into two subpopulations that remain separated for long times. Then, over many generations, the separated subpopulations may develop so many genetic differences that they become unable to interbreed if they come together again.[3]

Long times, perhaps on the order of hundreds of thousands of years, are required to produce new species of slow-growing trees and of animals such as panthers, whose generation times (to sexual maturity of the young) are on the order of several years to a decade or so. In plants and animals that produce one new generation a year, speciation might take 20,000 years—

still a long time. In animals that produce several new generations a year, it takes about 5,000 years. Extremely short times are needed for bacteria and other microorganisms, some of which can produce several generations in a day. In short, immense variation is the rule.

Over the more than three billion years since life first arose on Earth, hundreds of millions of new species have arisen on the planet. Nearly as many have also gone extinct. Until recently, however, the rate of production of new species has, on average, slightly exceeded the extinction rate, so that over the enormously long spans of time since the origin of life, net species gains over losses now add up to a total, for the world, of many millions of species—perhaps even ten million or more, no one knows. About 1.75 million species have been discovered and described. At least eight million and probably more species remain to be discovered, mostly among invertebrates, plants, and other living things.

Names of Species. Every known species has a scientific as well as a common name. Those featured in this book's photos are given both names in photo captions, but are given just their common names in the text. Every common name is an "approved" one, though: authorities have specified what it should be. Thus the snail-eating hawk that is native to the Florida Everglades is the "Everglade snail kite." Using the names assigned this way, all species discussed herein are listed in the Index to Species, which precedes this book's General Index, and the scientific name for each one is also shown. The Reference Notes and Bibliography list the authorities for the naming of species.[4]

A Count of Florida's Native Species. Florida possesses more than 3,000 native species of trees, shrubs, and other flowering plants. It has more than 100 species of native orchids (compared to Hawaii's two species). Its ferns, numbering some 150 species, are the most diverse in the nation, and besides all these, there are many mosses, hornworts, liverworts, and algae. As for the animals, a list of all of Florida's vertebrates—fishes, frogs, snakes, lizards, mice, birds, and all other animals with backbones—would number more than 800 species. And these are far outnumbered by Florida's *invertebrates* (animals without backbones such as snails, dragonflies, and earthworms), of which there are about 30,000 species on the land and no one knows how many in aquatic ecosystems. At least three other whole *kingdoms* of living things are required to accommodate other living things such as protists, bacteria, and fungi.[5]

The photographs in this book are intended to give a sense of the diversity of Florida's native species. In proportion to the numbers of species in each kingdom, however, animals (notably fishes) and plants (especially flowering plants) are over-represented. Florida is noted for the abundance of beautiful, conspicuous specimens of both.

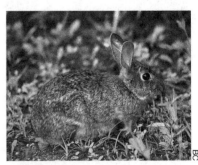

Marsh rabbit (*Sylvalagus palustris*). This shy creature finds food and protective shelter in marshes, bogs, and swamps.

Florida's Endemic Species. Some of Florida's native species are widely distributed across the continent or the world, some are limited to smaller regions, and some are completely restricted to Florida, and even to small parts of Florida. The latter are known as Florida endemics. Among the endemic plants are about 300 vascular plants and many algae. Among the native invertebrate animals, more than 400 endemic species are known; and among the vertebrates, 40 or more are endemic or nearly endemic to Florida. No one knows how many endemic bacteria, protists, fungi, and others there are.

Florida's native species, and especially its endemic species, are ours to protect or lose. An objective of this and the other volumes in this series is to make their value clear.

Florida's Species Today. Florida's species are among the most endangered in the nation. This is largely due to destruction of their habitats. When the last member of a species' last population dies out, the genetic information necessary to produce new individuals of that species vanishes forever. The total information available for making living things also diminishes. Upon extinction, the genetic blueprints assembled in a species over hundreds of millions of years is gone for all time.

It still takes approximately 5,000 years or more to produce a new species, on average, but worldwide species losses today, by current estimates, are amounting to dozens a day. Moreover, the extinction rate is accelerating.

Within Florida, the pace of species losses matches that of the rest of the world and also is accelerating. However, most of Florida's species have not gone, and need not go, extinct. If the people of Florida know and value local native species sufficiently, they will take what steps they can to protect local ecosystems.

A major reason why Florida's ecosystems support such a wide range of native species is that they are tied to a physical landscape which, although reputed to be flat, is not at all monotonous. Its physical features are surprisingly diverse and offer its resident species an immense variety of habitats

Adaptation to local environments is the key to the success of Florida's native plants and animals. They are adapted to specific habitats and surroundings and are able to survive the normal extremes that they have encountered over many millennia in these surroundings. The nonliving components of Florida's ecosystems are the physical support systems that have molded every species from the time of its arrival to the present.

DBM

Florida native, endemic: The thickleaf waterwillow (*Justicia crassifolia*) grows exclusively in Florida.

Support Systems: Climate, Soils, Topography, Water

Florida receives floods of life-sustaining sunlight and experiences mild weather that, for the most part, varies gently in temperature from season to season. Many living things thrive easily in such conditions. Stresses are presented, however, by alternating wet and dry seasons, punctuated by periodic tropical storms and hurricanes. Each species has developed adaptations to cope with the range of conditions it encounters, from hot to cold, sunny to rainy, droughty to flooded, and calm to stormy.

Florida near-endemic: The Florida willow (*Salix floridana*) grows only in Florida and very nearby.

Temperature and Humidity. Because the peninsula is so long, north to south, climatic conditions vary somewhat. Florida lies within the temperate zone, but south Florida's climate is subtropical and the Keys' climate is tropical. Winter cold fronts often penetrate north Florida, but seldom reach farther south, so north Florida winters have both more varied temperatures and more rain than winters in the rest of the state. This is one of many reasons why the species composition of ecosystems differs between north and south Florida.

The Gulf of Mexico also influences Florida's climate. Elsewhere in the world at Florida's latitude, deserts predominate, with wide variations in temperature and exceedingly dry air. Florida, though, has water on three sides. Warm water moves constantly along Florida's Gulf coast, around the peninsula's southern tip, and along the entire east coast. Proximity to water on three sides produces high humidity and abundant rain. The rain helps to maintain the interior's many lakes, streams, and wetlands, and these help to minimize temperature variations.

Although the climate is relatively constant over long periods and the weather is mild on average, day-to-day weather conditions in Florida vary tremendously, ranging in some areas from lows of below freezing on winter nights to highs of 90 degrees Fahrenheit or above on summer days. Snow, sleet, and hail, as well as temperatures above 100, although rare, are not unknown.

Rainfalls and Storms. The quantity of rain that falls on Florida sometimes seems stupendous. Even a single summer shower, if it runs down a slope and collects in a low place, can quickly become several feet deep. A stalled tropical storm can drop more than two feet of rain in just a few days, and nine inches of rain can easily fall on a single location within a single afternoon.[6]

Heavy rainfalls are not the rule, however. Most rain showers bring down an inch or less. Only because they are so frequent do they add up to some four and a half feet a year. If all that rain soaked into the ground, it could

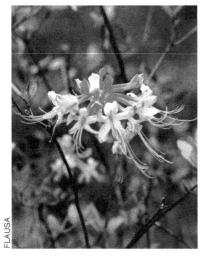

Sweet pinxter azalea (*Rhododendron canescens*). This native shrub grows in acid sandy soils along stream and swamp margins in north Florida.

The **weather** is the state of the atmosphere at particular times and places.

The **climate** is the long-term state of the atmosphere defined by its averages and extremes over time.

easily maintain groundwater levels against current and future demands for eternities to come. Actually, however, about three-fourths of the rain returns to the sky and about one-fourth runs off over land to the sea. Only a little rain soaks into the ground each year. It stays there for a while and then, if not recycled by the plants and animals above the ground surface, it ultimately runs out to sea by way of seepage and through springs.

The average rainfall in Florida amounts to about 53 inches in a typical year, but areas of the state vary. The western Panhandle receives somewhat more rain than does the rest of Florida—60 inches, on average. The east coast receives less—50 inches. Moreover, rainfall amounts deviate greatly from the average in many seasons.[7]

Any given area of Florida has, on average, some 120 rain events a year. Most are showers, but some ten to twelve of these events are storms. On clay-rich, sloping land, raindrops quickly gather in surface indentations, form channels, and run off into streams and rivers. On sandy land, water may collect in ponds and lakes or sink down into the soil and drain away underground. On its way down, the water may encounter a somewhat impermeable layer (a hardpan) underlying the sand; then it may accumulate in a shallow underground "lake" called a surficial aquifer. [8]

The most dramatic of Florida's storms cause rivers to surge out of their banks, sweeping their floodplains clean of accumulated litter. At the coast and in nearshore waters, these storms bring surges that rearrange masses of sand, annihilate beaches, deposit bars, shorten and elongate islands, and shift submarine shoals from place to place. As troublesome as these events may be for human beings, coastal ecosystems, if not interfered with, continue to adjust as they have for millions of years.

Small rainfalls produce different benefits. They clean leaf surfaces, add to groundwater reserves, and offer relief to Florida's dry-land plants during times of stress. Plants are adapted to withstand dry periods, but do not go altogether dormant. Prolonged droughts can set them back or even kill them.

Rainy and Dry Seasons. Alternating wet and dry seasons have characterized the region's weather patterns for thousands of years. Summers are wet all over the state throughout June, July, and August (Floridians call August's rainy days the "dog days"). Autumns are dry; in fact, October, November, and December are the driest months of the year. Other months' rainfalls differ between north and south Florida. North Florida has considerable rain in late winter (December to April), and then May turns dry. South Florida has little rain all winter except briefly before cold fronts.

Seasonal rains play a special role in the lives of wetland plants: they provide periodic times of inundation alternating with dry times. Wet times

have laid standing water on low areas twice a year for so many millennia that many plants, once rooted and growing, are able to remain alive even when standing in water for weeks or months at a time. Some plants tolerate standing water for three months every year; some five; some are adapted to almost continuous inundation. The effects of periods of wetness (known as hydroperiods) on vegetation are described further in the chapters to come.

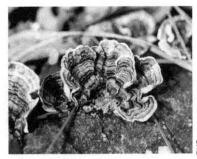

The turkey-tail mushroom (*Trametes versicolor*) is widespread across the world. Like its fellow fungi, it digests dead wood.

Some animals need equally specific wet-and-dry periods to breed and feed and raise their young. Without the accustomed hydroperiods, both plants and animals are stressed. In fact, without alternating wet and dry times, many plants and animals cannot reproduce or even survive. And extreme wet times each year—that is, annual floods—confer many benefits on wetlands and river bottomlands.

Although it may seem counterintuitive, many Florida wetlands are also dependent on periodic fires for rejuvenation—and Florida's environment provides these, too. Dry conditions combined with lightning make fires especially likely, and lightning strikes are frequent events, generating more strikes per square mile of the state's land surface than anywhere else in the country. In Tallahassee alone, 40 lightning strikes hit each square mile every year.

Most lightning storms occur in summer, that is, from May through August, and since May is dry, that is the month in which fires most easily ignite. Accordingly, Florida's fire-loving plants are especially well adapted to May fires. In natural fire-adapted ecosystems, fires started by lightning kill fire-sensitive plants, leaving fire-resistant plants in possession of the territory. May fires stimulate these plants to flower, and by the time their seeds drop, the ground is bare and nutrients released by fire become available as fertilizer.[9]

Tropical Storms and Hurricanes. Windstorms are another force affecting Florida's ecosystems, and all species populations must have ways of surviving them. Tropical storms produce winds of more than 40 miles per hour and hurricanes are the most extreme of tropical storms, having winds greater than 70 miles per hour. A hurricane may produce rain and sometimes dangerously high water over an area hundreds of miles across, while its wind gusts may reach speeds of 200 miles per hour and spawn tornadoes. Looking at just the *center-line* paths of all the tropical storms and hurricanes that struck Florida during the last century, one can hardly see the state's outline beneath the mass of tracks (see Figure 1-1).

The winds of tropical storms and hurricanes pull weak limbs from trees, break brittle trees off midway up their trunks, and topple strong trees, exposing their roots. The result is a massive overhaul of forests. Bare earth lies exposed for new seedlings to take root. Sunlight floods formerly

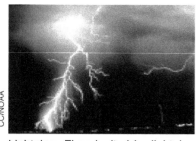

Lightning. Fires ignited by lightning are an important force shaping many Florida ecosystems.

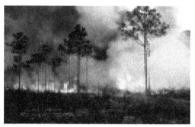

Fire burning through pine flatwoods. Fire is the natural agent of regeneration in many Florida ecosystems.

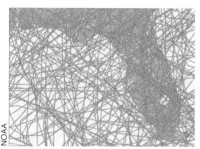

Tropical storms and hurricanes striking Florida in 100 years. *Source:* National Oceanographic and Atmospheric Administration.

shaded ground, permitting seedlings to grow. Seeds that fall on the tops of broken-off stumps and start growing there are perched high above the next flood where they can grow without rotting. The tipped-up roots of fallen trees expose crevices in which many animals can make homes. The opportunities for new life to take hold following a storm are a major means of forest regeneration—not all at once, as forestry practice so often plans it, but piecemeal, summer after summer, now here, now there.

In summary, Florida's living things are adapted to the temperatures, sunlight exposures, rains, droughts, fires, winds, and even storms as they have occurred through past millennia. Natural ecosystems are also adapted to variations over time, such as wet and dry spells of several years.

Florida's Surface Materials. Besides the climate and weather, the surface materials of which Florida is made profoundly influence the character of its ecosystems. That there are deeply cut ravines and high banks in one area; broad lakes and flat plains in another; and caves, sinkholes, and springs in still others is due to the diversity of the sediments of the southeastern U.S. Coastal Plain. This region, within which Florida lies, has well-defined physical boundaries. The innermost boundary is the base of the Piedmont, which flanks the southern Appalachian mountains. The outermost boundary is the coastline (see Figure 1-1).

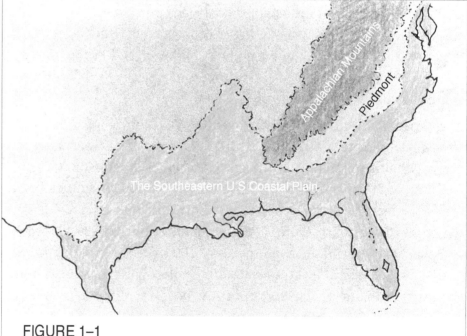

FIGURE 1–1

The Southeastern U.S. Coastal Plain

The southeastern U.S. Coastal Plain is the apron of loose sediments that spreads from the foot of the Piedmont to the shoreline.

Source: Brouillet and Whetstone 1993, Ch 1.

Three physical characteristics distinguish Florida (and indeed the whole southeastern U.S. Coastal Plain) from the regions to the north. First, *marine* sediments (limestone and dolomite) lie in thick layers all over Florida, at or below the surface. These calcium-containing sediments were deposited during earlier times when Florida lay under the sea and they profoundly influence the region's topography. Second, the whole Coastal Plain is deeply layered with *clastic* sediments (clay, silt, sand, and gravel). These sediments have been transported by streams and rivers from the Appalachian mountains over the past 65 million years and generally lie on top of the marine sediments. Third, a layer of *organic* soil (peat and/or muck) lies on or is mixed into the surface sediments. This layer may be nearly imperceptible on high, dry sand hills, but is inches to tens of feet thick beneath all kinds of wetlands and water bodies from small, shallow ponds and seepage slopes to large swamps and lakes.

Soils are the foundation materials of most of Florida's living communities and are mixtures of these sediments. Plants are adapted differently to grow on different kinds of soils. The well-drained soils of uplands challenge plants to obtain and retain water. In contrast, the water-saturated soils of wetlands exclude air with its life-giving oxygen, so that plant roots have to be specially adapted to obtain oxygen for their growth and metabolism.

Depending on what they are composed of—limestone, clay, silt, sand, gravel, peat, muck, or mixtures of these—Florida's soils may be fine or coarse, acid or alkaline, fast-draining or water-holding. Altogether, some 300 different types of soil occur in Florida, contributing much to the diversity of the state's ecosystems.[10] (There is more on wetland soils in Chapter 2.)

Contours of the Land. The land's topographic features, or contours, are profoundly influenced by the materials of which the land is made, and help determine what sorts of ecosystems will form in each area. Where there are clay-rich sediments, rain erodes gullies and stream valleys form. Where there are broad plains of sand, water soaks in instead of running off, and ponds and lakes form. Where limestone lies in thick layers just below the surface of the ground, rainwater percolates down through cracks and fissures and spreads across horizontal planes between layers, dissolving the limestone and creating sinks, springs, and caves. In various combinations, these processes occur in all regions of Florida. Clay-rich areas of the state are divided into many stream valleys with hardly any lakes; areas with deep sand are dotted with numerous lakes and ponds and have few streams. Limestone-dominated areas have many caves, sinks, and springs.

Florida's Groundwater Aquifers. Florida's ecosystems lie on soils derived from sand, clay, silt, gravel, limestone, peat, or combinations of these. Rainwater percolates down into these materials at different rates depending on their natural porosity. It moves slowly through clay and silt,

Peat is partially decomposed vegetable matter that accumulates as plant parts fall into water. Thick accumulations keep building up for as long as the water remains, and many of Florida's swampy lakes are full of it, so much so that peat is commercially collected by what are called peat or muck "farms."

Muck is simply a fluid accumulation of fine particles of partially decomposed organic matter which turns to peat if partly dewatered.

Soil is the particulate material lying on top of the land, which is capable of supporting plant life. Soil includes inorganic sediments, organic materials, living things, and air and water.

Sediments are particulate materials that settle to the bottom of liquids.

The **inorganic sediments** in soil are clays, sands, and other rocky particles.

The **organic materials** are peat, muck, and other residues of living things, described further in Chapter 2. The living things include microscopic organisms and earthworms, among others.

Soils may be characterized by their moisture contents:

Xeric soils are dry and well drained.

Mesic soils are usually moist.

Hydric soils are wet and waterlogged.

Limestone consists of **marine sediments**. These originate from salts, shells, and the like that settle out of ocean water. Florida's major marine sediments are derived from **limestone** and **dolomite**, whose principal ingredients are calcium and magnesium carbonates.

Clay is a **clastic sediment**; it is composed of fragments of rock eroded from the Appalachian mountains. Florida's clastics are composed largely of quartz (silicon dioxide) and feldspar (aluminum silicates). Clastics, in order of size from smallest to largest, are **clay**, **silt**, **sand**, and **gravel**.

Sand is composed of clastic and/or shell particles larger than clay and smaller than gravel. Sand is the principal material of Florida's sandhills, coastal lowlands, and beaches.

The Major Surface Materials of Florida

An **aquifer** is a body of permeable rock that can contain or transmit groundwater.

Groundwater is defined as the water beneath the surface of the ground. It consists largely of rainwater that has seeped down from the ground surface, and it is the source of the water in springs and wells.

The **Florida aquifer system** is Florida's largest and most important aquifer, which lies beneath parts of South Carolina, Georgia, and Alabama as well as most of Florida. It is deep enough below south Florida that it does not influence the Everglades (which is the only wetland in the state that is fed entirely by rainwater).

A **perched aquifer** or **surficial aquifer** is a small aquifer that lies on top a layer of impermeable material such as clay above the main body of groundwater.

but more rapidly through sand. Water pools up in underground reservoirs called unconfined surficial aquifers if there is no confining layer of tight clays, silts, or limestone above them. If the sand body is large, say the size of half a county, then the surficial aquifer can be thought of as an underground lake, with the water occupying all the spaces among the sand grains. In parts of west Florida where tight clays and looser sands occur as in a layer cake, the layers can be larger or smaller and deeper or shallower as they are stacked on each other. Small surficial aquifers in the sandy layers may bleed out of the ground down slopes that intersect the edge of the layer creating the moisture conditions for hillside seepage slopes.

Where limestone is at or near the ground surface, rainwater moves quickly into tunnels and other conduits that have been dissolved by groundwater circulating through them over the eons. Limestones may also be deep and lie under layers of clay and sand. Because the limestones are so old and so extensive, spreading south into Florida from Alabama and Georgia, they hold a much greater volume of groundwater than Florida's clays and sands, and the water circulating in the limestones is usually confined by their tunnels or capped by clayey/silty layers on top of the limestone. The groundwater in such confined aquifers always is under pressure because of groundwater at higher elevations in the tunnels inland.

The tops of aquifers are not level. Groundwater beneath a slope may itself be sloped, seeping out of the ground where its surface intersects the slope's surface. Groundwater beneath a hill may be piled up, mirroring the hill's own shape. Because of this, and because rain constantly adds to its volume, the groundwater constantly flows through the earth at various rates and in various directions. Its presence influences all wetland and aquatic

ecosystems as it adds to, mixes into, and exchanges with the waters of streams, ponds, lakes, sinks, and wetlands. At the coast, it seeps out to sea.

In quantity, Florida's groundwater is enormous. According to the *Water Resources Atlas of Florida*, the spaces in the earth beneath the state hold more than a quadrillion gallons, one-fifth as much water as in all five Great Lakes.[11] The groundwater plays a major role in supporting all of Florida's wetlands.

By far the largest of Florida's aquifers is the Floridan aquifer system, which extends throughout the state. It is relatively close to the surface in central and north Florida and a thousand feet below the surface in south Florida. Enormous volumes of fresh water are constantly moving through this system. It is largely a confined aquifer, the water in it trapped in the pores and tunnels by the limestone itself, or by the impermeable clay and silt layers on top of it.

Other, smaller aquifers, known as surficial aquifers, lie above the Floridan, perched upon beds of impermeable materials such as clay. Water can escape these unconfined aquifers by moving laterally or seeping down through clay, but only very slowly.

Fresh and Salt Water. Finally, the water bathing Florida's ecosystems is highly variable. Coastal communities grow in water of every degree of saltiness from fresh to brackish to saline. Interior Florida's water, when it wells up from the ground and is filtered through limestone and sand, is alkaline and often as clear as window glass. Water that collects in swampy areas is acidic and stained a deep red-black by plant acids. Water flowing down streams from clay hills is often clouded with loads of sediments eroded off the land.

Water temperatures vary as well. Water from underground is a cool 68 to 70 degrees all year long, whereas shallow surface water may range upwards of 100 degrees in summer and, in north Florida, may freeze in winter.

This chapter has laid the groundwork, literally, for appreciating Florida's wetland ecosystems. Additional details will be added in the chapters to come. Chapter 2 introduces the freshwater wetlands of interior Florida and is followed by three chapters describing them: seepage wetlands (Chapter 3), marshes (Chapter 4), and swamps (Chapter 5). Chapter 6 introduces the saltwater wetlands of coastal Florida and describes beach and marsh intertidal zones, and Chapter 7 describes coastal swamps.

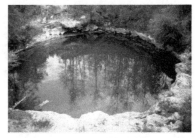

A window into the Floridan aquifer system: a sinkhole. The aquifer water visible in sinks is extraordinarily blue and clear.

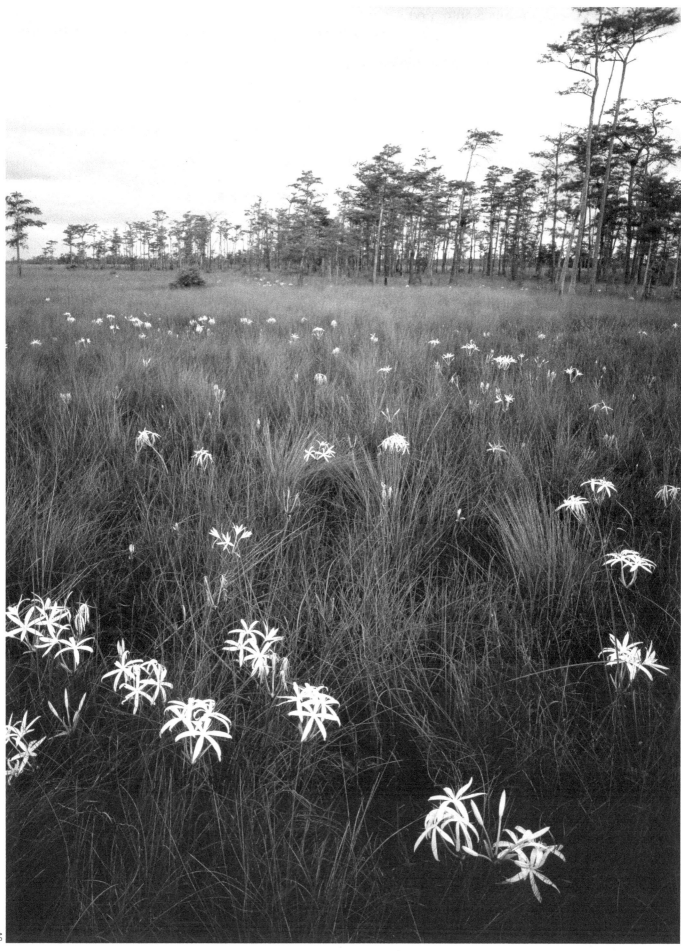

CHAPTER TWO

Interior Wetlands Introduced

A hundred years ago and more, wetlands were not recognized as the ecologically rich places that we now know them to be. They were viewed with aversion as 'bogs,' 'swamps,' or 'quagmires'—meaning dangerous areas with soggy ground in which fearsome monsters lurked, where a walker might risk sinking out of sight in mushy earth.

In contrast, uplands are considered valuable real estate. People live and work on high land wherever possible. The owner of swampy or marshy lands, however, might well try to make them resemble uplands by clearing them, draining them, filling them, paving them, and building upon them.

Today, interior freshwater wetlands are still treated without respect by a few who don't appreciate them, but many more people prize them as a vital resource, as habitat for an abundance of fascinating plants and animals, and as places of great beauty. And today, many wetlands can be visited and appreciated, because visitors can explore them easily and safely by way of boardwalks and boats.

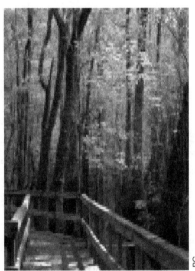

Boardwalk into a gum swamp. Boardwalks like these make exploring wetlands easy.

Delineating Interior Wetlands

This and the next three chapters feature "interior" wetlands. These are freshwater wetlands located in inland Florida as contrasted with brackish or salty wetlands that occur along the coast and are treated in Chapters 6 and 7.

Public understanding of their contributions to the ecological health of the land has led to many provisions in the law protecting wetlands. Some activities are prohibited in and near wetlands. Landowners must obtain

String lilies (*Crinum americanum*) in a south Florida wet prairie. Big Cypress National Preserve, Collier County.

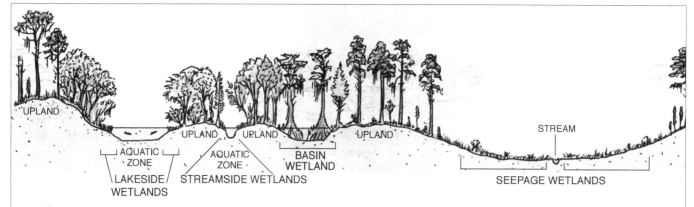

FIGURE 2-1

Profiles of Interior Wetlands

Some interior wetlands form borders between upland ecosystems and open water bodies such as lakes and streams. Others stand in circular or linear depressions without being adjacent to lakes or streams.

Interior wetlands may be *bogs, marshes,* or *swamps.*

A **bog** is a squishy place on the landscape where water seeps out of the ground and flows gently in a shallow sheet into a swampy creek. Examples are hillside seepage bogs, wet flats or prairies, and shrub bogs.

A **marsh** is a wetland dominated by herbaceous vegetation, usually rushes, sedges, grasses and other forbs. Examples are the Everglades and cattail marshes.

A **swamp** is a wetland dominated by trees. Examples are floodplain forests and cypress domes.

permits before they fill or drain wetlands. Also, some activities within and around wetlands that pollute them or alter their water regimes are prohibited. To enforce the law, however, people must know how to identify wetlands. If unrecognized, they may be damaged or lost. Defining just where a wetland's boundaries lie is an important part of land-use decision making.

It is a simple and true statement that interior wetlands are intermediate between upland and aquatic ecosystems in both wetness and position on the land. Figure 2-1 shows how all wetlands are located between uplands and water bodies. But this description is not sufficient to permit unequivocal determination of a wetland's boundaries. Three criteria are used to achieve greater certainty: surveyors look for a combination of (1) wetland plants, (2) wetland soils, and (3) wetland hydroperiods—that is, periods of saturation or inundation long enough or frequent enough to drown non-wetland plants. Using these criteria, experts can usually determine wetland boundaries accurately to within ten feet or less.

Wetland Plants. Like animals, plants must respire, consuming oxygen to obtain the energy they need for their metabolism and growth. This requirement pertains to all plant tissues—their stems and roots as well as their leaves. Sun-exposed leaves can generate oxygen when conducting photosynthesis, but plants have no circulatory systems that can deliver oxygen to their roots. If a plant is rooted under water with its leaves or blades on or above the water's surface, the leaves can respire but the roots cannot—nor can they normally obtain much oxygen from the water that surrounds them. Oxygen cannot penetrate water much below the water's surface and cannot reach the underwater roots of plants unless the water is moving or turbulent.

How, then, can any plant grow and reproduce successfully in a wetland? It has to be able to live between air and deep water and survive—that is, it must have adaptations that enable it to tolerate periodic or long-duration inundation and low-oxygen conditions. Emergent plants have special adaptations for this way of life and it is these adaptations that distinguish them from upland plants. Some go dormant during wet times. Some have roots with special adaptations for obtaining oxygen; examples are cypress and tupelo, which are featured in Chapter 5.

During dry times, to be sure, one may observe upland plants establishing themselves in wetlands, but as soon as they are submerged in water, they die. Conversely, some wetland plants are unable to grow in uplands—but not because the soils prevent their growth; rather, because they are unable to compete with upland plants. These are known as *obligate* wetland species and they are the clinchers that identify wetlands unequivocally. To identify a wetland, then, surveyors first look for obligate wetland plants. A manual developed by the State of Florida identifies several hundred such plants and List 2-1 and Figure 2-2 identify a few of them.[1]

Unfortunately for the amateur botanist who is attempting to learn to identify wetland areas, some plants that grow in wetlands may be found growing outside of wetlands, but this occurs only if other plants are excluded. These, called *facultative* wetland species, may be seen in parks and gardens where gardeners control the competition.

Wetland Soils. A further aid in wetland identification is their soils. Surveyors look for hydric soils—soils that are wet, and therefore low in oxygen, for long times. Such soils hold accumulated organic matter that has incompletely decomposed, because decomposition requires oxygen. Hydric soils are found wherever the water table is near the surface or where capillary action lifts water to the surface. In practice this means that wetland soils are often peaty or mucky in texture, their colors are the black of slowly decomposing vegetation, and they often smell of sulfur.

Wetland Hydroperiods and Water's Signatures. It might seem logical to base the definition of wetlands on their water regimes. After all, water is either continuously or periodically present in all wetlands. However, during a prolonged dry spell, a wetland may be dry for several years and during prolonged rains it may lie altogether under water for a time.

These extremes are not only natural; they are necessary for the perpetuation of some wetland species. Cypress seedlings can germinate only when water is absent; then a special sequence of events fosters their successful growth. First, they outgrow the competing species that became established along with them. Then the water returns and rises just high enough to leave the cypress tops above water while killing the competitors.

Marsh plants can survive only if water levels fall enough to permit

Facultative wetland plants (examples)

These plants normally grow only in wetlands, but can grow in uplands if competition is excluded. They help, but do not conclusively identify wetlands.

Red maple
Sweetgum
Sycamore
Tuliptree

Emergent plants help identify wetlands. Emergent plants are rooted at water depths of about five feet or less, and their topmost tissues spread on or extend above the water's surface. (**Aquatic plants** are either submersed—that is, rooted at depths of five to 15 or more feet with their topmost tissues completely under water; or floating—that is, having roots that do not reach the bottom. Volume 3 of this series, *Florida's Waters*, deals with aquatic plants.)

LIST 2-1
Obligate wetland plants (examples)[a]

Black willow
Dahoon
Pickerelweed
Pitcherplants (several species)
Smoothbark St. John's-wort
Sphagnum moss
Spiderlily species
Swamp rose
Sweetbay

[a]These plants grow naturally only in wetland soils because they are unable to compete with upland plants.

American white waterlily (*Nymphaea odorata*)

Broadleaf cattail (*Typha latifolia*)

Pond pine (*Pinus serotina*)

Chapman's butterwort (*Pinquicula planifolia*)

Virginia iris (*Iris virginica*)

FIGURE 2-2

Native Wetland Plants (examples)

The waterlily, cattail, butterwort, and iris can grow only in, and are diagnostic for, freshwater wetlands; they are obligate wetland plants. Pond pine grows preferentially in wetlands but can grow in dryer soil as well. It is a facultative wetland plant.

A wetland's **hydroperiod** is the length of time during which it is saturated or inundated each year. The hydroperiod is a key factor governing what plants will grow in a wetland.

fires to kill encroaching shrubs. Such fluctuations, including *irregular, long-term* fluctuations, are necessary if wetlands are to endure. Yet land surveyors cannot wait for years to measure an area's hydroperiod. They often have to identify wetland areas within a single season. How can they recognize a wetland, no matter what the current state of wetness?

Signs of water's earlier presence may help in wetland identification. Even if an area is dry at the moment, mats of dried algae may remain on the ground; high-water marks may be visible on the trunks of trees where recent high water killed lichens that were there earlier; drift lines may appear where water-borne debris has been left behind in shrubs or trees. These and other signs are summarized in List 2-2 and examples are in Figure 2-3.

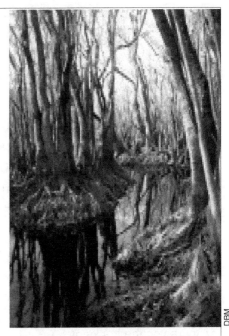

Crayfish chimneys. Each chimney consists of wet soil that a crayfish has excavated from the wet earth to make its burrow. If numerous, such chimneys are evidence of prolonged saturation of the soil.

Enlarged oxygen-intake organs. These "pimples" near the base of the tree, technically hypertrophied lenticels, indicate that the trunk is under water for part of the year. This is a wax myrtle growing on the margin of a lake.

Adventitious roots. Tangled, branched roots that sprout from the sides of a tree or shrub above the water line indicate a wetland. These are ogeechee and swamp tupelo trees in a swamp adjacent to the Apalachicola River.

FIGURE 2-3

Three Wetland Indicators

DIVERSITY OF FLORIDA WETLANDS

Before the Europeans came, Florida was an extremely watery place: there seemed to be wetlands everywhere. Interior wetlands included bogs, marshes, and swamps with standing or flowing fresh water. Swamps predominated in the north, marshes in the south, and over much of southwest Florida, water flowed in miles-wide sheets over and around marshes and swamps embedded in the Everglades. Coastal wetlands included marshes and swamps influenced by estuarine and marine waters.

Figure 2-4 shows that Florida has by now lost most of its wetlands. Still, in the interior, swamps and marshes embrace all the lakes and streams that remain in their natural state, and they also still occupy large and small basins and swales in the land. Over much of southwest Florida, although the Everglades wetlands are much reduced in area, some water still flows. Coastal wetlands are also diminished and damaged but still present and ecologically important.

Many factors govern what kind of wetland occupies an area. One is, of course, the topography. Some wetlands have standing, and some have flowing, water. Other factors are the duration and depth of water's pres-

ence and the degree of drying between times. Water stands deeper and for longer times on low or level ground than on high or sloping ground, so higher-elevation parts of wetlands have shorter hydroperiods and therefore different plant assemblages than do lower-elevation areas.

In turn, the depth and duration of water's presence influence the formation of peat. Plant litter that falls into water decomposes so slowly that peat can, in some aquatic habitats (lakes and ponds), and some wetlands (marshes and swamps), become many feet thick. Peat holds moisture even in dry times, so it helps to keep plant roots hydrated in all but the most severe, years-long droughts.

Fire frequency is also important. Marshes burn frequently, swamps almost never. It is because these factors vary, and the variants occur in many combinations, that Florida's wetlands are of so many different kinds. Consider the different conditions that produce a seepage wetland, a basin swamp or marsh, and a floodplain swamp. Brief descriptions of each of these follow and the next three chapters provide more detail on each.

Seepage Wetlands. A seepage wetland's water oozes onto the surface from an aquifer near the surface of the ground beneath nearby higher land and moves continually across the ground in sheets and small runnels, keeping the soil moist virtually all the time. Seepage wetlands never flood, because their water is always running off at the same rate as it is flowing in.

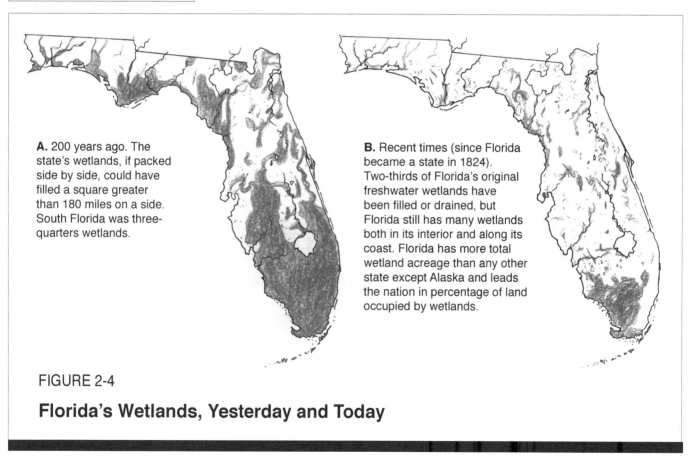

A. 200 years ago. The state's wetlands, if packed side by side, could have filled a square greater than 180 miles on a side. South Florida was three-quarters wetlands.

B. Recent times (since Florida became a state in 1824). Two-thirds of Florida's original freshwater wetlands have been filled or drained, but Florida still has many wetlands both in its interior and along its coast. Florida has more total wetland acreage than any other state except Alaska and leads the nation in percentage of land occupied by wetlands.

FIGURE 2-4

Florida's Wetlands, Yesterday and Today

A seepage bog in Blackwater River State Forest, Santa Rosa County. Water-tolerant herbs, including pitcherplants, thrive in seepage water flowing downhill from the higher-elevation pine forest.

The nutrients in seepage water vary somewhat, depending on the source, but most seepage wetlands on sandy soil are acidic and nutrient poor.

Herbs, shrubs, and trees whose roots are able to live with low oxygen levels can all grow in seepage wetlands. It is the frequency of fires that determines which will predominate. Frequent fires support herbs. If fires become less frequent, shrubs take over; and with very infrequent fires, wetland trees such as bays and evergreen shrubs of several species come to dominate a seepage site.

The open-water centers of lakes and ponds are treated in Volume 3 of this series, *Florida's Waters*. The wetlands found in basins and along shoreline zones and the emergent plant margins of lakes and ponds are described further in Chapter 4, "Interior Marshes."

Depression Wetlands ("Basin" Wetlands). The term *basin* has been used to describe many depressions in the landscape that hold water more or less continuously and that are bordered by wetland plants standing in the water and on the nearby land. In this volume, we largely avoid the term *basin* and refer to them using more specific names, based on their area and depth and on the level of the water in the ground beneath them (the water table).

Decomposition of organic materials such as plant litter proceeds rapidly where oxygen is abundant but slowly when oxygen is limited. This is why plant parts remain undecomposed for long times in water.

Air is 21% oxygen, which translates to 210,000 parts per million (ppm). A typical lake or pond may have only 10 ppm (parts per million) of oxygen at the water's surface, and no oxygen at all at the bottom. Organic matter that is exposed to air quickly decomposes, but in water, its decomposition is greatly slowed or halted.

A very shallow depression may be called a **depression marsh** or **temporary pond** or (because it holds no water during dry times), an **ephemeral pond.**

A depression of intermediate depth may hold a marsh or swamp.

A very deep depression holds a pond or lake.

Some depressions are very small and shallow. In these, the water table rises above the ground surface only about a foot or two at most and may periodically fall below it. The smallest ones may be only an acre or less in area: these are depression marshes or temporary ponds. They are dominated by emergent plants: sedges and grasslike plants. Thousands of these marshes and ponds dot Florida's landscape, some with open water at their centers, some with emergent herbs throughout, and some varying over time between the two states.

Deeper depressions hold permanent standing water except in extremely prolonged droughts. If all of their water is five feet deep or less, they are

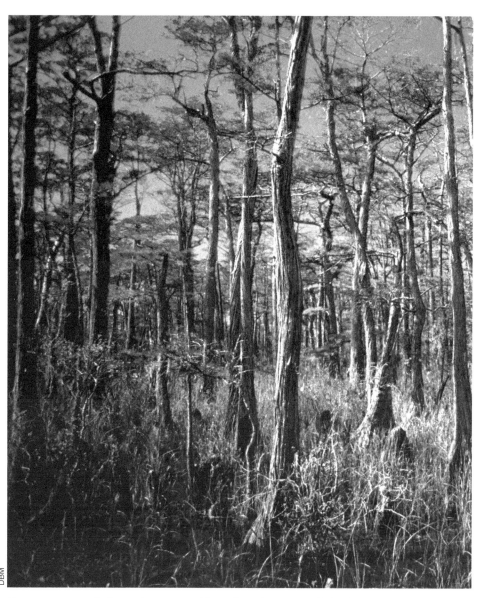

Cypress swamp during a dry season. Even though no water is in sight, the soil, hydrologic indicators and trees tell the surveyor that this is a wetland. Orange cypress needles indicate that it is autumn: cypress is an unusual conifer that drops its leaves in fall.

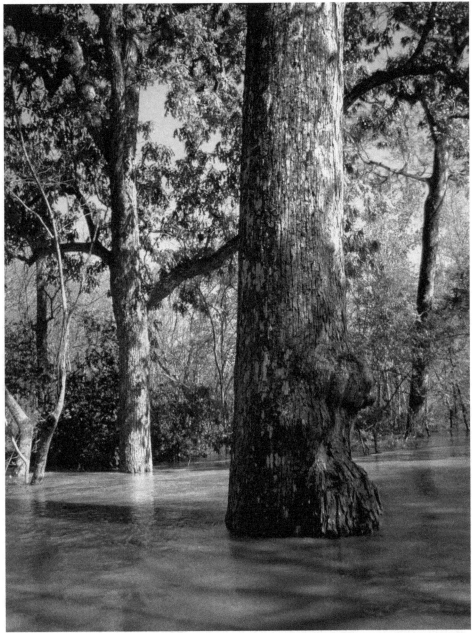

A floodplain swamp known as Sutton's Lake in the Apalachicola River floodplain. Deep in water during rainy seasons, this terrain is free of standing water in the dry season.

marshes or swamps and they support different combinations of tupelos and cypresses.

Depressions that are deeper still, those that have water that is more than five feet deep for extended periods, have marshes and/or swamps around their edges but open water in their centers. The open water may occupy a small percentage of the area or may occupy many tens of acres. We call the open-water areas ponds or lakes and discuss their aquatic characteristics in Volume 3 of this series, *Florida's Waters*.

Limestones occur underground throughout all of Florida, but may lie so deep below the surface in some areas, such as in Florida west of the

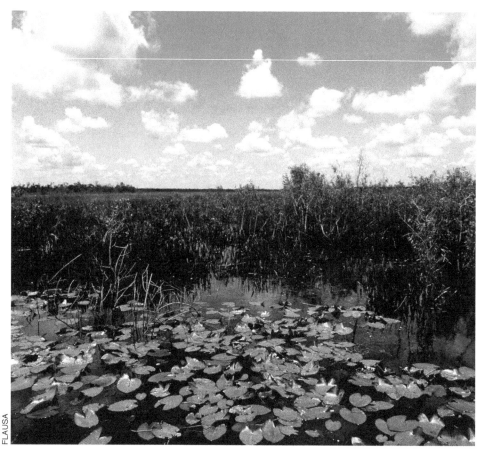

Spatterdock-sawgrass marshes in the Everglades. Water flows slowly and constantly during the rainy season and completely dries up during nearly every dry season.

Choctawhatchee River, that dissolution by circulating groundwater exerts no slumping effect on the surface of the ground. In all the rest of Florida, limestones either may be overcapped by many feet of clastic sediments or may be very near the ground surface and exposed or covered by a thin veneer of sand. Where the clastics overlie limestones by a few hundred feet, such as on the Central Florida Ridge or in the Tallahassee Red Hills, sinkholes form by the collapse of underground cavities. Lakes form as streams cut into the limestones and sinkholes develop along the sides of the lake that develops in the deepening stream valley bottom.

In most of Florida where the limestones are close to ground surface, collapse of underground cavities is an ongoing process and a karst landscape is constantly and actively developing. Occasionally the national news carries images of whole blocks of suburban areas with homes and automobiles being swallowed up by a rapidly developing sinkhole. Groundwater circulating in tunnels in the limestone continuously dissolves their walls, so that over time they can expand into huge underwater caves. So long as these caves and tunnels remain full of water, which is noncompressible, collapse is prevented. However, during droughts when the water table drops, the tunnels and caves become filled with air—which is compressible.

Tiger salamander (*Ambystoma tigrinum*). This is one of many rare salamanders that depend on temporary ponds to breed.

Any air-filled cavity with a ceiling too thin to support the overburden will inevitably collapse.

Clearly, from the preceding several paragraphs, *flux* is the predominant characteristic of depression wetlands. The water's depth is constantly changing in depth and breadth with the level of the water table below. Wetlands grow deeper and shallower, and also expand and contract, with wet and dry seasons and with longer periods in which droughts or floods occur.

Thus, to describe a wetland as if it were a static system is to present just a single frame in a constantly moving film. A dramatic example of this flux in depressions is seen in the Okefenokee Swamp, which was once a large, 25-foot deep lake, but is now a peat-filled swamp. The lake was an aquatic habitat until accumulating peat rose to within five feet of the surface. Then the habitat became colonized by emergent plants that, by definition, made the site a wetland.

Finally, depression ecosystems change greatly over long spans of time depending on which surface sediment is most abundant. Upon much of north Florida, deep deposits of silt and clay predominate. Water doesn't readily sink into these sediments; rather, much of the water runs off over the ground, eroding gullies into it. (The map of Florida shown in Figure 2-5 shows that basins are few: rather, streams and rivers predominate across the Panhandle.) In contrast, upon much of the rest of Florida, sand overlies limestones over wide areas. In these areas, water readily sinks down into both the sand and the porous limestones, finally merging with the groundwater. (The map shows that much of the peninsula is dotted with many lakes and ponds; this is where the basins are.)

If lake- and pond-forming processes were to cease, all lakes and ponds would eventually fill in with sediments washing into them and ultimately "die." They would become level with the ground around them and cease to hold water. However, landscape processes are dynamic. In karst regions, dissolution of limestone by groundwater circulating in underground cavities will continue until the limestones are dissolved all the way down to sea level. Lakes may become peat-dominated marshes or even swamps, temporary ponds may expand into lakes by coalescing with adjacent sinkhole depressions, and stream valley bottoms may sink so low that they become closed basins (as in Lake Jackson in Leon County.)

Floodplains. A river floodplain may be largely dry during one season of the year and flooded during another. Each flood delivers moving water that sweeps loose organic matter along with it, and as a result, peat accumulates only in low places such as sloughs, backswamps, and oxbow lakes while litter left on higher ground is swept away or quickly decomposes when the floodwaters recede. Fires virtually never spread into river floodplains because they are moist and offer little or no fuel.

> A **karst** area is a special type of landscape whose topography is influenced by the presence of limestone at or near the surface of the ground. Dissolution of the limestone produces sinkholes, sinking streams, caves, springs, and depressions in the ground.

Mexican primrosewillow (*Ludwigia octovalvis*). This plant grows in marshes throughout Florida.

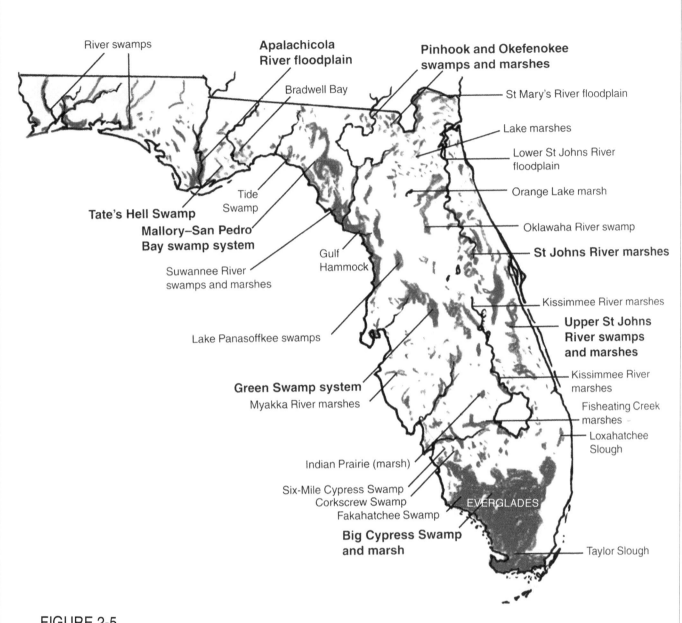

River swamps

Apalachicola
River floodplain

Bradwell Bay

Pinhook and Okefenokee
swamps and marshes

St Mary's River floodplain

Lake marshes

Lower St Johns River
floodplain

Orange Lake marsh

Tide
Swamp

Tate's Hell Swamp

Mallory–San Pedro
Bay swamp system

Oklawaha River swamp

St Johns River marshes

Suwannee River
swamps and marshes

Gulf
Hammock

Kissimmee River marshes

Upper St Johns
River swamps
and marshes

Lake Panasoffkee swamps

Kissimmee River
marshes

Green Swamp system

Myakka River marshes

Fisheating Creek
marshes

Loxahatchee
Slough

Indian Prairie (marsh)

Six-Mile Cypress Swamp

Corkscrew Swamp

Fakahatchee Swamp

EVERGLADES

Big Cypress Swamp
and marsh

Taylor Slough

FIGURE 2-5

Florida's Major Interior Wetlands

This is an enlargement of Figure 2-4B with the major wetlands identified. Labels in boldface
type indicate swamp-and-marsh mosaics that are characterized briefly below. Each is a
complex ecosystem interconnected with others..

Floodplain soils vary. In the Panhandle, they are rich in nutrients, because floods repeatedly drop clay-rich sediments eroded from upstream headwaters and banks. Around streams that arise from limestone springs, soils may be rich in calcium, whereas around blackwater streams, soils may be rich in decaying organic matter.

A river floodplain has varied contours; mounds, ridges, basins, swales,

and many other features, most of which are wetlands because they are inundated annually. Many different communities of trees, shrubs, and groundcover plants grow on these landscape features. Floodplain wetlands are described further in Chapter 5, "Interior Swamps."

WETLAND SERVICES

Wetlands are indispensable parts of the natural landscape. They are knit into larger, interacting systems through which water, materials, and energy flow unceasingly, and they serve all of Florida's ecosystems in many ways. They are powerful water managers, regulating water's purity, routes, and rates of flow. They also help control local climates and nourish their own and neighboring plant and animal communities.

Water Purification. The many wetlands that lie downslope from upland areas can capture water-borne pollutants flowing out of uplands before releasing the water to the ground or to nearby water bodies. Wetland plants extract these materials from water and deposit them in their own tissues; then when the plants die or shed their leaves, the pollutants settle into the wetland's bottom sediments.

Until polluted recently by sugar farming and other agriculture, the water running through the Everglades sawgrass marshes carried few nutrients and the plants were able to extract them all. By the time the flowing water emerged into the bays at the end of the land, it was crystal clear. Adventurer Hugh Willoughby and his men, crossing the Everglades in 1897, dipped up water from the marsh, drank it copiously, and reported that they "did not know a sick hour."[2]

Even now, the Everglades sawgrass marshes take up most of the nutrients in the water passing through them and release water that is purer—although today it is still unnaturally high in nitrogen and phosphorus from upstream sugar and other farming. Teeming hordes of sea creatures in Florida Bay and the coral reefs off the Keys depend on the purity of this water.

We humans have learned to use the water-filtering capacity of wetlands to our own advantage. If not overburdened, wetlands can trap pollutants from human-produced runoff and thus help protect groundwater, streams, lakes, and bays.

Water Capture. Lakes and ponds are retentive wetlands. They capture and hold rainwater rather than allowing it to flow to the sea through rivers and streams and into such large wetlands as the Everglades. Basin water eventually percolates down through lake or pond beds and finds its way into the Floridan aquifer system, helping to recharge it. The Green Swamp of central Florida consists of 870 square miles of which half are

A coral reef off south Florida in John Pennecamp Coral Reef State Park, Monroe County. If the Everglades does not purify the water flowing off the land, reefs like this cannot survive.

When water is retained on the surface of the land and eventually sinks into the ground, this is called **retention**.

When a land area slows floodwaters down before releasing them laterally, this is **detention** (or **attenuation**).

retentive wetlands whose recharge of the Floridan aquifer system provides vital groundwater to south and southwest Florida.

Flood Abatement. The vast floodplain wetlands in natural river bottomlands let water flow through them, but they slow it down (detention). By doing so, they reduce peak flood levels and prolong the time it takes for floodwaters to move into rivers and run off downstream. A river embraced by a broad band of floodplain wetlands rises and falls more moderately than when it is confined within man-made levees or when the adjacent land is cleared or paved. When a natural river rises and is free to wash into and out of its floodplain swamp, the swamp detains some of the water, soaks it up like a sponge, and then gradually releases it. According to researchers, if wetlands occupy ten percent of a landscape, flooding is reduced by as much as 60 percent. If wetlands occupy twenty percent of the land, flood reduction amounts to a dramatic 90 percent. Detention performs a vital service in moderating flood extremes.[3]

Detention also eases the stress of drought. Long after the rains have ceased to fall, water detained in wetlands remains available to slake the thirst of animals and plants.

The water management services performed by wetlands affect systems all the way to coastal estuaries whose waters alternate between fresh and saline extremes during wet and dry seasons. Oysters and other estuarine organisms are adapted to, and in fact require, this alternation in saltiness. However, it must take place at a pace, and within limits, that they can tolerate. They cannot handle overly extreme shifts from salty water to sudden, silty floods. As nature writer Gerald Grow puts it, "Without the flood detention performed by wetlands, Florida's great oystering areas, such

Wetland productivity. The base of the food web in this wetland is a mass of organic matter such as this watery muck, formed from partially decomposed algae. The muck provides underwater food for the zigzag bladderwort (*Utricularia subulata*), a carnivorous plant with tiny traps that capture tiny animals swimming in the muck.

as Apalachicola Bay, would be devastated. . . . Wetlands sponge up floods and release them at a pace that . . . organisms can live with."[4]

Climate Control. Florida's highly prized peat and muck sediments accumulate in still or slowly moving water. These substances tie up carbon, which, when oxidized, forms carbon dioxide, a global-warming gas. Peat and muck wetlands hold masses of carbon out of the atmosphere in such volumes that they help to regulate the climate. The Okefenokee Swamp and the Everglades are among Florida's big peat and muck wetlands that contribute to this effect.

The moisture in wetlands also contributes to regional humidity. Evaporation and transpiration of water from leaf surfaces in the Everglades is thought to contribute to seasonal rains all over south Florida, and the draining of the Everglades in the early 1900s is thought partly to blame for the local droughts of recent times.

> The term **evapotranspiration** refers to the evaporation and transpiration of water from plants, when the two processes occur together.

Productivity. Wetlands are also factories that generate many products we use, not least among them, food. As wetland plants drop litter or die and decompose, they yield detritus by the ton that nourishes huge populations of animals. Wherever water flows rapidly through the floodplain swamps along high-discharge rivers such as the Chattahoochee, Apalachicola, and Ochlockonee, it sweeps the detritus downstream to nourish ecosystems where the water flows next. Most of the great salt-marsh and estuarine fish nurseries along the coast are fed primarily by detritus from river floodplain wetlands. Botanist Andre Clewell warns ocean fishermen to guard interior wetlands: "Do you fish? Your catch spent its early life in the protective and food-rich confines of a wetland—mangroves, tidal reeds, pickerelweed, maidencane . . . Take away the river swamps, and. . . there won't be any more [seafood]."[5]

> **Detritus** is another important resource. On a dirty city street, the term may refer to garbage or litter, but in a healthy ecosystem, detritus is simply plant litter, which becomes food for microorganisms, and forms the base of the food chain.

Thus wetlands give rise to wildlife. It has been said of freshwater wetlands that they "take in air, sunlight, water, and nutrients and turn out bass, anhingas, ducks, herons, eagles, raccoons, alligators, turtles, snakes, frogs, salamanders, mink, . . ."[6]

Links in the Landscape Mosaic. Figure 2-5, shown earlier, illustrates that Florida's wetlands share the landscape with other interconnected ecosystems, most notably aquatic systems such as lakes and streams. Originally, all of Florida's wetlands were embedded in such broad landscape mosaics. Today, wherever large areas have been preserved, such mosaics are still functioning as they did in the past. Tomorrow, perhaps these landscapes will be more extensively restored. The Everglades, especially, is in great need of restoration, a vital task. As Marjory Stoneman Douglas said, "The Everglades is a test. If we pass it, we get to keep the planet."[7]

Upland chorus frog (*Pseudacris feriarum*). This minute amphibian can use tiny wetlands, even rainwater pools, to court and breed.

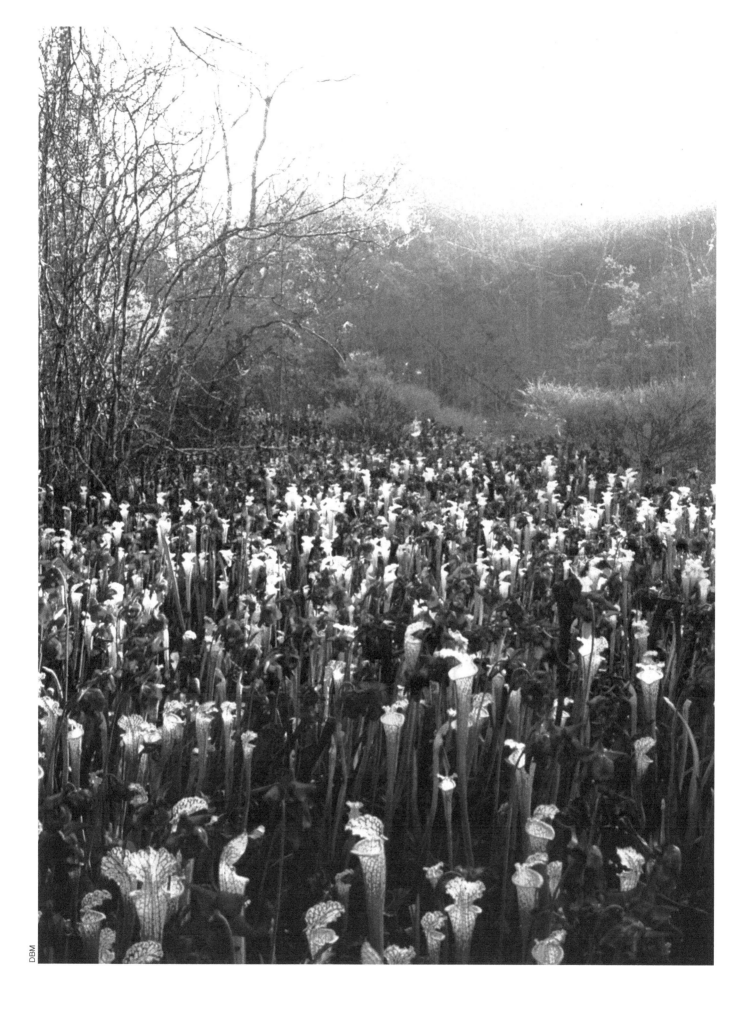

CHAPTER THREE

SEEPAGE WETLANDS

This chapter describes four types of seepage wetlands that are common in interior Florida: seepage herb bogs, shrub bogs, bay swamps, and Atlantic white-cedar swamps. These wetlands occur on seepage slopes—inclined areas where fresh groundwater seeps out onto the surface of the ground, keeping it cool and wet. The simplest type of seepage wetland is shown at left: water seeping from a hillside feeds directly into a stream and supports an herb bog.

Figure 3–1 depicts a gentle flatwoods slope that supports a series of seepage wetlands and shows the water flow that maintains them. Wetland herbs begin to grow along the border where groundwater first seeps out of the soil. Shrubs take over farther down the slope, where the soil is soggy with water-soaked peat, and water moving through the shrub bog feeds into a small, blackwater stream.

Longer sequences of seepage wetlands can also occur. Downslope from the herb and shrub bogs, there may be an Atlantic white-cedar swamp (in North Florida) or a bay swamp, or both—and beyond them, a deep-water swamp that finally gives way to an open-water channel. The transition from one of these communities to the next in any flatwoods may take place over an elevational decline of only a foot or two and over a horizontal distance of only 50 feet or more. This sequence may occur in parallel bands or in adjacent arcs on slopes, as shown in Figure 3-2.

Seepage wetlands are diverse in appearance, but they all have several things in common. They are kept constantly wet by shallow, slowly flowing water, and it is mainly groundwater; rain is a secondary source. The water tends to be nutrient poor and strongly acidic. Deeper seepage wetlands have floors of peat maintained by the constant moisture.

Threadleaf sundew (*Drosera fili-formis*), carnivorous plants that are exclusive to seepage margins around Bay and Washington county sandhill karst lakes and ponds.

OPPOSITE: A pitcherplant bog on Eglin Air Force Base in Okaloosa County. A throng of whitetop pitcherplants (*Sarracenia leucophylla*) is growing in peat that has accumulated at the edge of a freshwater stream fed by seepage along its sides.

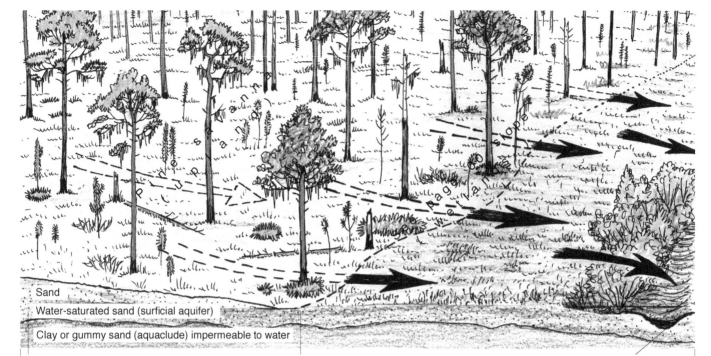

Sand

Water-saturated sand (surficial aquifer)

Clay or gummy sand (aquaclude) impermeable to water

Here, water is flowing laterally within the ground because the underlying aquaclude blocks its downward percolation.

At this point along the slope, the flowing water seeps onto the surface of the ground and flows across it.

At the foot of the slope, the water collects into a stream.

FIGURE 3–1

A Flatwoods Seepage Slope

The underlying layer of clay or organic hardpan (aquaclude) keeps water from sinking down, creating a surficial aquifer. Water from this aquifer moves laterally through the sand, seeps onto the surface, and then flows downslope until it reaches a creek. The moving water supports one or more seepage wetlands.

Source: Means and Moler 1979.

A **seepage slope** is an incline where water from beneath adjacent higher land seeps out onto the surface of the ground and then runs across it. (A clay or other water-impermeable underlayer keeps the water from sinking farther below the surface.)

In this book, we are retaining the term **herb bog** for this community. Other names for this community are *wet prairie* and *seepage slope*.

Seepage slopes appear in specific places in Florida. They are strung out all across the Panhandle, both on the northern highlands and on the sandy lowlands. They occur in northeast Florida along the bases of high slopes, and in central Florida along the base of the central ridge. Seepage is uncommon in south Florida where the topography is flat and wetland water comes from rain.

The reasons why the vegetation changes across a seepage slope—why herbs grow in one part, then shrubs, then white cedars, sometimes, and bays—will become clear in the sections to come. A stroll from an upland pine community down to a stream can illustrate the array of plant populations just mentioned: herbs —shrubs—bays or Atlantic white cedars.

A Seepage Herb Bog

Start out from an upland pine community—say, a longleaf pine–wiregrass sandhill or flatwoods in the Panhandle. Ease down off the higher ground

LEFT: A wetland series forms bands across a slope. Upland pine is highest. Then, where seepage water first wets the ground, there is an herb bog, beyond it a shrub bog, and then a bay swamp. Then comes a deep-water swamp of cypress and tupelo, and beyond that, open water.

RIGHT: A similar wetland series is clustered around the head of a stream. All of the wetlands might appear in the same sequence, but in the case shown here, the bay swamp borders the stream; there is no cypress-tupelo swamp.

FIGURE 3–2

Seepage Wetland Mosaics

Seepage wetlands may be arranged on the land as arcs around the head of a stream, or as bands on a slope. Not all communities appear in every array. Occasionally, Atlantic white cedar occupies sites usually occupied by bays.

and you find yourself on a gentle slope where the ground is moist and spongy underfoot. You walk, first, into a grassy meadow where, perhaps, a few slash pines may be mixed with the longleaf. As you walk farther downslope, the ground becomes more squishy. The wiregrass is patchy, and in its place are plants that tolerate wet conditions well: toothachegrass, other coarse grasses, and sedges. Club-moss weaves its soft tubular arms across the moist earth. Carnivorous plants are abundant: sundews dot the ground among the grasses and pitcherplants are everywhere.

This is an herb bog, and this particular bog is maintained throughout the year by seepage from a small aquifer that is perched on an impermeable layer of earth (a hardpan) not far below the surface. (Other herb-dominated wetlands, which go dry when the rains stop coming, are classed as marshes and are described in Chapter 5.) Some species of plants and animals can survive only in seepage bogs, as described here.

Herb Bog Plants. The flowering plants in an herb bog are extraordinarily diverse. Because the moisture changes gradually across such a broad expanse of land, it allows space for many different species to spread out and flourish, each in its own zone. Toward the top of the moisture gradient, 40 species of plants share the terrain. Only a few steps farther down the gradual slope, although there are still 40 species, 20 of them are different. A few steps more, and again they change. One square meter of herb bog contains the highest species richness of any such area yet inventoried. Many of the plants are also unusual (see List 3–1). Among them are rare wild orchids, rare lilies, and carnivorous plants unlike any

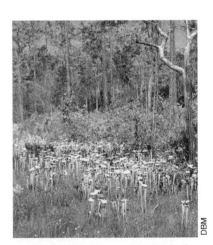

A mosaic of seepage wetlands. In the foreground is a grass- and sedge-dominated pitcherplant bog. Farther down the slope is a shrub bog and, beyond that, a bay swamp, with pond pine in the transition zone.

others, anywhere on earth. Botanists travel to north Florida from all over the country to see them in their season. Why have they assembled here? Acid soil and fire provide the needed support.[1]

The soil in which herb bog plants flourish is hostile to other plants. It is soggy, acidic, and infertile. Water cannot drain down because of the aquaclude below, and moves only slowly across the gradual slope. The acid comes from dead plants, which decompose slowly in the water. Acid makes it hard for living plants to obtain and retain nutrients. In acid water, plants actively lose nitrogen and phosphorus by leaching; and their uptake of mineral nutrients is inhibited. Even if fertilized, plants would grow slowly in such acidic, water-soaked sand. Aluminum, one of the minerals in the soil, reaches such high concentrations in bog soils that it, too, inhibits plant growth. Nearly everything is stunted. Even the few 100-year-old cypress trees are scrawny and spindly, but carnivorous plants thrive in nutrient-poor, acidic soils, thanks to the insects they capture and digest.

Among Florida's carnivorous plants are five species of sundews, of which two are shown in Figure 3–3. Florida's bogs also host six butterworts, a dozen bladderworts, and six species of pitcherplants. Butterworts have broad, tapering leaves that lie flat on the ground. The leaves are adorned with dewlike drops of a gummy substance to which tiny spiders and insects stick as if on fly paper. The plants digest them through the leaf surfaces. Bladderworts grow underground or float in the water of bogs with their stems and leaves below the surface. Their leaves are modified to serve as tiny, basketlike traps. These bladders trap swimming prey too small for the human eye to see—tiny animals such as water fleas, rotifers, and other microorganisms—and these serve as food for the plants.[2]

Pitcherplants are among the oldest flowering plants on the planet. They date back to the time when dinosaurs were still roaming the earth, and in the 80-some million years since then they have evolved elaborate mechanisms for capturing insects and other small prey. The strategies of two of them are shown in Figure 3–4.

Other creatures take advantage of the attractiveness of the pitcher. A spider may spread its web across the top of a pitcher and catch bugs being attracted into the trap. A treefrog may sit inside the lip of a pitcher to escape the midday heat while catching bugs. A moth may lay its eggs inside a pitcher and then spin a layer of silk to close the top. When the larvae emerge, they eat their way out through the pitcher-plant walls. The belly of a carnivorous plant seems a hazardous place for tiny animals to live, but it is a protected place, shady, and with constant humidity and temperature. For those that can avoid its pitfalls, it provides a fine habitat. Several species of mosquitoes, for example, spend their larval lives in the water of pitcherplants.[3]

Pink sundew (*Drosera capillaris*). These tiny rosettes spread their sparkling leaves flat on the damp earth. Gluey hairs on the leaves attract, capture, and digest insects to nourish the plant.

FIGURE 3–3

Two Florida Sundews

Tracy's sundew (*Drosera tracei*). LEFT: A field of Tracy's sundews. Each unfurls slender leaves up to eight inches high, and each leaf glistens with shiny, sticky hairs that attract and capture insects. CENTER: Close-up of one leaf with three trapped insects. The leaves digest their prey with powerful enzymatic juices and absorb the end products. RIGHT: Tracy's sundew flower.

Besides the hapless victims of the plant and predators that take advantage of their being attracted there, other creatures scavenge the parts that the plant doesn't digest. A single, giant carnivorous maggot is often found floating on the surface of the water in a pitcher; it devours whatever bugs fall in and also cannibalizes its own kind (which is why there is only one). Other scavengers include bacteria, protozoans, nematode worms, copepod crustaceans, mites, mosquitoes, a midge, six kinds of mosquito larvae, a gnat, a wasp, and others. Of three flies known to feed on the plant's captives, each avoids competition with the others by specializing. One feeds on new captives floating on the surface; one feeds on debris suspended within the liquid, and a third eats the corpses at the bottom. Still other small creatures, including a root borer and the moth larva mentioned earlier, eat parts of the plant. In these age-old relationships, each participant has found a niche, adapted to it, and secured a place for itself. Each kind of pitcherplant attracts somewhat different insects, dividing the resource rather than competing.[4]

The plants' life cycles are synchronized with the seasons. In spring when the new pitchers first rise from the earth, they are empty, but by late fall they are full of insects. When they die, the undigested remains return to the earth. If a fire comes through, the remaining nutrients are freed as ash, and help to fertilize the plants in their next growing season. Thus these plants contend successfully with the challenges of an environment that is far too hostile for other plants.

Most of the plants described here can grow without seepage water, on soil such as in wet flats that remains boggy for most of the year due to poor

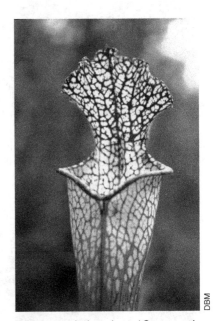

Whitetop pitcherplant (*Sarracenia leucophylla*). Because nitrogen and phosphorus are hard to come by in their habitats, pitcherplants are adapted to trap insects and digest them to obtain these nutrients.

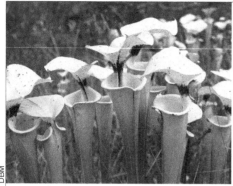

Yellow pitcherplant (*Sarracenia flava*). This tall pitcher has an umbrella that keeps rainwater out. If it filled with water, it would fall over. The bait and trap are shown at right.

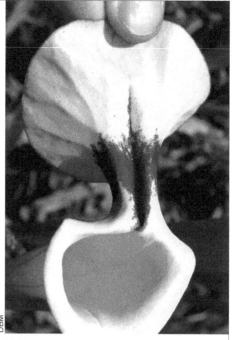

Yellow pitcherplant bait and trap. Bright colors and sugars glisten on the underside of the umbrella. Insects are attracted, fall into the deep, slippery trap, and then can't crawl back out.

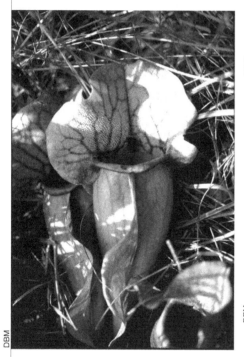

Gulf purple pitcherplant (*Sarracenia rosea*). Having no umbrella, this pitcher fills up with water and lies on the ground. Bait and trap are at right.

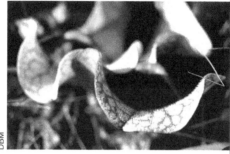

Purple pitcher bait and trap. Bright colors attract insects; then when they crawl down the ramp, downward-pointing hairs prevent their escape. They die by drowning and enzymes secreted by the plant's walls digest their soft tissues.

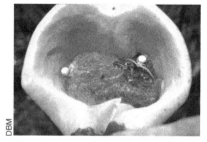

Two opportunists. Two crab spiders tend a web in the mouth of a pitcherplant, where they will easily catch insects.

Another opportunist. A pine woods treefrog conceals itself within the lip of a pitcher to catch flies lured there by the plant.

The prey. When the plant is held open, the undigested remnants of bugs, flies, grasshoppers, moths, and tiny snails are revealed. At the end of the season, when the plant itself dies down to the ground, these remains will decompose and fertilize the next generation of plants, the next season.

FIGURE 3–4

Two Florida Pitcherplants

drainage. But some plants can live *only* in seepage bogs. The Panhandle lily is an example. It grows only in Florida's four westernmost counties and in two adjacent counties in Alabama. It requires wet seepage habitats near permanent flowing water and thrives best at a clean boundary between an open sunny herb bog and a brushy, shady shrub bog. Today, the lily is found at only 20 to 30 sites in the western Panhandle, and each population is small.

Fire in Herb Bogs. Surface fires burn frequently into herb bogs from higher ground, and frequently sweep all the way across the bogs. Fine, grassy litter is readily flammable even over wet soil. The fires burn out only at the edge of the shrub bog, where the shade is dense, there is no grassy fuel, and the litter on the ground is water-soaked.

As in upland pine communities, fires stimulate the reproduction of a bog's groundcover plants while killing woody vegetation or at least keeping it from growing tall. Herb bogs are absolutely dependent on fires, which must bite back encroaching shrubs at intervals of not more than one to three years.

The seepage bog's place in the landscape just downslope from a piney upland guarantees the conditions that maintain it. The slope supplies constant moisture in which even the tenderest, most water-dependent herbs can thrive. The pine community invites lightning to ignite fires, which then can burn into the bog, eliminate competition, clear away litter, and release nutrients.

Cutthroat Seeps. This description has featured a Panhandle seepage bog, but should acknowledge that other seepage bogs exist in other parts of Florida. On the central Florida ridge, there are seepage bogs in which cutthroat grass is the major groundcover plant. Only a very few such bogs remain today; a photo of one appears in Figure 3–5.

Herb Bog Animals. Some common bog animals are shown in Figure 3–6, and the Pine Barrens treefrog is singled out here for a closer look. This tiny creature, only 1-1/2 inches long, is a dazzling little jewel of a frog. Bright lime green on its back, it has a chocolate brown mask and sides fringed with bright yellow. The inside surfaces of its legs are a glowing orange with yellow spots and a lemon-yellow band surrounds each eye.

The Pine Barrens treefrog is a specialist: it requires seepage, and in Florida it lives mainly in the same bogs where the Panhandle lily grows. Outside of Florida, only two other locations in North America support Pine Barrens treefrogs: one in the Carolinas, and the other in the Pine Barrens of New Jersey. The three widely separated populations of frogs are all of the same species, indicating that they must have originated from a single population at some time in the past. There was a time, during the past two

Panhandle lily (*Lilium iridollae*). For most of the year, the Panhandle lily is just a cluster of slender leaves growing from an underground bulb. During July and August it grows a stem four to six feet tall, with one or more showy flowers at the top.

A **surface fire**, or **ground fire**, is one that burns through litter and undergrowth. A **crown fire** is one that burns through the tops of trees. In presettlement times, crown fires almost never burned in longleaf pine savannas, but did occur in dense stands of sand pine during their infrequent fires. When there is a closed canopy above a hot surface fire, an accompanying crown fire is almost inevitable.

FIGURE 3–5

A Seepage Herb Bog in Central Florida

Dominated by cutthroatgrass (*Panicum abscissum*), a moisture- and fire-dependent endemic herb, this wetland in Polk County is known as a "cutthroat seep." The trees are pond pines.

million years, when seepage bogs formed a continuous line all the way from New Jersey to Florida and even farther west. The bogs came and went over thousands of years of climate change, and the treefrog populations expanded and dwindled along with them.

Further fragmentation of the treefrogs into isolated populations occurred after the Europeans came. They built roads, dug ditches, timbered, plowed firebreaks, and thereby altered groundwater flows, wiping out thousands of acres of herb bogs and leaving only patchy remnants. Today, only a few seepage herb bogs remain in the Panhandle, and populations of Pine Barrens treefrogs are rare. You can find them by listening, on rainy nights during the breeding season, for the males' nasal "quank, quank" calls. A typical breeding chorus includes about ten males; some choruses have only three or four males, or even only one or two.

When not breeding, the adult treefrogs live in nearby shrubs and trees of the shrub bog. They shelter there, defend their territories, and catch insects and spiders for food. In the next rainy season, males call from shrubs at the edge of herb bogs. Females meet them there, and lay their eggs in tiny seepage puddles, the males fertilize them, and the tadpoles develop in those puddles.. A small puddle may be teacup-sized—seemingly insignificant, but without such puddles, the tadpoles cannot develop into

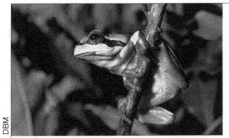

DBM

Pine Barrens treefrog (*Hyla andersonii*)

BM

Mimic glass lizard (*Ophisaurus mimicus*)

DBM

Squirrel treefrog (*Hyla squirella*)

BM

Eastern ribbon snake (*Thamnophis sauritus*)

FIGURE 3–6

Florida Herb Bog Animals

frogs—hence the requirement for constant seepage. The water has to be cold, too, and seepage water meets this requirement. It stays at 68 to 72 degrees, like the surficial aquifer from which it emerges, even as it flows through puddles that are in full sun. The water also must be crystal clear and highly acidic, with the acids that characterize seepage sites—tannic acid and others. Seepage water rarely dries up and rarely stands still. It stays cold and pure, providing just the right environment for the frogs' rendezvous and tadpole nurseries.

Like the Panhandle lily, the Pine Barrens treefrog can reproduce its kind only in a bog that has a clean boundary; shrubs must not be crossing the line into the bog. The sharp dividing line is important for several reasons. If nearby shrubs began to invade upslope into the herb bog, they would suck up water, because woody plants return rainwater to the air more efficiently than herbs. As a result, the needed puddles would soon dry up. Frequent fires are necessary to maintain the clean boundary the lily and frog require. If you see shrubs encroaching on an herb bog, you can be sure that fire has been excluded for too long. The sun-loving bog plants will soon find themselves in full shade and will die out.

A SHRUB BOG

Downslope from the green expanse of the herb bog, an evergreen shrub bog abruptly takes over, where woody shrubs form a tangled wall of greenery that rises to 25 feet in height. This is one of Florida's most sharply defined natural borders: it exactly marks the line at which the last herb-bog fire burned out.

Shrub Bog Plants. A shrub bog appears to be impenetrable, but only

the sun-exposed edge is thick with greenery; shade keeps the interior open. Look for an animal trail into the shrubs: it won't be hard to find. (Wear wettable shoes that can drain, not rubber boots that might fill with water and grow heavy.) Slip into the deep shade among the shrubs and explore this miniature swamp. Each shrub is 10 to 25 feet in height and looks like a small, ancient, gnarled tree. The twisty branches support prickly greenbrier vines. Birds sing and flit among them, attracted by titi fruits, holly berries, greenbrier berries, and insects.

In contrast to the bright green herb bog, this is a shady world. In places, an inch or more of cold water covers the ground, and soft leaf litter is floating in it. The floor consists of a spongy dark soil that is rich in peat from earlier litter. Instead of tender green herbs at ground level, now the ground is covered with deep twig and leaf litter. Wetter sites may support large mats of lime-green sphagnum moss.

Plant diversity is low in a shrub bog. Two species of shrubs called titi (pronounced TYE-tye) predominate in north Florida, among perhaps a dozen species of other evergreen shrubs. Bright splashes of color in spring indicate occasional clusters of sweet pinxter azalea. A few conifers stand well above the canopy: pond pine, slash pine, and perhaps Atlantic white cedar. Some young hardwood trees may be present: red maple, loblolly bay, swamp bay, and sweetbay. The water and shade prohibit the growth of groundcover plants, except for sedges in sunny spots or sphagnum moss in shade. List 3–2 names some common shrub bog plants.

The shrubs in the bog all exhibit similar adaptations to the environment in which they grow. They all have small, glossy, leathery leaves that are coated with wax. They resemble the leaves on desert plants, whose thick skins resist water loss—but this is a wetland. Why are the leaves drought-resistant here? Paradoxically, the answer probably has to do with dry conditions just as in the desert. Although wetland shrubs must usually cope with water-saturated soil, drought resistance is necessary, too, if they are to survive many decades.

The small leaf size may also be a function of nutrient-poor soil, which supports only slow growth at best; of acid water, which inhibits nutrient uptake; and of the aluminum compounds that accumulate in acid soil and are toxic to most plants. The leathery texture may be an adaptation to protect against water loss, because wetland shrubs are poorly equipped, in other ways, for dry times. They have shallow roots, an adaptation that helps them cope with waterlogged soil—the oxygen that roots need to grow is available only near the surface. But shallow root systems make plants especially vulnerable to droughts when water withdraws far beneath the surface.

When the bog shrubs drop their waxen leaves, they become a highly flammable litter on the ground. This adaptation, together with the bog's

Sweet pinxter azalea (*Rhododendron* ... ʻnlike other azaleas, s well in wetlands.

closed canopy, enables hot surface fires to burn across the shrub bog floor and leap to the canopy during severe droughts, which occur every decade or so. The shrub species survive such fires: their above-ground stems and branches may be killed, but their thick bases are left undamaged. The shrubs soon resprout vigorously, sending up many stems from each root crown and replacing the entire thicket within a few years, much as before. The multiple stems of the shrubs is evidence that they have resprouted repeatedly after earlier fires. No wonder they look old: despite the small size of their stems, their root crowns may be several centuries old.[5]

Given periodic fire and perpetual seepage water, bog shrubs can hold their territory indefinitely. In the deep shade beneath their closed canopy

Florida visitor: Chestnut-sided warbler (*Dendroica pensylvanica*). This small songbird pauses in brushy habitats in Florida during its fall and spring migrations.

LIST 3–2
Shrub bog plants (examples)

Occasional trees
Loblolly bay
Loblolly pine
Pond cypress
Pond pine
Red maple (stunted)
Slash pine
Swamp bay
Sweetbay

Typical shrubs
Black titi
Fetterbush
Gallberry
Large gallberry
Swamp titi

Other shrubs
Myrtle dahoon
Red chokeberry
Swamp doghobble
Sweet pepperbush
Virginia willow
Wax myrtle

Vines
Laurel greenbrier

Herbs (sparse)
Floating bladderwort (in
 puddles)
Pitcherplants
Tenangle pipewort
Virginia chain fern

Source: Adapted from *Guide* 2010, 125-126.

A shrub bog. The tall shrubs are black titi. Pure stands like this typically grow between herb bogs and bay swamps next to swampy creeks.

Two species of evergreen shrubs known as titi (TYE-tye) grow in Florida's shrub bogs.

One of the two is **black titi** (*Cliftonia monophylla*), which holds the drier territory and is the first shrub encountered when one walks downslope into a titi swamp. The other, known simply as **titi**, or **swamp titi** (*Cyrilla racemiflora*), tolerates water better and holds the wetter territory.

Titis are so common in north Florida that their community is often named for them, a titi swamp. (Titis do not, however, grow south of Gainesville because the climate is too warm for them; fetterbush, staggerbush, and others take their place.)

Florida black bear (*Ursus americanus*). Swamps and forests are suitable habitat for this big animal.

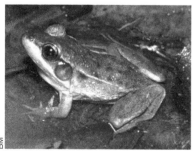

Florida bog frog (*Rana okaloosae*). This frog is a common resident of shrub bogs and is endemic to a small part of the Florida Panhandle.

and in the acidic soil produced by their litter, other species win no space.

Shrub Bog Animals. A shrub bog provides habitat radically different from the open, sunny herb bog upslope. Along its sun-bathed edge, a tangle of vines and branches permits the Pine Barrens treefrog and five-lined skink to forage for insects among the branches. Inside some special shrub bogs in the Panhandle that are always flooded with seepage water, the Florida bog frog finds comfortable wetness here complete with plenty of small prey animals and many good hiding places under leaves and litter. Other frogs breed in pools beneath the shrubs. The green anole and coal skink frequent the bog margin.

Attracted by the abundance of small prey, the common garter snake and eastern ribbon snake hunt here, together with the southern black racer and eastern indigo snake. Birds find abundant berries, insects, and nesting places. Marsh rabbits and two species of shrews also use the bog. Southern mink, raccoon, and bobcat come and go.

Deer browse and bed down in the shrubby thickets; up to 65 percent of a deer's diet may be titi leaves and bark. Even the Florida black bear is at home in shrub bogs, where it can stay well hidden while dining on berries and fruits.

A Bay Swamp

Now follow the gentle slope farther downhill, into a stand of trees that are increasingly taller than the shrubs—sometimes as much as 60 or 80 feet tall. Now the ground underfoot is a springy floor of water-soaked peat. This is another seepage community, a bay swamp, and like the herb and shrub bogs upslope, it is a seepage wetland. The peat in which the trees stand may be mixed with sand, and may be anywhere from a few inches to well over six feet deep, too deep to measure with a standard soil borer. In areas where the peat is shallow, heavy rains may erode it, leaving channels or pools where the sand beneath it is visible.

Bay Swamp Trees. Usually, most of the trees in this zone of a seepage slope are bay trees—sweetbay, loblolly bay, and swamp bay (but not redbay, which grows in somewhat drier habitats). These three bays are evergreen hardwoods adapted to life in hydric habitats that seldom burn. The leaves of these evergreens are larger, but otherwise resemble those of the evergreen shrubs described earlier: they are leathery, coated with wax, and highly flammable. Once or twice in a century, when this swamp finally burns, it will burn completely.

Bay trees grow more slowly than shrubs, but given 10 to 25 years without fire, they finally grow stout enough to withstand shrub bog fires. Then they form a high, closed canopy, shading out all but a few shrubs, ferns, and mosses beneath them. List 3—3 itemizes some of the other plants that

may grow among them.

Like a shrub bog, a bay swamp hosts fewer than 30 woody species of note. The few that are adapted to these severely restrictive growing conditions have come to dominate all others. The understory is patchy and consists mostly of mid-sized offspring of the canopy trees. A few titi and other shrubs remain but are dying out. The ground is brown with fallen needles and leaves; less than one percent is covered in patches of green, mostly sphagnum moss.

In addition to bay trees and tupelos at the center of the swamp where the trees are tallest, towering slash pines may reach more than 100 feet in height and measure three feet across at chest level. After rains, water stands several inches deep. Even in dry weather the air is humid, thanks to the great volume of water held within the peat. The air bears a fresh, earthy aroma of decaying wood. Silence enfolds the scene.

Bay Swamp Animals. In the stillness of a bay swamp, animals are inconspicuous, but small animals including salamanders and shrews are numerous. If you see a large animal, it will probably be an opossum, rabbit, raccoon, bobcat, deer, or bear. High in the canopy, diverse birds feast on insects, and on bay fruits in their season.

Fire and Bay Swamps. Because they are fringed by shrub bogs around their edges, bay swamps are protected from all but the most catastrophic, wind-driven fires that occur during the severest droughts at intervals longer than 50 years. When fires burn into shrub bogs, the stems are top-killed but each shrub resprouts vigorously from its roots and re-establishes the shrub bog zone. Depending on soil moisture, fires may or may not burn into the swampy bay forests, but if they do, these trees also resprout from their roots.

When a bay swamp burns, the peat floor may well burn, too, leaving bare ground. Then the water will return, peat will again build up, and the swamp will regrow as before.

Large bay swamps may have cypress-tupelo swamps within them and may grade into river floodplain swamps. They may also have elevated sites within them, holding temperate hardwoods.

AN ATLANTIC WHITE-CEDAR SWAMP

Walking down the seepage slope from the north Florida shrub bog, you might be lucky enough to encounter not a bay swamp but a rare Atlantic white-cedar swamp. White-cedar stands are sparsely distributed and grow in seemingly dissimilar habitats, but they all have one key feature in common: their soil is very moist and remains so in all seasons.

LIST 3–3
Bay swamp plants (examples)

Major canopy trees[a]
Loblolly bay
Swamp bay
Sweetbay

Other canopy trees
Atlantic white cedar
Loblolly pine
Pond cypress
Pond pine
Slash pine
Swamp tupelo
Sweetgum

Understory[b]
Black titi
Coastal doghobble
Dahoon
Fetterbush
Florida anisetree
Large gallberry
Myrtle dahoon
Red maple
Swamp doghobble
Swamp titi
Virginia willow
Wax myrtle

Vines (often abundant)
Coral greenbrier
Laurel greenbrier
Muscadine

Groundcover (absent or sparse)
Cinnamon fern
Netted chain fern
Sphagnum moss
Virginia chain fern

Notes:
[a]The three bays are also dominant in the understory.
[b]Understory species vary by region and by soil moisture.

Source: Adapted from Wolfe and coauthors 1988, 153; *Guide* 2010, 177-179.

A **bay swamp** can occur in a basin as well as on a slope kept wet by seepage. A whole basin may then be called a **bay** (as in Bradwell Bay, in Wakulla County).

A bay swamp may form an arc around the head of a small creek, especially in flatwoods. Then it is called a **bayhead** or **baygall**.

A bay swamp may also run linearly for some distance along a slender stream. In such a location it is called a **bay branch**.

European settlers gave bay trees this common name because of their resemblance to the familiar Mediterranean bay leaves they used in cooking. The most common bay trees in Florida are wetland species such as sweetbay (*Magnolia virginiana*), loblolly bay (*Gordonia lasianthus*), and swamp bay (*Persea palustris*) or upland species such as red bay (*Persea borbonia*) and bull bay (*Magnolia grandiflora*). Because of their aromatic flavors and their dark green, lanceolate, leathery leaves, they resemble the bay leaves that the settlers remembered from their homes in Europe. Except for the magnolias, they are in different plant families

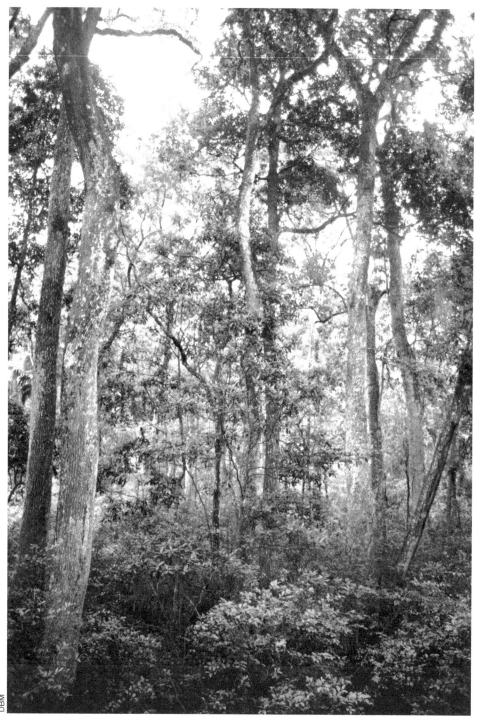

A bay swamp. The trees are loblolly bay (*Gordonia lasianthus*). This is Florida's largest loblolly swamp, in Ocala National Forest, Marion County.

Atlantic White Cedar. In a stand of white cedars, the trees stand tall and perfectly straight. Their bark spirals around the trunks like candy-cane stripes, and their shallow roots spread broadly across the ground's surface. The air is cool, thanks to the cold water within the peaty floor and the treetops that help to hold in the coolness in. Groundcover plants are sparse, due to the deep shade.

When you walk in an Atlantic white-cedar swamp that is supported by

seepage, you are walking on water, in a sense. The ground may not look wet, but poke a deep hole in the peaty earth with a rake handle and it will fill with water all the way to the top. An Atlantic white-cedar stand is a true wetland, and the tree itself is a wetland indicator species.

White cedar is remarkably disease resistant and so can outlast other trees. Other trees grow old, suffer attacks by insect pests and fungi, and eventually collapse, but cedar is immune. By the time white cedars have reached maturity, only a few other trees remain standing among them.

Not uncommonly, mature white cedars reach heights of 100 feet, girths of three feet, and ages of 200 years. A few true giants remain in Florida that measure more than *15 feet* in diameter at breast height, not unlike the redwoods of the West. The virgin white-cedar swamps in early Florida must have been extraordinary.[6]

Old cedars can be blown down, but they die more often from lightning strikes. Lightning selects the tallest cedar in a stand, shoots down the trunk, and heats the interior moisture to steam, blasting the tree apart and hurling slabs of wood up to 20 feet long and a foot wide all around the tree. Lightning seems to be the main agent limiting the age and size of Florida's white cedars.[7]

Other plants growing among cedars may be of many different species. Some are midstory and groundcover plants, unusual in Florida but typically seen farther north in cooler climates. A cedar stand at Deep Creek, in Putnam County, has specimens of fairywand, largeleaf grass-of-parnassus, and swamp thistle, all typically found further north. Tuliptree, hazel alder, and Florida willow are also found here and otherwise grow only farther north.

Animals in white-cedar stands include the same ones as in bay swamps: mud and dwarf salamanders, shrews, rabbit, raccoon, opossum, bobcat, and bear. The large white-cedar stand in the Ocala National Forest supports a healthy population of Florida black bears, and the bark on many of its trees is shredded by bear claws up to a height of six and a half feet.

* * *

This chapter began on the green expanse of a flatwoods seepage bog, and has ended in shady bay and white-cedar swamps with towering trees. In deeper swamps, another transition occurs—to ecosystems in several feet of water, such as cypress or tupelo or bottomland hardwood swamps, described in Chapter 5.

Florida visitor: Black-and-white warbler (*Mniotilta varia*). This warbler spends its winters in Florida, foraging among the trunks and larger branches of deciduous woods.

Atlantic white cedar is also called **juniper**. A white-cedar swamp is the same as a juniper swamp.

Largeleaf grass-of-Parnassus (*Parnassia grandifolia*). This rare flower depends on continual seepage and grows well in seepage bogs.

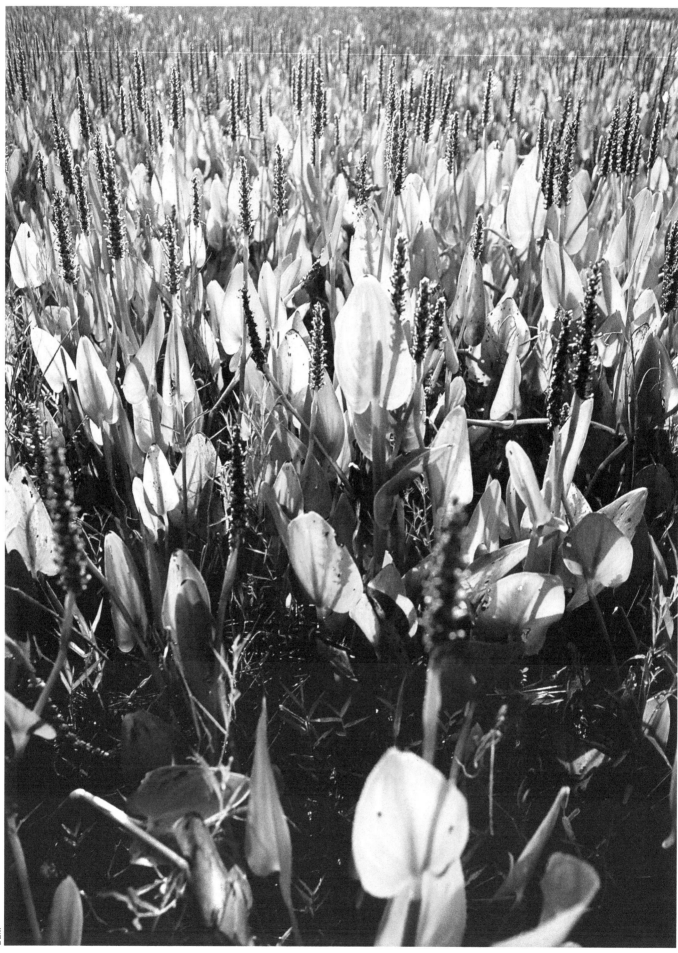

CHAPTER FOUR

INTERIOR MARSHES

Although Florida has plenty of topographical relief, as the previous chapters have shown, it is rightly reputed to be largely flat. Its lowlands, particularly, consist of broad, level plains holding vast marshes which, in the past, were of mind-boggling scope. Florida writer W. R. Barada, writing about rains in the marshes in the distant past, describes them this way:

> *When the summer rains came, lake water levels rose to spread over surrounding lowlands, and meandering rivers and streams overflowed into floodplains. . . . Marsh vegetation, fish and waterfowl thrived; water table aquifers rose to bathe the roots of thirsty upland vegetation; grazing wildlife fed on the new greenery . . . and marine life flourished in brackish coastal marshes and estuaries.*[1]

Those were the days when much of Florida, and nearly all of south Florida, held water several feet deep over hundreds of square miles throughout the rainy season and for several months beyond. Those days are gone, but even now, many marshes and marsh lakes remain, because annual rainfall exceeds annual evapotranspiration and the land drains poorly and holds water.[2]

Marshes occur on several types of terrain. Still-water marshes occupy the borders of open-water lakes. Flowing-water marshes may border streams all along their length. Both still- and flowing-water marshes also occupy thousands of acres of Florida's flat lands, where their boundaries are irregular. On the central ridge, the marshes are scattered all over Alachua, Lake, Putnam, Sumter, and Marion counties. On the lowlands, flatwoods marshes are dotted all over the flats along both coasts and across the Panhandle. Florida's lowlands also have vast, flowing-water marsh systems. Numerous, vast floodplain marshes interconnect with the St. Johns River; and marshes abound throughout south-central Florida.

Bandana of the Everglades (*Canna flaccida*), also known as Golden canna. This gauzy flower blooms in Florida swamps and marshes in spring and summer.

Reminders: A *marsh* is a wetland dominated by herbs that are rooted in saturated soil on which water stands for much of the year.

Evapotranspiration is the sum of evaporation (in which liquid water turns to water vapor) and transpiration (in which plants take up liquid water through their roots and release it to the air). It is a major route of water loss from wetlands.

OPPOSITE: A marsh bordering Lake Jackson, in Leon County. The flowers are native aquatic plants, pickerelweed (*Pontederia cordata*).

String-lily (*Crinum americanum*). This graceful lily blooms over vast expanses of marshes and wet prairies in summer, as shown in the opening photo of Chapter 2.

FORMATION AND MAINTENANCE OF MARSHES

Marshes on low land may exist for a long time, maintained by the constant presence of water near the surface or in adjoining streams or lakes. Marshes on high land are often relatively short-lived; they may soon become either lakes or dry land.

A highland marsh may begin to develop when a sink becomes plugged or when the land subsides, forming a depression that fills with water and wetland herbs. The plants drop litter every year and the litter decays, becoming loose, fluffy material that floats for a while, then sinks to the bottom, forming muck and peat. If an area of open water remains in the middle of the depression, it is called a marsh lake. (There are also aquatic zones in Florida's lakes, which are described in Volume 3 of this series, *Florida's Waters.*) If the basin fills in entirely with herbs, it is called a marsh. Later, if the water table falls and remains low for several years (as in a prolonged, severe drought), it may progress to become a shrub bog or swamp unless fire razes it and water returns. Paynes Prairie is a well-known example of transitions like this: it was once a dry grassland; then because the sink that drained it became plugged, a lake; then as the lake level fell, a marsh.[3]

In all types of marshes, water rises and falls with the seasons, but the highs and lows vary greatly from one marsh to another. In the rainy season, one marsh may hold only a few inches of water while another may hold five feet. In the dry season, one marsh may still hold standing water, while in another, the standing water will have disappeared, although the soil remains saturated at or not far below the ground level. In north Florida, which has both winter and summer rainy seasons, only very shallow marshes normally go dry every year. In south Florida, where winter rains are rare, even the deep Everglades marshes go completely dry nearly every April. The hydroperiods of Florida marshes—that is, the spans of time during which water actually stands on the surface—range from only a few weeks to twelve months of the year, but nearly all marsh soils remain saturated year-long except during prolonged droughts.

If a marsh goes completely dry for more than a month or two, it may be invaded by shrubs and trees. Then fire, as well as water, is needed to keep it from becoming a thicket or hardwood hammock. If a marsh burns consistently every one to three years, tree and shrub seedlings are killed before they can root effectively and all of the plants will be tender young herbs. If the fire interval is longer, perhaps as long as ten years, the marsh will contain patches of shrubs and small, sprouting trees. An occasional cypress tree may even start growing during a dry time and then survive subsequent flooding and fires. With limited water fluctuation, large stands of cypress and tupelo may form within a marsh. But if a marsh remains

Fragrant ladies' tresses (*Spiranthes odorata*). During high-water times, this orchid is able to grow submersed with only its flowers showing above the water.

A buttonbush marsh in St. Andrews State Park, Bay County. Common buttonbush shrubs were overtaking this marsh, which had not burned in recent years.

constantly inundated with standing water, provided that the water rises and falls with the seasons, it can exclude trees for a long time.[4]

MARSH PLANTS

The plants that grow in marshes face challenges different from those on seepage slopes, already described. Seepage wetlands never flood and rarely dry out: their soil is virtually always saturated—and with flowing water. Inland marshes, in contrast, are deep in water for part of the year and nearly or altogether dry for part—and their water flows slowly if at all. Marsh plants have seasonally timed adaptations that enable them to deal with alternating high and low water. Coastal marshes may be inundated all year long.

Many marsh herbs are perennial. They have massive root systems, and although they die back as the water falls in the dry season, they easily re-grow when the rains return and the water rises again. They also have ways to keep their heads above water. Sedges, rushes, and reeds are equipped with stiffening fibers that enable them to stand tall, but to bend, if necessary, without breaking. Other marsh plants, such as waterlilies, have such buoyant leaves that they float to and fro at the ends of their pliable stems.

The thick, shallow root systems of marsh herbs monopolize the ground surface and help to exclude woody plants. Even in dry times, tree seeds

Many families of plants have grasslike stems and leaves. Some are wetland plants.

A **sedge** is a grasslike plant, different from other grasslike plants in having a solid, usually three-sided stem.

A **rush** is a grasslike plant with a round, usually spongy stem.

The term **reed** is a common name that refers to several tall grasslike plants of wet places. Reeds may be members of any of several plant families. Many reeds are grasses, plants with jointed stems.

can seldom find a way to put down roots among them. Tree seedlings start up slowly if at all, and the next water's rise almost invariably kills them.

It is to the benefit of marsh plants to be flammable, and they are: they can even burn over standing water. Marshes typically burn, not at the peak of the dry season, but when the first summer thunderstorms blow in. Lightning ignites the marsh and fires can burn many acres before rains become heavy and frequent. Then the seeds of marsh plants, buried earlier in the soil, have a good chance to start growing wherever fire has cleared the way for them.

If the water rises too quickly, the plant seeds cannot germinate, but the plants have another way to recover: they can resprout from their roots. Conveniently, peaty soil holds enough moisture to protect the shallow roots of marsh plants, so they can regrow fast, fertilized by ash, just as the water is rising.

As for the variety of plants in marshes, if they appear monotonous, look again. Most likely, the marsh you are looking at has dozens of species of plants, each species occupying a subtly defined site where its own best growing conditions prevail. Spikerush, maidencane, and Jamaica swamp sawgrass grow best if inundated for 70 to 90 percent of the year. Arrowhead thrives with 85 to 95 percent inundation; American white waterlily, with 90 to 100 percent. These plants also require that the water levels fluctuate between certain limits. Lower the low or raise the high water level, and the plant distribution changes. Stabilize the water level and the marsh will, in time, fill in with undecomposed litter and then with shrubs and trees.

Several arrays of plants may grow in Florida marshes (see List 4–1). Which array will predominate depends partly on what plants happened to seed in to begin with, but mainly on water depth and hydroperiod, fire frequency, soil, and degree of drying between times of inundation. Which plants grow in a particular marsh seems not, however, to be influenced by Florida's range of temperate to subtropical climates. Nearly all marsh plants are temperate, and the same plants grow in marshes all over Florida.[5]

The marsh plants in List 4-1 are the ones that people see, those whose tops are in the air. Other plants live wholly under water, and so are easily overlooked. Notable among them are billions of microscopic algae that coat the submerged stems and blades of every plant—periphyton (pronounced "perry-FYE-ton"). These algae dangle from the underwater parts of plants and rocks in ropes, clumps, and mats, looking for all the world like useless slime. Indeed, they are slimy, but they are not useless: they are the base of the food web, as described next.

MARSH ANIMALS

Although it may look peaceful, a marsh is an extremely busy place. Hosts of animals are present that human-sized observers hardly ever see, both below and above the water line. To begin with, nearly 300 species of tiny animals live among the periphyton. Tiny invertebrates (copepods and amphipods) eat the algae and disintegrating parts of plants. These in turn are eaten by midge larvae, water fleas, mosquito larvae, and fly larvae. Salamander larvae and tiny fish then eat these. Apple snails, millions of them, graze the marsh plants under water, then periodically glide to just below the surface to draw fresh oxygen through their strawlike breathing organs.[6]

Above the water line, innumerable insects crowd the marsh. Figure 4–1 shows just three of the dragonflies, but mayflies, mosquitoes, gnats, deerflies, horseflies, water bugs, and water beetles also thrive in marshes. To see them, beat some marsh plants over a white cloth: a horde of insects will fall out and be visible on the cloth. The air is alive with a cacophony of insect hums, clicks, and crackles. Spiders harvest a bounty of edibles in such an environment; spun among the grasses are countless webs.

In the water and on the bottom, feeding on this cornucopia of tidbits are grass shrimp and crayfish, themselves well hidden by the plants. In

> **Periphyton** is a coating of algae on the underwater parts of rocks and plants. Literally, it means "growing around plants." It is extremely abundant in marshes and a highly significant part of the ecosystem, both when wet and alive, and when dead and dry, when it turns to marl.

> **Marl** is a crumbly, alkaline soil that forms from periphyton when it dries.

Four-spotted pennant (*Brachymesia gravida*)

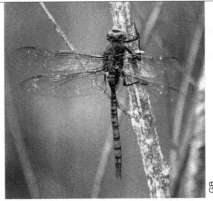

Comet darner (*Anax longipes*)

Royal river cruiser (*Macromia taeniolata*)

FIGURE 4–1

A Sampling of Florida Dragonflies

Florida has 112 species of dragonflies, a third of all those known in the United States and Canada combined, and also 44 species of damselflies. And no wonder: Florida has abundant fresh surface waters, the environment in which these insects breed, and offers them uncountable mosquitoes, their favorite prey.

These insects don't bite people, but they do gobble up insects that bite. The largest one, the royal river cruiser, which has a five-inch wingspan, does double duty: as a larva in the water, it gobbles up mosquito larvae, and as an adult in the air, it devours mosquito adults so avidly that it is nicknamed the mosquito hawk. Unlike pesticides, however, it leaves behind no poisonous residue to contaminate the environment.

Source: Dunkle 1991.

permanent-water marshes, fish also abound—especially small species like topminnows and killifishes, which can outlive larger fish during dry periods when crowded into shrinking water bodies.

Frogs and newts are numerous; so are snakes and turtles—and alligators. Listen by a natural marsh on a summer night: the frog serenade will be overwhelming, and in the alligator mating season, the bull gators' bellows are added to the chorus. Shine a strong flashlight into the marsh and you will see hundreds of sparkling eyes. Beneath each leaf are several tiny sapphires: these are spider eyes. Tiny pairs of rosy lights are the eyes of moths. Bigger pale ones are frogs' eyes, and—surprise! several huge pairs of bright red eyes betray several alligators closer than you would have guessed. List 4–2 names some frogs, snakes, birds, and other denizens of marshes.

The crayfish and the alligator are both key species in marsh ecosystems because they dig small and large holes. Crayfish burrows house many other tiny creatures; alligator dens accommodate big ones. Aquatic organisms can retreat to these underwater sanctuaries when the rest of the marsh is dry. Then when water levels recover, they recolonize the marshes.

Mammals are not numerous in marshes, although the round-tailed muskrat and white-tailed deer are common. Both love newly sprouting young marsh plants, which make tender eating in the early rainy season. Round-tailed muskrats can swim when the water is high, and burrow in exposed peat when the water table sinks below the marsh floor. Deer can forage in shoulder-deep water; they browse contentedly on pickerelweed and waterlilies.

By far the most abundant of the animals people see in a marsh are birds, especially wading and water birds, which nest in nearby swamps at night and forage daily in the marshes. Colonies of mixed species, mostly white ibis, have in the past been estimated at 35,000 birds or more. The red-winged blackbird, northern cardinal, Carolina wren, and purple gallinule nest in marsh vegetation at a density of several hundred birds per square mile. In several central Florida marshes, Florida sandhill cranes court and breed and raise their young. Predatory northern harriers and bald eagles find abundant small prey in the marsh and soar over it, shrieking. The eastern phoebe, belted kingfisher, and marsh wren terminate their southward migrations to stay in Florida marshes through the winter, when the bird population rises to more than 1,000 per square mile.

Land and water animals are tied together in relationships governed by marsh hydroperiods, which differ between north and south Florida. South Florida normally has a major summer rainy period, and water levels are high in summer and fall. During high water, the marshes fill with tadpoles,

salamander larvae, and fish. Then in winter, when the water recedes, these animals become concentrated in small areas. Predators such as raccoons, opossums, snakes, and birds gather to feast on this easy prey, and nest in the spring, while they are well nourished and able to produce healthy young. Mosaics of marshes dotted across the landscape enable bird populations to produce thousands of new individuals in each generation.

North Florida has a second rainy season in winter, during which marshes again fill with rain and produce salamanders, tadpoles, and fish. During the normal May drought, the water falls; then in summer it rises again, and again the water animals multiply. Whenever the water rises, invertebrate eggs and cysts hatch, aquatic organisms recolonize the marsh from deep solution holes and gator holes, and the cycle begins again. Humans may disparage marsh hydroperiods, calling them "floods" and "drought," but ecologists rightly call them "the rejuvenation process."

Among Florida birds dependent on marshes are wood storks, giant birds with a five-foot wingspan that soar for up to 40 miles in a morning to find shrinking shallow ponds and marshes brimming with prey. Wood storks are most efficient at feeding when the prey are concentrated in shallow water. They grope in the mud with the sensitive tips of their bills to find their food. The dropping of winter water levels is the stimulus that prompts the woodstork to nest. It is a sign that food will be abundant enough in small areas so that the birds can efficiently feed their big, hungry chicks and rear them to fledgling size. Either too little or too much water beneath a colony site during breeding season, or too much rainfall or runoff within a foraging area, can result in nesting failure.

Wood storks also require strong, stout trees in which to raise their broods. The ideal habitat for wood storks is a mosaic of ponds, cypress, and pine on the unaltered landscape.

Periodic filling with water and drying up again of marshes is thus crucial to the survival of many kinds of animals. Occasional dry winters, and especially several dry winters in a row, severely reduce animal species populations. This is a natural cycle and animals can withstand it as long as the marshlands refill with water when wet years come again—hence the importance of identifying wetlands correctly even during dry times.

Wood stork (*Mycteria americana*). Common only in Florida marshes, this big bird feeds on fish, reptiles, and amphibians that become stranded in drying pools during the dry season.

Wood storks nesting in a cypress swamp in the Florida Panhandle.

Types of Marshes

The Florida Natural Areas Inventory (FNAI) names marshes, not by their predominant plants as in List 4—1, but by characteristic biological and physical features. The next sections begin with the smallest and shallowest of Florida's marshes and end with its greatest marsh system, the Everglades.

Depression Marshes. As discussed previously, lakes and ponds occur in depressions, or basins, on the land. Extensive marshes are commonly found around the margins of lakes and ponds in Florida. Many of Florida's large lake basins are, in fact, mostly marshes with little open water, such as lakes Panasofkee, Tsala Apopka, Iamonia, Miccosukee, and many others. These and other lakes and ponds are partly depression swamps because cypress and tupelo trees grow in them or parts of them. In the rolling hills of north Florida, one can walk from a high pine upland down to a shallow (less than five feet deep) marsh in a lake basin or into a swamp of cypress and tupelos before reaching open water. In flatwoods or some sandhills, one can walk downslope from a high pine upland into a small limesink basin that may have only herbaceous vegetation emerging from pond water or cypress and/or tupelo trees forming small, often circular swamps.

A depression marsh is so subtle that one can easily fail to notice it at all. It may be very small—only fifty feet across, and it may dry up completely each dry season, or even for several years at a time, yet at other times it may fill with so much water that it seems more like a true pond. It is classed as a wetland but often called a temporary pond, and it is important precisely because for a lot of the time, it is not filled with water. This feature makes it a habitat that is indispensable to some creatures.

The plants in a depression marsh are similar to those in other shallow marshes, but some of the animals are unique. Small, egg-laying animals such as certain crustaceans, salamanders, and frogs, can reproduce successfully in wetlands like this, because there are no fish to eat them. Fish can't survive in temporary ponds, because they die when the ponds go dry, but the other small animals either live in the adjacent uplands or go dormant and wait for the next rainy season to become active again.

Free of predation by fish, the crustaceans, salamanders, and frogs can live out their life cycles and reproduce most successfully in depression marshes. Some of these animals are found only in the depression wetlands of north Florida. They breed in the winter rainy season, and winter rains are rare south of Ocala.

Temporary pond in the dry season. Because it completely dries up each year, the pond supports no fish.

Same pond during a winter rainy season. The pond now measures about 75 feet across.

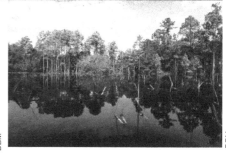

Same pond in 100-year flood. Now 500 feet across, it is still free of fish, and safe for small aquatic animals.

The fruitful time in a depression marsh begins after the first winter rains, when tiny animals come alive from their dormant forms and swarm in the shallow water: fairy shrimps, clam shrimps, grass shrimps, crayfishes, isopods, amphipods, and decapods. Thanks to the great numbers of these small prey, the larvae of a special set of salamanders can find food there. Panhandle Florida has four of these: the marbled salamander (in hardwood bottomlands), the flatwoods salamander (in flatwoods), the tiger salamander (in ponds in loamy soils), and the mole salamander (which lives in all types of ponds). Other salamanders, called newts, breed in the ponds and spend a few months to about a year in them as larvae, then metamorphose into terrestrial juveniles (called efts) and depart to take up their lives in adjacent woodlands. They metamorphose a second time, becoming adult salamanders, when they return to water to breed.

Even more dependent on depression marshes are frogs—specifically for egg-laying, fertilization, and the early life of their young. Different species breed in different seasons, as if they were "time-sharing" the ponds. During winter rains, from November to February, the spring peeper, ornate chorus frog, and Florida chorus frog breed in the ponds. From February to April, the southern toad and southern leopard frog breed. The dusky gopher frog, a strictly terrestrial frog, requires the ponds between October and March, just for breeding. Beginning in May or June and continuing until September, the oak toad's tadpoles, together with those of the narrow-mouth toad, the pine woods treefrog, the barking treefrog, the squirrel treefrog, the little grass frog, and the cricket frog, are teeming in Panhandle depression marshes. Other frogs also use the ponds, but can survive where there are fish as well: the green treefrog and Cope's gray treefrog.[7]

The chicken turtle also depends on depression marshes. It wanders from pond to pond in flatwoods and pine woods. When one pond dries up it finds the next wet one, and so continues its life. When it cannot find a pond, it buries itself in leaf litter in longleaf pine woods and keeps still until rains come again.

Because they are small and the law protects only large wetlands, depression marshes require special attention. Size alone is not an adequate indicator of the value of a wetland.

Flatwoods Bogs and Wet Prairies. Besides temporary ponds, many broad, flat parts of Florida hold standing water for long enough times each year to be classed with marshes. Their water depths may be minimal, to be sure, and they may form mosaics with mesic and dry terrain interspersed, but they fall within the shallow end of the marsh spectrum. They have prosaic, water-soaked names such as "herb bogs," "boggy flatwoods," "seasonally flooded flatwoods," "wet flatwoods," and the like, but

Little grass frog (*Pseudacris ocularis*). This is Florida's smallest frog. It depends on fish-free ponds for breeding and nursery grounds.

Turtle hatchlings. At left is the chicken turtle (*Deirochelys reticularia*). At right is the pond slider (*Trachemys scripta*). These turtles use marshes and ponds as their habitats.

Pine lily (*Lilium catesbaei*) with eastern tiger swallowtail (*Papilio glaucus*). The pine lily grows best in flatwoods bogs. The butterfly is widespread across the eastern United States.

they can be extraordinarily beautiful. Here, they are called wet flatwoods.

Wet flatwoods communities are also remarkably biologically diverse, due to subtle differences in small patches of terrain. Water leaves flat, poorly drained land primarily by evaporation, and it stands for longer or shorter times depending on differences in elevation of only an inch or two. That inch or two, by affecting hydroperiod, makes the difference between one suite of plants and another. As a consequence, floral diversity in wet flatwoods is as great as in seepage herb bogs, with dozens of species per square meter.[8]

Given such a great variety of plants, immense numbers and kinds of insects and other small invertebrates thrive, and where those animals are, others follow. To give but one example, twenty different species of burrowing crayfishes have been observed in different parts of Florida's wet, flat lands. Crayfishes can tolerate alternately wet and dry conditions and can use both plants and insects for food. Each crayfish species creates its own distinctive type of burrow and each conducts its affairs in its own style. Some prefer mud, some sand. Some occupy areas where the water table is within inches of the surface, others where it is several feet down. Some roam the flats and dig burrows only when they need water in dry seasons. Some live in burrows and move into open water during rainy seasons. Some always stay in their burrows. That so many crayfish species live on Florida's flat terrain speaks volumes about the diversity of available habitats in what looks like featureless level ground.[9]

Crayfish species in wet flatwoods may well be keystone species there,

Bogbutton (a *Lachnocaulon* species). Bogbutton can thrive in flatwoods bogs and wet prairies, and can also survive dry times, as seen here.

A wet flatwoods (herb bog) in the Florida Panhandle with October flowers blooming. The diversity is evident from the colors in the foreground. This wetland may well support 150 species of herbs.

similar to the gopher tortoise in pine grasslands. Where crayfish are numerous, the ground is riddled with their tunnels. By heaping up piles of earth wherever they dig, crayfish expose earth where seeds can start to grow even when fires have not burned through and bared the soil. Many plants of wet flatwoods release their seeds at the end of the winter dry season, the season of the most intense burrowing activity by crayfish. Crayfish serve as another example of the general principle that the plants of a community depend on animals, just as the animals depend on plants. Also, for small animals, crayfish burrows probably serve somewhat as gopher tortoise burrows do on higher ground: they are shelters in which to escape weather extremes and predation.

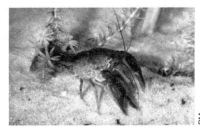

A burrowing crayfish (*Procambarus hubbelli*). This animal burrows in flatwoods marshes in the far western Panhandle.

Marl Prairies. Marl prairies occur only in south Florida, notably in the Everglades National Park and in Big Cypress National Preserve, where they lie interspersed with sawgrass and other marshes. Marl forms in marshy areas where limestone is near the surface. Marl is derived from periphyton, masses of algae and other minute organisms that grow floating or loosely attached to bottom limestone and to underwater plant parts. While growing under water, the algae take up calcium carbonate; then when the water level drops and they dry up, they form a crumbly, highly alkaline, thin soil that resembles fine gray or white mud (see Figure 4–2).

Walking on a marl prairie is an altogether different experience from a stroll across a wet flatwoods. The ground may be rock-hard in the winter dry season, but wet, soft, and slimy during summer rains. The soils are seasonally flooded but for extremely variable periods of time. Marl prairies are unlikely to burn; there is not enough dry vegetation to carry fire.

Some of the plants found in marl prairies are itemized in List 4–3. Many

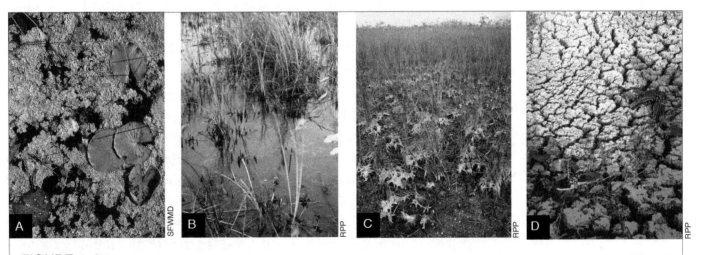

FIGURE 4–2

Periphyton's Various Aspects

Periphyton forms as loose, half-floating, half-sinking vegetation at or beneath the water's surface (A) and (B). When it dries, it remains draped over living vegetation (C) or forms a fissured mat of crumbly organic matter—that is, marl (D).

LIST 4-3
Plants of marl prairies (examples)

<u>Dominant species</u>
Black bogrush
Elliott's lovegrass
Florida little bluestem
Gulf hairawn muhly
Sand cordgrass
Sawgrass (a short form)
Spreading beaksedge

<u>Other characteristic species</u>
Alligatorlily
Arrowfeather threeawn
Bluejoint panicum
Gulfdune paspalum
Narrowleaf yellowtops
Rosy camphorweed
Southern beaksedge
Starrush whitetop
Sources: Gunderson and Loope 1982; Porter 1967.

Also, in Big Cypress, widely scattered stunted pond cypress, possibly hundreds of years old.

Source: Flohrschutz 1978.

A **swale** is a low-lying stretch of land, a depression between ridges. In the Florida interior, the Everglades lies in a giant swale. At the coast, the hollows between dunes are called swales.

The word **slough** (SLOO) is used to describe any minor drainage channel in a wetland. A slough may be a deep-water channel in a *swamp* (Chapter 5), but here, it means a deep-water channel in a *marsh*.

As of 2010, the Florida Natural Areas Inventory (FNAI) gave the name **glades marsh** to the swales of the Everglades and Big Cypress regions and renamed other sloughs, **slough marsh**.

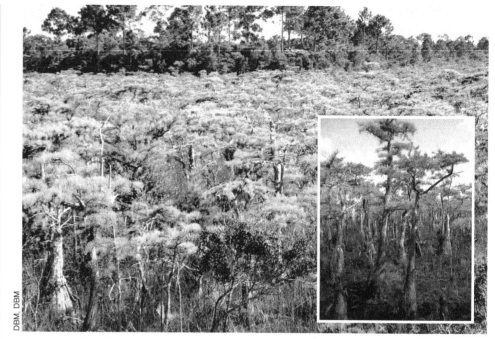

Cypress (*Taxodium distichum*), dwarfed form. These tiny, ancient cypress trees grow scattered across a wetland that is marshy, but flooded only for short periods. Dwarf-cypress marshes may burn, but fires seldom kill the trees, both because fuel on the ground is sparse and because cypress is very resistant to fire. This marsh has not burned in recent memory. (For more about cypress, see the first pages of Chapter 5.)

are endemic. A stunted form of cypress may be present, known as dwarf, toy, or hat-rack cypress. Dwarf cypresses may be hundreds of years old as evidenced by the huge boles at their bases, but they seldom grow to more than ten feet in height. Animals are shared with neighboring ecosystems; see "The Everglades," next.[10]

Swales and Sloughs. Swales and sloughs are unlike the other marshes described so far in that their water flows perceptibly during much of the year. During wet seasons, swales are "rivers of grass," and they can be many miles wide.

Swales are found predominantly in east, central, and south Florida where the land is nearly flat. Along the coast, rims of sand, clay, or limestone contain them so that their water does not run out to sea. Many marshes of this type are found along the St. Johns River, which is confined behind an old coastal dune and barrier-island system. Rain falling in the river basin meanders north for several hundred miles before finding its way to the sea at Jacksonville. Central Florida's Kissimmee River flows similarly, but in the opposite direction—south—and it, too, is a marshy, flowing-water system. In fact, from the Kissimmee's headwaters all the way to the tip of Florida, all water flows south down the almost imperceptible slope of two inches per mile. South Florida, too, has a rim—in this case, of limestone—along its

coastlines; it is shaped like a broad, shallow spoon. The result is a grand, slow flow of water over land for two hundred miles from the Kissimmee's headwaters through Lake Okeechobee and the Everglades, finally reaching the sea at the extreme southern tip of Florida. The Everglades is Florida's premier example of a swale-slough system.[11]

THE EVERGLADES

Whatever words are used to describe the Everglades, *vast* is always among them. Before engineering projects altered the region's drainage, the whole Everglades system encompassed 3,500 square miles (see Figure 4–3). Even today, although much reduced in size, the Everglades system is bigger than the whole state of Delaware. Everglades National Park alone occupies 1.5 million acres and the adjoining Big Cypress preserve holds another 728,000 acres.

The Everglades is an endless plain of Jamaica swamp sawgrass in shallow, slowly moving water that extends to the horizon. It is almost featureless. Here and there is a hummock (a tree island, clad in tropical hardwoods); here and there a watery hole in the marsh that reflects an

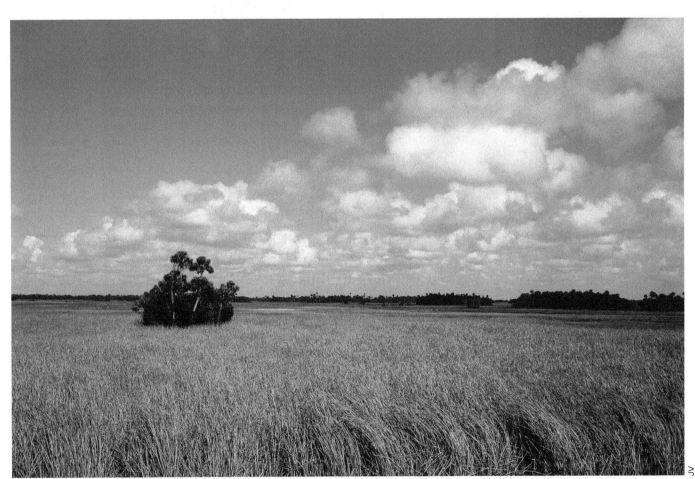

Everglades marsh. Jamaica swamp sawgrass (*Cladium jamaicense*) stretches for miles under an ever-changing sky, broken only here and there by a tree island or a slough.

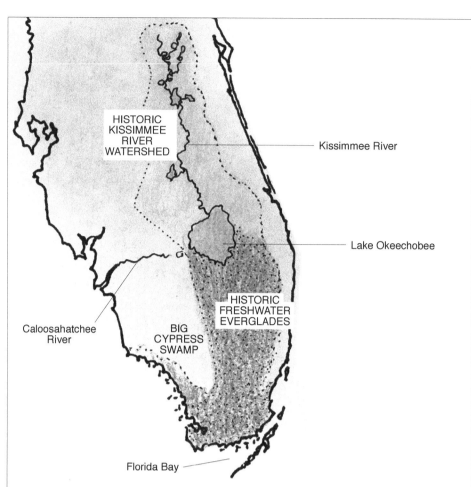

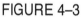

FIGURE 4–3

The Everglades (before Alteration)

South Florida tilts gently southwest between coastlines that are slightly higher than its center, so that from the Kissimmee River's headwaters all the way down the peninsula, all surface waters flow south over land. Before the system was altered, rain coalesced into lakes, the lakes overflowed into streams and swales, and these meandered down the Kissimmee River watershed into Lake Okeechobee, a lake basin 50 miles wide. Then the lake overflowed at its southern end as a sheet of moving water 40 to 70 miles wide—the great swale known as the Everglades. The Everglades' water eased down the slanted Florida penin-sula and, finding few outlets east or west, finally slid off the land's southern and southwestern end through mangrove swamps into Florida Bay.

The light blue area represents the original Kissimmee River/Everglades ecosystem watershed. The entire basin covered much of Palm Beach, Collier, Broward, Monroe, and Miami-Dade Counties. Today, to redirect the original flows of water, much of the Kissimmee has been straightened, canals now carry much of the system's water to coastal cities, and Lake Okeechobee is diked.

Sources: Strahl 1997; Douglas 1947, 5. Drawings are adapted from figures in Hinrichsen 1995.

Today's Everglades. Note the greatly reduced area of flowing water from the Kissim-mee's headwaters all the way down the peninsula.

alligator's den-digging work. Except for the scattered, dark humps and an occasional slough, the marsh seems utterly monotonous. Even the seasons, although intense, are repetitive. The pattern of sun, rain, and storms varies

FIGURE 4–4

Jamaica Swamp Sawgrass (*Cladium jamaicense*)

In the foreground is the flowerhead; in the background is the "grass"— actually, a sedge. This is the dominant plant in most of Florida's flowing, freshwater marshes. Native to the U.S. Southeast, the West Indies, and Central and South America, it is well adapted to the nearly level, marshy terrain it occupies. It may reach some ten feet in height and every blade has fierce serrations made of silica that can cruelly cut flesh and tear clothing, so the plants form a forbidding, impenetrable mass. They also store nutrients beyond their own needs, depriving other species of the chance to grow in the nutrient-poor marsh.

Jamaica swamp sawgrass tolerates cold weather, and it loves fire. The bud grows buried in the soil wrapped in its own living leaves, which protect it from the flames. The higher, older leaves, in contrast, are so flammable that they will burn even above standing water. Then they rapidly regrow, fed by the nutrients that the burning sawgrass released as ash into the water. If floods rise too high too fast, newly growing sawgrass will die back, and even die out, but it can usually outpace rising water levels. It can grow more than a foot in two weeks.

little from year to year. Dry and wet seasons follow each other predictably and the marsh dries and refills in concert with them.

No groundwater flows into the Everglades from subterranean springs or seepage slopes as in north Florida. The Floridan aquifer system, which is relatively close to the surface in central and north Florida, is a thousand feet below the surface in south Florida. Immediately beneath the Everglades is a sand-and-gravel aquifer that fills only with rain and empties by evapotranspiration (and pumping). All of the Everglades' water is from rain, some falling directly on the Glades, and some flowing overland from two hundred miles to the north.

Fresh water has flowed through the Everglades since sea levels rose and raised groundwater tables to near the surface about 5,000 to 6,000 years ago. The marshy waterways are the youngest parts of today's Everglades: they began to develop at that time or later. Most of the plants and animals that came to colonize the marsh, however, have been around for tens of thousands of years. The predominant plant is Jamaica swamp sawgrass (Figure 4—4).

Where the water is too deep for sawgrass, spikerush and other rushes take over. Bladderworts by the millions float among them, their yellow blossoms lighting up broad expanses of water with a golden glow. Hundreds of other, less conspicuous plants also live in the Everglades.[12]

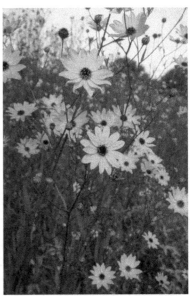

Southeastern sunflower (*Helianthus agrestis*). This sunflower grows in peninsula marshes and blooms in summer.

In the water beneath the plants is a mass of mucky periphyton. When first measured 100 years ago south of Lake Okeechobee, the muck was 15 feet deep. Today, people periodically drain the land and let oxidation proceed, but the muck is still nearly five feet deep. Recently formed layers are loose and fluffy, partly floating and partly sinking in the water. The oldest layers are compactly stacked on the underlying rock.

The sawgrass and rushes support an immense community. Hundreds of species of fish and other animals thrive in this environment in enormous numbers. Microscopic plants and animals become food for a myriad of flashing silver minnowlike fish through whose tiny bodies the marsh's nutrients repeatedly pass. The tiny fish become food for larger fish, frogs, birds, watersnakes, baby alligators, and other predators.

The enormous algae-and-insect base of the food web supports impressive numbers of larger animals as well—otters, raccoons, opossums, hawks, and alligators. Most conspicuous are the wading birds that breed in the Everglades—shallow water makes a perfect fishing environment for a wader. In the 1800s, egrets, herons, roseate spoonbills, and white ibises nested there in rookeries of more than 100,000 birds. Bird numbers have declined but can still number in the tens of thousands.[13]

Other birds that prosper on the marsh's abundant fare include the Florida sandhill crane, limpkin, purple gallinule, and common moorhen. Top predators flourish as well—bald eagle, barred owl, osprey, and the two kinds of kites shown in Figure 4-5. These avian top predators among the

Everglade snail kite (*Rostrhamus sociabilis*). A rare bird, this kite nests in shrubs a few feet above the water, hovers low in the air, and drops to snatch up apple snails when they approach the surface to breathe. It holds the snails in its talons and uses its curved bill to extract them from their shells. The kite depends absolutely on these snails: its talons are too weak to hold other prey, such as turtles, and its beak is the wrong shape to pull them out. When rearing its young, the kite may catch 60 large snails a day.

Swallow-tailed kite (*Elanoides forficatus*). This kite nests in pinelands, where it uses Spanish moss or hairy lichens to weave its nests together. Unlike the low-flying snail kite, the swallow-tailed kite flies gracefully, high in the sky. It hunts for snakes, lizards, and bird nestlings over both upland habitats and marshes. Nature writer Susan Cerulean says, "The challenge swallow-tailed kites offer us [is] to hold as much as possible of the state's remaining natural landscape intact."

FIGURE 4–5

Two Native Kites

Sources: Robbins and coauthors 1983, 69; Toops 1998, 23; nest behavior and quote from Cerulean 1994.

birds reflect the richness of the ecosystem. Each has its hunting specialty and there is enough for all.

Although birds are most conspicuous, other animals are present, too: panthers, bobcats, rats, marsh rabbits, bears, cottonmouths, and others. Altogether, more than 600 species of terrestrial vertebrates live in all the park's different habitats. For these reasons, the Everglades National Park today is a United Nations World Heritage Site.[14]

Seasons in the Everglades. Water is king in the Everglades, definer of the seasons. No spring, summer, fall, or winter occurs here; rather, there are two seasons: wet and dry. The marsh is green in the rainy season, brown in the dry. Depths and seasons of inundation define the habitats and determine the life cycles of all living things in the marsh.

The rains begin in May, sometimes late May. They may go on all summer, or they may hold off at times, but storms set in, in earnest, in late July through September. Sometimes a single storm will drop 10 to 12 inches on part of the marsh in an hour. Says an observer:

Invasive exotic pest plant: Punktree (*Melaleuca quinquenerva*). The punktree has invaded vast areas of the Everglades. It sucks up water and transpires it to the air, drying the marshes and opening the way for invasion by other nonnative species.

> *Thunder rocks the earth and lightning splits the sky. All the silence becomes rattling, booming noise. All the emptiness is filled with blasts . . . of light. The whole wide horizon is a sound and light show, and the windows of Heaven open. The Everglades rise up a foot and the desert turns back into a river.*[15]

More than half the year's rainfall may arrive in just two months and evapotranspiration can't keep up. After a heavy rain, water runs over the land at a steady pace. And rains are also falling on central Florida around Lake Okeechobee. That water, too, runs south over the land and arrives in the Everglades days later.

In October or November, daily thundershowers end and the marsh begins to dry. For months, it rains only a little or not at all. Evapotranspiration exceeds rainfall, the water level falls, the flow ceases, and parts of the marsh dry up altogether. Dew forms and drips in the mornings, but the sun soon dominates in cloudless skies. Some 60 percent of the water that falls in the rainy season rises again in the dry season—it literally dries up. The water level sinks below the soil; the soil becomes parched marl with deep crevasses in it; and the slimy periphyton that was suspended in the water dries on the ground to crispy curls like cracked paint.

From December through April, puddles become fewer and smaller. Fish and bird populations decline. Lightning, when it strikes, starts fires that burn for miles across the marsh, renew the marsh plants, and kill young shrubs and trees. Fish crowd into shrinking, soupy pools, struggling to stay under water. Big fish—bass, bream, and gar—die and float, belly up, to the edges of the pools, attracting millions of buzzing flies. Vultures circle and land to strip the decomposing carcasses.[16]

Punktree bark.

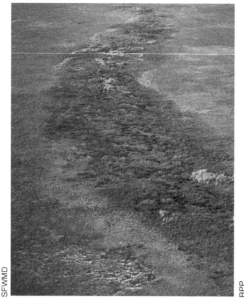

The wettest part of the Everglades. This is Taylor Slough, one of many marshy waterways through the Everglades. Even when the Glades are dry, as here, the slough holds water.

The rock beneath the Glades. Low water and recent fire have exposed the underlying rock, whose sharp contours have given it the name *pinnacle rock*.

Unlike the big fish, the tiny fish keep going. Some, known as topminnows, can swim in the very top inch of water, where oxygen is still available. Their protruding lower jaws and up-tilted mouths are adapted for surface feeding. Many species of these tiny fish live in Florida's marshes; four are shown in Figure 4–6.

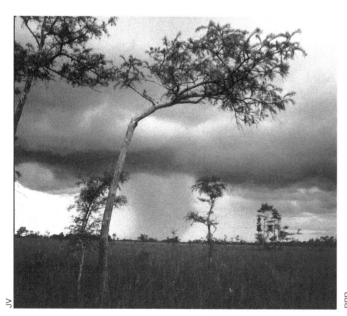

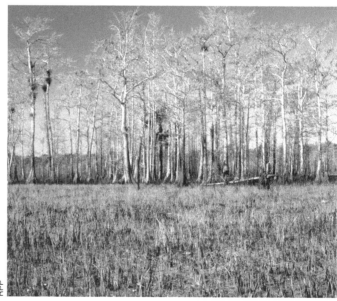

Water rules the Everglades. Ear-splitting claps of thunder and blinding lightning flashes dominate the Glades throughout the rainy season.

Fire takes control. This portion of the Glades has burned, but in the foreground, sawgrass is resprouting and in the background, the cypress trees are making a comeback.

FLORIDA'S WETLANDS

Mosquitofish (*Gambusia holbrooki*).

Mosquitofish (*Gambusia affinis,* melanistic variant).

Seminole killifish (*Fundulus seminolis*).

Golden topminnow (*Fundulus chrysotus*).

These tiny fishes and their many relatives thrive by the billions in the Everglades marsh, even when the water is low.

FIGURE 4–6

Native Topminnows

Then the rains resume, perhaps in late May, renewing life in the Glades. Sawgrass and other sedges and grasses spring back to life and regrow. Frogs, which have lain dormant, emerge to join in a noisy chorus and mating frenzy that will soon produce millions of fertilized eggs. Small fish mobilize from their expanding ponds, swim into rivulets, and energetically work their way upstream against the runoff coming down from the north. The Glades waters are moving again, and these fish are adapted to holding their ground against the current. They have to be: to keep the Glades occupied, they must replenish their upstream populations or they will be washed away.

Most of the Glades animals, from mosquitoes and snails to fish and alligators, breed just before or during the rainy season. Then their young are born as the rains are bringing forth lush new vegetation that will support the rapid growth of plant eaters and, in turn, their predators. By the time the dry season begins, all are prepared to withstand its harsh rigors. Eggs, larvae, and adults are buried in the mud or lingering in alligator pools, awaiting the next year's rains.

The alternation of wet and dry seasons places demands on all the marsh inhabitants. To keep going, they have to be adapted to both extremes. They may thrive in one season, but unless they can at least survive in the other, they will be unable to perpetuate their kind.

The alternating seasons mostly favor native species, which are equipped to cope with the extremes. Most recent arrivals succumb. Unfortunately, however, some invader trees such as the Brazilian pepper and punktree possess adaptations similar to those of the native plants, and are shouldering aside native vegetation in much of the Everglades.

The Glades Engineer: The Alligator. A keystone species in the Glades ecosystem is the alligator, whose deep dens hold water during dry times and help hundreds of animals hang on from one wet season to the next. This important ecological role is crucial in the Everglades.

Green anole (*Anolis carolinensis*). On green vegetation, this animal is green, so in the Everglades' rainy season, it is well camouflaged.

On brown vegetation, the anole has the knack of turning brown, which comes in handy in the dry season. Here, the animal is shedding its skin. The new skin underneath is even more like the twig on which it is perched.

One plant

Duckweed (a *Lemna* species). Duckweeds are among the world's smallest flowering plants.

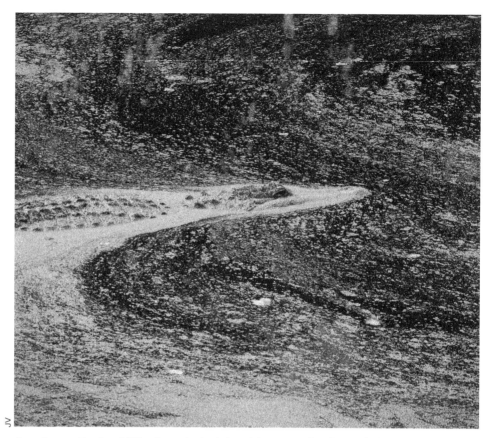

American alligator (*Alligator mississipiensis*) among Duckweed. The alligator is the Everglades' dominant predator.

When the marsh has gone dry, the alligator goes on the move, looking for water beneath the caked mud and marl. When it finds such a place, the animal rolls, kicks, and digs out an underwater hollow, usually in peat, up to six or seven yards across and several feet deep, until water seeps into the bottom.

Once dug, a gator hole may last for decades. The piled-up mud around its border becomes an ideal place for shrub seedlings to take hold. Willows, bays, and coco plum grow around the hole, creating a privacy fence that might confer solitude on the alligator but for the attractions the hole offers to other creatures. A big hole may serve dozens of gators in an exceptionally dry year.[17] Most importantly, during drought, a gator hole serves as a refuge for juveniles of large fishes such as bass and bream, small species of fishes, and larvae of amphibians, all of which, being too small for the gators to eat, remain ready to repopulate the wetlands when water returns.

When the female gator nests, she piles up grasses and aquatic plants on the bank to keep her eggs warm. Decomposition sets in, the green matter begins to steam in the sun, and she digs into its center and lays her eggs. Eight weeks later when she hears her offspring squeaking, she digs up the eggs, opens them, carefully takes the babies in her mouth, and releases

them near the nest. Thereafter, she will watch over them for up to two years.

The gator nest, like the gator hole, becomes a shared resource. Turtles dig into the heap of warm plant material and lay their eggs, taking advantage of both the compost's warmth and the gator's protection. Raccoons risk gator attacks and raid the nest for eggs.

Birds congregate around gator holes, catching abundant prey. The birds share the food resource in gator pools much as frogs share prey in north Florida's temporary ponds. Each bird has its own prey and fishing technique, so all can flourish without much competition. The great blue heron dips for fish in the deepest water. The tricolored heron wades in shallow water, searching for fish, frogs, and other prey. The little blue heron patrols the edge of the pool, catching mosquitofish. The wood stork searches the water with its sensitive bill for for young bream, topminnows, madtoms, mollies, and other small fish. The white ibis probes the bottom mud and tweezes up snails and crayfish. The anhinga swims under water and spears its prey, using its sharp beak as a dagger.

Gator holes have been around for a long time and birds and other animals have evolved an ability to use them to maximum advantage. Now and then, a bird becomes a meal for the gator, of course, but at no significant cost to the bird population as a whole. Indeed, the ancestors of today's alligators have been digging pools like this in North America for some 65 million years.[18]

* * *

Despite all the variety displayed by the marshes in this chapter, they are but one class of wetlands. Water rises and falls in them, but flows very slowly or not at all. The next chapter is devoted to another class of wetlands—swamps, in which conditions are dramatically different.

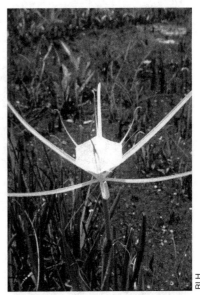

Alligatorlily (*Hymenocallis palmeri*). This graceful flower is a Florida endemic. It blooms summer and fall in marshes and cypress swamps in central and south Florida.

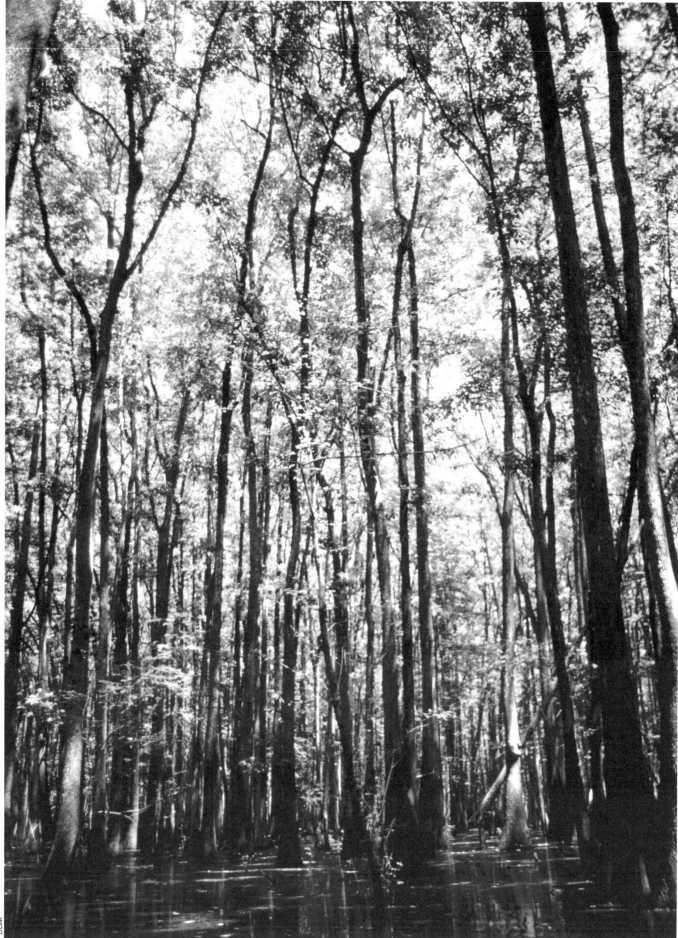

CHAPTER FIVE

INTERIOR SWAMPS

Swamps, by definition, are wetlands with trees. Three seepage swamps were described in Chapter 3, swamps in which titis, bays, or white cedars grow and in which water moves slowly through the ground. This chapter covers strands and swamps that are flooded every year with flowing water—those that are named in List 5–1. Notice that two of them are called *forests*, but unlike the forests described earlier, these two are considered wetlands.

Swamps occupy thousands of acres all over the state, and taken together, they contain well over 300 species of plants, all adapted to wetland habitats. This chapter begins by describing swamp trees, whose adaptations give them predominance on land where water rises and falls. Then it turns to the swamps in which they grow.

SWAMP TREES

Swamp trees grow in environments where most marsh herbs would decline and die. Water levels vary much more widely in swamps: the highs are higher, and the lows lower, than in marshes. Swamps sometimes hold deep water for longer periods than marsh plants can tolerate; and swamps also may go completely dry, whereas marshes nearly always hold some water. Cypress and tupelo trees are Florida's foremost swamp trees. They serve as prime examples of the adaptations that enable trees to grow in wetlands.

Cypress Trees. Cypress trees have long been thought to exist as two separate species, pond-cypress and bald-cypress. Recent genetic studies suggest they may be merely variants of one species, however, much as north and south Florida slash pine are variants of slash. In this book, cypress is given its generic name only (see Figure 5–1).[1]

Red maple (*Acer rubrum*). This common tree, which can grow both on uplands and in wetlands, makes the splashes of red one often sees in swamps in spring.

WBSP

LIST 5–1
Flowing-water swamps

Alluvial forest
Bottomland forest
Floodplain swamp
Freshwater tidal swamp
Hydric hammock
Strand swamp

OPPOSITE: Young water tupelos in a floodplain swamp along the Apalachicola River.

Rolled-up leaves. Trees with this appearance may be called pond-cypress, but it may be that in dry times, any cypress tree rolls its leaves around the branchlets to reduce water loss.

Splayed-out leaves. Trees that look like this may be called bald-cypress, but it may be that wherever cypress stands in permanent water or saturated soil, it spreads its leaves at right angles to the branchlets to enhance release of water.

FIGURE 5—1

Cypress (*Taxodium* species)

The question whether cypress exists as two species is still under investigation. It may be one species whose leaves vary in appearance.

Cypress can grow on high land that never floods, but meets with tough competition from other trees there and seldom wins a place for long under natural conditions. In many wetlands, though, cypress competes more successfully than any other tree. It is adapted to grow where water stands several feet high around its trunk for months at a time. It easily survives droughts, and it is fire tolerant as well.

The base of a cypress tree is a masterpiece of biological architecture. The trunk grows strongest and broadest exactly where strength is needed most, producing a swollen, extra-stable base, or buttress. This is an adaptive response to the inundation that kills other trees.

Trees require oxygen for the activities of their root systems as all plants do, and they need more oxygen than do marsh herbs, because they are more massive. Oxygen is limited or unavailable under water and in saturated soil, so a cypress tree's roots can't deliver oxygen during high-water times. But cypress can grow adventitious roots (already shown for tupelo in Chapter 2, Figure 2-3). When the water is high, these roots float out around the tree on the surface of the water and keep delivering oxygen as well as nutrients and water to the tree. Cypress also grows "knees," which may help to deliver oxygen. Cypress knees are shown in Figure 5-2. Because cypress copes so well with rising and falling water, it can grow not only around depression wetlands, lakes, and ponds but also around rivers and oxbow lakes in river floodplains.[2]

The events of a cypress's reproduction coincide with events in the wet

A buttress. This cypress tree is in a pond where the water rises to about the same level every year. Below the water line, downward transport of hormones and nutrients halts and they accumulate there, stimulating the trunk to thicken.

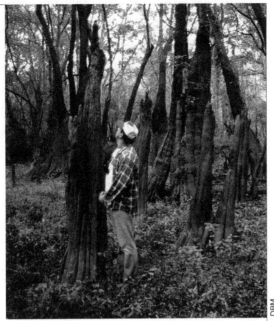

FIGURE 5—2

Cypress Knees

Knees grow up from deep cypress roots where floods deprive the main roots of oxygen for long times. The tops of the knees just reach the average seasonal high-water level, which in this case is higher than a man is tall. The function of knees is unknown, but they respire fastest when the water is highest, so it seems they may serve to capture oxygen from the air.

and dry seasons. In fall, the tree goes dormant and therefore, as winter flood waters rise and deprive the roots of air, its oxygen needs simultaneously become minimal. In winter, the needles (leaves) turn brown and begin to fall, but the cones produced the previous summer remain closed. In spring, as the new, green leaves are coming in, the cones open and drop their seeds. Thanks to this timing, the seeds land in retreating water, and it is not long before they lodge in a mulch of the tree's own needles, on wet shores. Thus the seedlings begin to grow at a favorable time, when floodwaters are receding, and in soil kept moist by the tree's own litter.

Up to the age of two years (up to 1-1/2 feet in height), a cypress seedling must keep at least a few leaves above water, or else ten days of summer flooding will kill it. (In a cold season, when a seedling is dormant, it may be able to survive inundation longer.) The seedling also needs sun: exposure for 80 percent of the day is optimal. Cypress seedlings in deep shade may grow vigorously at first, but they won't survive for long without sunlight.

The seedling's requirements of moisture (without flooding) and abundant sun are not often met. In most years, most cypress seedlings drown. In a dry year, they grow fast, but then they have to compete with hardwoods that are also springing up. The final step in the successful launching of cypress trees is a properly timed flood that kills all the competing hardwood trees, leaving only the cypresses alive. Given the optimal timing of high and low water, cypress can claim and hold wetland territory where most other trees are excluded.

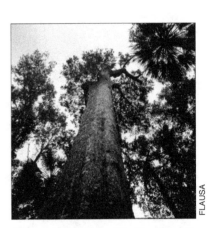

Senator Cypress, Big Tree Park, Longwood, Orange County. This famous, giant tree is 118 feet tall.

Fires are rare in cypress habitats, and even if they do occur, they may not kill the trees. In low sites in river floodplains where cypresses are growing, fires cannot spread for lack of fuel. In areas where cypress stands are growing in peat, a severe drought may produce a fire that burns through and scorches the tree trunks, but their bark is corky and protects the underlying living tissue so that the trees still remain alive. To kill the trees, fire has to actually burn down into the peat, as may happen in a very rare, severe, regional drought. Then it can burn the cypresses' vulnerable roots and kill the trees.

One amazing adaptation of cypress is its ability to sprout from its burned or cut trunk. In wet flatwoods, small cypresses whose roots are protected in silty soil resprout from their roots, often creating dozens of stems in a "fairy ring." Who knows how old the root crowns may be?—maybe hundreds of years old.

Old cypresses are huge. They achieve heights of 100 to 120 feet, even 150, feet. They continue growing in girth throughout their lives, so they can become massive around their bases. The giant, old-growth cypresses of commercial value were logged out a century or more ago, but some large, old, hollow cypresses still loom above Florida's rivers, evoking the majestic river swamps of times past.[3]

Cypress, like Atlantic white cedar (described in Chapter 3), is resistant to insect pests and fungal attack, so it can survive when other trees are aging and dying. As other trees disappear, these paragons of longevity come to dominate large areas, sometimes living to 1,000 years of age.[4]

Canoeing among giant cypress trees can be an exalting experience. They stand in stately ranks, with their swollen buttresses making them look like enormous, broad-based bottles. Cypress existed as a species millions of years before Florida first appeared as dry land, and they were among the first trees to colonize this land. When you enter among ranks of old-growth cypress trees, you are part of an ancient world.

Tupelo Trees. Tupelo trees exhibit their own adaptations to the demands of life in deep-water swamps. Like cypresses, tupelos are deciduous, dropping their leaves in fall. They stand dormant during deep winter floods; then in summer they leaf out, gather energy, and grow. Also like cypresses, tupelos have trunks that are flared at the base. Unlike cypresses, though, tupelos often split up wetland territory among three species: swamp, water, and ogeechee tupelo.

In other ways, the adaptations of tupelos differ from those of cypress. For example, an older Ogeechee tupelo consists of a ring of many trunks forming a massive, hollow basket, or barrel, open at the top, and young

trunks growing up from around its giant, expanding base (see Figure 5-3). Some of the trunks become hollow, leaving short, vertical "tunnels" for animals that live in them. Animal feces drop into the basket, and litter gets trapped in its center as high water deposits flotsam into it. Later, micoorganisms decompose the litter, forming the tree's own "compost." Then, roots grow into it from the *inner* walls of the surrounding trunk and absorb the nutrients. Additionally, since the compost in the basket is well above the base of the tree, the adventitious roots are able to obtain oxygen much better than in the dense silt of the soil below. Thus, although a mature Ogeechee tupelo looks aged and half rotten, it is remarkably well equipped for the life it leads.

Like cypress, Ogeechee tupelos seem practically immortal. They can live for hundreds of years and they keep replacing their stems, so they need not reproduce frequently. Still, new tupelos have to get started sometimes, or the species would finally perish. They do so in a variety of ways. A seed may start its life on a hummock of peat where it won't be inundated at first. As it grows, the seedling invades the peat with fine roots that hold it together, and because they are above water nearly all the time, the roots continue to have access to oxygen throughout the life of the tree.[6]

During droughts, seeds may also fall on dry ground, where ordinarily they would quickly die out due to competition from upland trees. But when the habitat becomes wet again, then the tupelo seedlings will be the survivors, because they can tolerate inundation while the other hardwood species cannot.

Young thicket in winter. These saplings must have started up in peat at a time of low water, then survived high water in which competing species perished.

FIGURE 5—3

Ogeechee Tupelo (*Nyssa ogeche*)

Old ogeechee tupelo, winter. This giant, barrel-shaped tree stands in Sutton's Lake along the Apalachicola River.

Champion ogeechee tupelo. This is a rare example, because it has only a single stem. One of the biggest tupelos in Florida, it stands in the heart of Bradwell Bay, Wakulla County.

Swamp tupelo (or black gum) is a handsome tree with a straight trunk and rounded crown. It is native from Maine to Florida in all kinds of swamps but is unusual for also growing on upland soils with other hardwood trees. It can reach 90 feet in height in the wild and is easy to recognize in fall thanks to its bright red leaves.

Water tupelo is a large aquatic tree that is native to floodplains and standing-water swamps from Florida to Texas and north to Missouri, Illinois, Kentucky and Virginia. It is often seen growing either in pure stands or in combination with cypress and other tupelos. It grows to 80 feet (less frequently to 100 feet) and features a swollen base (like cypress), a single upward-tapering trunk, and a rounded, spreading crown. Its glossy, oblong leaves are distinctive. They are four to eight inches long, the largest leaves of the three tupelo species, and some of them have one or two marginal teeth (like the teeth on holly leaves). They turn yellow in fall.

Thanks to the abundant growth of both Ogeechee and water tupelos in their river swamps, the Apalachicola River basin as well as the basins of the Chipola, Ochlockonee, and Choctawhatchee rivers are the only places in the world where the highly prized, distinctively flavored, and certified tupelo honey is produced.

STRAND SWAMPS

A strand is a water-filled channel in which trees are growing. Water flows slowly through a strand, often from a source such as an overflowing basin swamp or swamp lake, and often terminating in a blackwater stream.

When a strand supports a cypress swamp, it is known as a cypress strand. But strands often accommodate many other plants (List 5-2 offers examples). In south Florida, where sunlight is especially abundant, Jamaica swamp sawgrass may dominate the undergrowth, or there may be a lush understory of shrubs, ferns, and mosses. Pond apple is often found alongside the deeper channels in cypress strands. Willows are pioneer species that colonize the muddy inside bends of silt-laden streams. Their root systems form natural mats helping to control soil erosion.

The Big Cypress region was named for its cypress strands, which are everywhere. Virgin stands of cypress remain in Corkscrew Swamp, whose hollow, old, unlogged trees are 400 to 700 years old and 100 feet tall. Unaltered strands have luxuriant bromeliads and orchids on the trees and lush, soft ferns beneath. Bromeliads are common in cypress strands and are given attention in Figure 5—4.

Ancient cypress strands house major animal populations. On fallen logs decked with ferns, Florida redbelly turtles sun themselves while wood storks and other big wading birds nest overhead. In earlier times, 7,000 to

To minimize confusion over names, it is helpful to remember that *swamp tupelo* has many nicknames. It may be called *gum* or *blackgum* or *sourgum;* and a *tupelo swamp* is often called a *gum swamp.* The two other tupelo species, water tupelo and ogeechee tupelo (o-GEE-chee) have no "gum" names.

Swamp tupelo usually grows in ponds, lakes, and stream swamps; water tupelo in ponds and floodplains. Ogeechee tupelo may join them in flowing-water swamps.

Another tree called a gum is *sweetgum,* but it is an altogether different tree, not closely related to the tupelos.

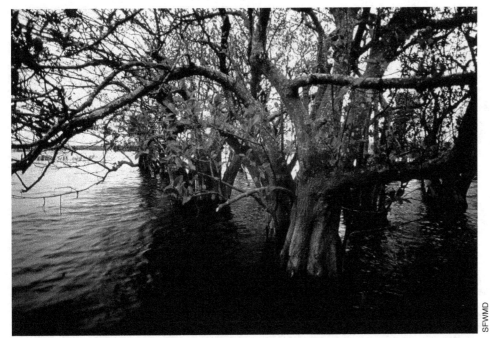

Pond apple (*Annona glabra*) in a slough in the Fakahatchee Strand. The needed water regime has been disturbed in the Everglades system, but pond apple still remains healthy in parts of Fakahatchee.

A **strand** is a broad, water-filled channel in which trees are growing.

LIST 5-2
Plants within cypress strands (examples)

Principal trees
Bald cypress
Pond cypress

Woody understory
Cabbage palm
Coastal plain willow
Common buttonbush
Florida royal palm[a]
Myrsine
Pond apple
Red maple
Strangler fig
Swamp bay
Swamp laurel oak
Sweetbay
Wax myrtle

Ferns and herbs
Giant leather fern
Sawgrass
String lily
Toothed midsorus fern
Water hyssops

Also numerous vines, epiphytic orchids, and bromeliads.

Note: [a]Florida royal palm occurs in the Faka-hatchee Strand.

Source: Guide 2010, 167-169.

10,000 wood storks nested each year in Corkscrew Swamp, and it is still their largest remaining breeding ground. The big birds fight for space in the giant trees, striking each other aggressively with their heavy bills.[7]

Other animals of cypress strands are the wild turkey, Florida black bear, bobcat, and even the Florida panther. Only a few panthers remain in the wild; they can survive only in large territories where sufficient prey animals (deer, rabbits, raccoons, otters, escaped domestic hogs, and others) are still available. Most are in the Big Cypress region.

STREAM CHANNELS AND FLOODPLAINS

Streams shape the land over which they flow in a variety of ways. A stream may cut a channel that is V-shaped or U-shaped, shallow or deep. A stream may stay within its channel, eroding it ever more deeply; or it may repeatedly change course, leaving old channels behind and creating new ones. In rainy times, a stream may overflow, and the water that spills out of the main channel may reshape the surrounding land, dropping sediments on it, scouring sediments from it, and moving them around. Most small streams flow within their channels and have minimal, if any, floodplains. Larger streams (third-order and higher) escape their channels and create floodplains.

Stream order is of special interest on sloping land, as in north Florida's highlands. There, the first- and second-order streams flow rapidly down

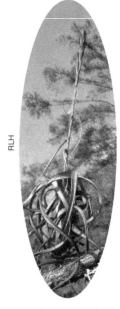

Powdery strap airplant
(*Catopsis berteroniana*)

West Indian tufted airplant
(*Guzmania monostachia*)

Northern needleleaf
(*Tillandsia balbisiana*)

FIGURE 5—4

Florida Bromeliads

Bromeliads have developed special adaptations for obtaining both water and nutrients. Many, including the one on the right, obtain water directly from the air. A few have leaves that form a funnel, which channels rain water down to the center of the plant. And a few have leaves arranged in a whorl around a central tube. Each leaf clasps an interior leaf at its base where rainwater and leaf litter accumulate. These leaf axils (technically known as "phytotelmata," literally meaning "plant ponds") are microcosms of living organisms including bacteria, algae, protozoans, nematodes, insect larvae, and even sometimes tadpoles and earthworms.The two on the left are arranged this way. Insects become trapped, drown, and decompose there, giving up some nutrients. Fallen litter and rain supply nutrients, too, and the plants have specialized structures on their leaves to absorb them. Root-associated fungi also help absorb nutrients, especially from cypress trees.

The powdery strap airplant is unique among bromeliads in being a true insectivore. The white powder attracts insects and is very slippery. They fall into the water trapped in the leaf axils of the plant and the plant digests them.

Among the parts of a stream system, the smallest head-water streams are called **first-order streams**. When two of these join, they form a somewhat larger, **second-order stream**. When two of the latter merge, they produce a still larger, third-order stream, and so forth.[8]

relatively steep slopes in which they erode V-shaped valleys. They tend not to change course, but only to cut their grooves ever deeper. Third- and higher-order streams form lower on slopes, where the land is leveling out. There, stream water can spread more broadly, eroding a U-shaped channel (see Figure 5–5).

During dry seasons, a stream's water flows in the main channel only. During rainy seasons, a third-order (or higher-order) stream spills out of its main channel and drops, onto the surrounding land, some of the sediment load it has scoured out of the terrain upstream—that is, the stream creates a floodplain. Thus a stream has, in a sense, two compartments: the channel, in which it flows all the time, and the floodplain, across which it flows during high-water events. These two compartments, which together are called the stream or river bed, persist all the way to the sea.

Florida panther (*Felis concolor coryi*). An endemic subspecies related to the western cougar, this big, wild cat roams and hunts in Florida's swamps.

Large rivers (which may be seventh- or higher-order streams) may have floodplains that are several miles across. These floodplains, and the swamps and forests they support, are in the spotlight here. To appreciate their characteristics, one has to understand how the stream reworks both its channel and its floodplain.[9]

The Channel. During low water (and assume for a moment that the water level never changes), a stream's channel constantly migrates back and forth. If it were filmed from the air and the film were then shown at high speed, the river channel would appear to be wriggling all over the floodplain like a snake. Water flowing around the channel's curves continuously sculpts the channel banks, eroding sediments from outside bends, and adding sediment to inside bends. Outside bends typically have steep, undercut banks and trees toppling into the river. Sediments eroded from each outside bend are deposited on the next inside bend, forming a point bar, which grows ever longer. At the same time, the swirling water cuts away the bank on the outside bend across from the point bar. Thus, the channel maintains a constant width while making its curves ever more pronounced.

The sinuousness of the meandering river channel and its position on the floodplain changes dramatically in time frames of decades to centuries because loops of a river are continually migrating. Remember, all of this takes place even if the water flow is constant.

Few rivers, however, ever have constant flow. (Even spring-fed rivers vary with major rainy seasons and droughts.) High-water events intensify the dynamics just described, and exert additional effects on the

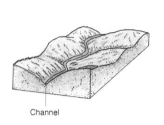

Channel

A small stream on sloping land flows swiftly downhill, cuts a V-shaped channel, and creates no floodplain.

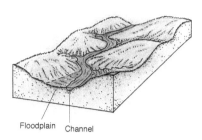

Floodplain Channel

A larger stream on more level land overflows at times and lays down a small floodplain.

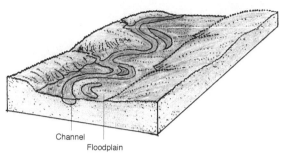

Channel

Floodplain

Near its terminus on the level land near the coast, a large river winds back and forth, erodes a U-shaped channel with sinuous meanders that change course over time, and lays down a broad floodplain.

FIGURE 5—5

How Streams Shape Their Streambeds

A stream's **channel** is its open-water part, the part that people normally think of as the stream. A stream's **floodplain** is a level plain of sediment deposited by the stream on the land along the sides of the channel. Together, the channel and the floodplain are known as the **streambed** or **riverbed**.

The stretch of a stream that is visible between bends in a river channel is a **reach**.

Each curve in a meandering-stream is called a **meander**, or **loop**.

A **point bar** is a promontary of sand protruding into a stream on the inside of one of its curves.

A **levee** (LEVV-ee) is a high wall of sand along the side of a stream.

surrounding floodplain.

The Floodplain. When fast-moving water spills up and over the banks along all reaches of a river, it slows down due to friction with the top of the bank, and loses some of its sediment-carrying power. The heavier sediments (in Florida, sand), therefore, drop out on top of the bank, building a levee that is higher than the floodplain beyond. Levees are tallest and most pronounced along outside bends where water moves fastest. (They are usually only small parallel ridges on the point bars of inside bends.) Imagine you are walking in the floodplain of a large, sediment-laden river such as the Apalachicola at low-water time. As you approach the river channel, the land rises: you have to climb a wide, gentle slope whose crest is at the river's edge. This ridge of high land has drier soil than lower parts of the floodplain, and it supports special trees, such as sycamores whose roots cannot tolerate long inundation, and sometimes trees that are found in uplands, rather than in wetlands. It is a levee.

Another important function of high water is the transport of fine, suspended sediments (clays and silts) into the floodplain. When flood waters recede, the muddy waters slow down; the clays and silts settle out; and over time, they slowly fill in the low places. In sum, both the low- and high-water regimes in rivers have erosional and depositional properties. Low water cuts the banks of outside bends and adds sediments to inside bends. High water speeds up these processes, erodes sediments out of the low water channel, and deposits them on levees, in backwaters, and on low places in the floodplain. With these processes understood, one can understand why the natural communities in stream floodplains are so varied.

Floodplains as Habitats. Constant change characterizes the floodplains of major rivers. During every flood, a mass of moving water up to 100

--------------SAME LEVEL--------------

FIGURE 5—6

Flood Volume in a High-Discharge River

These two pictures were taken of the same tree in the Apalachicola River floodplain. The photo at left shows the height of a normal flood. Flood stage that year was more than 18 feet, not unusual for a river of this magnitude. The photo at right was taken during the dry season.

times the volume of the low-water channel shapes and reshapes the land. A large river rises many feet, and huge volumes of water wash across its floodplain (see Figure 5—6). Large volumes of moving water exert powerful forces. Unstable trees are pushed down, others are stressed, and expanses of soil are left bare. In such an environment, trees and other plants must be adapted to constant change if they are to survive and reproduce successfully.

The shaping of a floodplain's terrain is most active for rivers of high discharge—that is, rivers with both a great volume of water and a rapid rate of flow. Floodplain sediments, dropped every time flood waters wash over the floodplain, create varied habitats for plants.

The Apalachicola River illustrates well the ways floods shape floodplain wetlands. Lesser streams have smaller floodplains, but all have at least some of the features described here. The Apalachicola is Florida's highest-discharge river, it works most forcibly on the surrounding terrain, and it carries masses of sediments that its tributary streams have eroded from the Appalachian Mountains. Over millions of years while the sea level was higher, the river deposited the piles of clay we now call the clay hills across the Panhandle; then after the sea level dropped, it built a great triangle of land out into the Gulf of Mexico. The living elements of the river system

have been evolving together for several million years and now reflect specific adaptations each organism has made to this particular watershed. The floodplain holds a massive system of swamps and forests with several hundred species of trees, shrubs, and groundcover plants. List 5-3 offers a small sampling of floodplain swamp trees, shrubs, ferns, and herbs.

The river is now dammed just south of its tributaries, where the Chattahoochee and Flint rivers, come together (just north of Florida), but it still remains in a partially natural state. It possesses the largest forested floodplain in Florida and it holds one of the last unbroken bottomland hardwood communities in the United States. It provides a protected north-south corridor along which plants can disperse and land and water animals can travel back and forth, all the way from the southern Appalachian mountains to the Gulf of Mexico.

FLOODPLAIN FEATURES

The next sections describe an imaginary tour of parts of a floodplain, with attention to the vegetation. The first stops are the banks of a curve in the river: an outer bank, with its high levee, and an inner bank, with a point bar. Then, in the interior of the floodplain, two points of interest are an oxbow lake surrounded by a swamp, and a great bottomland hardwood forest. On higher ground within the floodplain and on the river banks are several other types of forests. Down the river towards the coast, these forests give way to a hydric hammock and then a freshwater tidal swamp. The last section of the chapter presents the animals.

Levees and Point Bars. A levee is the highest part of the floodplain and may bear a high, dry forest of oak, hickory, and spruce pine like high xeric hammocks elsewhere. Directly opposite a levee, a point bar is a gently sloping bank often with bare sand at the water's edge indicating its recent deposition. Such new land is colonized by pioneer species. The point bar has a zoned array of plants: herbs by the water, a thicket of shrubs behind them, and trees farther back on the land. New sand just laid down by the water is first colonized by pioneer herbs such as panicgrasses or dotted smartweed. These plants are native weeds: they appear promptly on disturbed sites where newly exposed earth affords opportunities to move in. They spread easily and grow fast, and advancing point bars are always offering newly exposed earth.

Behind the herbs in presettlement times, there was most commonly a zone of river birches, the first trees to grow on the rising sandy soils. Behind the birches, any number of other swamp forests might be encountered depending on the history of the floodplain. It might be a stranded slough, or a southern magnolia/pignut hickory/water-oak forest on the high bank

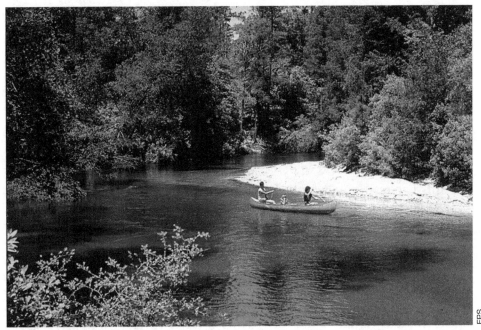

A point bar. As it rounds a bend, the Blackwater River of the Florida Panhandle constantly adds sand to this little beach. As the point bar grows, pioneer herbs, then shrubs, and finally trees colonize it.

of an outside bend left behind when the main channel abruptly shifted position, or a gradual gradient up into an overcup-oak/water-hickory swamp forest.

Unfortunately, the rivers and streams of north Florida have been receiving agricultural sediments from Alabama and Georgia for so long that point bars are now covered in heavy deposits of silt and clay. These attract black willow, which forms dense thickets at the water's edge. As the willows elongate, they lean toward the water, finally toppling onto the sand. Wherever they touch the sand, they put down new roots, grow new branches, and become new willows, a mode of propagating that gives them an advantage over competitors in claiming new ground in the sun. At high-water times, the growing willow thicket slows the water down so that it tends to drop more sand and further add to the point bar. Thus, in a sense, the willows keep creating new habitat for themselves: the point bar and willow thicket advance together. Willows can grow five feet in a single growing season, so they rapidly colonize newly-laid-down sand.

As the black willows march forward, they overtop the panicgrasses and other herbs, but new herbs keep springing up in front of them. Meanwhile, the oldest willows, farthest from the river, grow old and die, giving way to bottomland hardwood trees. On the Apalachicola River, some point bars have several recognizable zones of trees: willows on new ground, swamp cottonwood behind them, and American sycamore still farther back. Other species may accompany these, such as planertree and river birch.

Some day, of course, the river channel may erode the point bar away

Swamp thistle (*Cirsium muticum*). This common native weed grows freely in swamps and its blossoms provide nectar for many insects.

and leave it behind as an island between two river channels. Later still, levees may close off the old river meander, creating an oxbow lake; that story is told next. When the open-water channel migrates away, old levees remain as forested humps in the floodplain

Oxbow Lakes and Floodplain Swamps. Figure 5–7 shows the genesis of an oxbow lake. As soon as it is closed off from the main river, an oxbow lake becomes a place of standing water, but unlike other lakes, it is frequently swept clear of debris by river floods, setting back its progress towards becoming a swamp. Its deep standing water is ideal for cypress and water tupelo, which may have started up when the land lay along the main river channel. At the center of an old oxbow lake, giant cypress and water tupelo may have been standing for centuries.

With repeated inundations by sediment-laden river water, the oxbow lake slowly fills in and supports the growth of additional trees, becoming a floodplain swamp. As the lake grows shallower, the hydroperiod grows shorter, and different hardwood tree species succeed those that grew there at first. Undergrowth is sparse in the deep shade, but shrubs and ferns grow here and there beneath the trees, including swamp titi, wax myrtle, royal fern, and others.

An **oxbow lake** is a U-shaped lake formed when a river cuts off one of its meanders at both ends and leaves it behind.

An oxbow lake or other depression in a floodplain ultimately fills in and becomes a swamp.

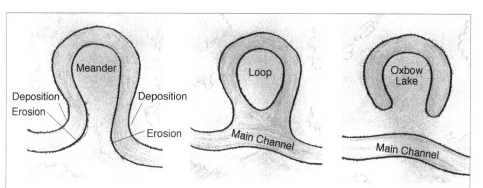

1. A meander. The neck of the loop grows narrower as the river erodes sediment from the outside bend of each curve. At the same time, the river deposits sediment on the point bar of each curve.

2. A meander loop. The river cuts across the neck at its narrowest point. Now there is a new main channel, in which the current flows fast, while it flows slowly around the loop.

3. An oxbow lake. Sediment accumulates alongside the river's main channel and closes off the loop, forming an oxbow lake.

FIGURE 5–7

Origin of an Oxbow Lake

These drawings show one stretch of a river at three successive intervals in time:

1. The river has doubled back on itself, forming a meander.

2. The river has cut across the narrow neck of the meander, forming a loop. Now, most of the river's flowing water follows its new main channel, bypassing the loop, in which the water flows sluggishly if at all.

3. The river has dropped sediment across the ends of the loop and cut it off, forming an oxbow lake. Later still, the lake will fill in, becoming a swamp.

Bottomland and Alluvial Forests. Behind the river's levees, and protected by them for most of the year, are the bottomland hardwood forests. Here, tremendous trees stand on massive root systems in muddy earth. Some have toppled over, leaving behind deep holes in the mud.

Bottomland and alluvial forests are America's most towering forests. Many tree species grow taller, faster, in river bottomlands than anywhere else. The alternation of floods and retreat of flood waters speeds up the decay and release of nutrients on the forest floor. Continual flooding would deprive decomposer organisms of oxygen and so inhibit decay, but alternating wet and dry conditions give decomposers both the water and the oxygen they need to do their work. Soil moisture, held in place between floods by leaf mulch, feeds needed water to growing trees through dry times.

On higher ground, an observer encounters several different assemblages of trees. On the lower parts of slopes are green ash and sweetbay, trees that can tolerate quite moist conditions. Higher on slopes, overcup oak and red maple become prevalent, then American sycamore and water oak. Finally, on the tops of ridges in the floodplain, other oaks, hickories, and spruce pine are growing.

Just by looking at the tall, dark trunks of the trees, one can hardly tell that each species grows best at a certain level above the river. However, when the members of each tree species are carefully surveyed to the elevations of their rooted bases, it is found that in general, different trees predominate at elevations that differ by only a foot or two.

How do trees "know" to grow along a strip of land at a certain elevation? One part of the answer is the hydroperiod at each level. The lower a tree lives in a floodplain, the longer its roots will be in saturated soil. Another part of the answer is that a floodplain's soil texture varies with elevation. Rivers deposit sand on high places while still running fast. They deposit silt and clay lower down when running more slowly. Soil organisms are different, too. Long periods under water create airless conditions in which anaerobic organisms grow. Shorter periods permit more penetration by oxygen and accommodate aerobic soil organisms.[10]

As a result of all these variations, and thanks to the annual delivery of fresh nutrients by floods, many more species of trees can grow in bottomland and floodplain forests than in acid swamps or mesic hardwood hammocks. Altogether, some 52 canopy tree species flourish in the Apalachicola River floodplain, and there are even more species of small trees, shrubs, and groundcover plants than canopy trees. List 5—4 displays a sample of the prodigious variety found in a well-developed bottomland hardwood forest, but note that only some three dozen species are named there. For comparison, nearly 300 species of trees, shrubs, and herbs have been counted near the banks of the Apalachicola River in just one survey.

The Florida Natural Areas Inventory identifies several forested communities growing in river floodplains. Chief among them, the **bottomland forest** grows on the floodplain floor and the **alluvial forest** grows at a slightly higher elevation.

A **freshwater tidal swamp** is a swamp near the coast, where fresh water rises and falls among the trees, in concert with the tides.

A **freshwater tidal marsh** is a marsh near the coast where fresh water rises and fall in concert with the tides. Farther from the interior are brackish and then salt marshes (see Chapter 6).

Trees themselves work variations on floodplain topography, thereby promoting further diversity. Because their roots are shallow due to lack of oxygen, they tend to fall over when they die, raising giant, muddy tip-up mounds and leaving hollows filled with water where their roots have been pulled from the ground. Even long after a tree has completely decomposed, a mound and pool remain where it stood, and present an array of microhabitats for various floodplain plants and animals. Red maple, for example, can grow in a bottomland forest only because its seedlings can get started on mounds where the hydroperiod permits their growth. When attempting to restore bottomland forests and swamps that have been clear-cut and leveled, ecologists have learned that if they recreate mounds and pools, then more species will return spontaneously and the community will develop more naturally.[11]

Tidal Swamps. Close to the coast, the river runs through a freshwater tidal swamp. The water, although still fresh, rises and falls as the tides alternately push in and flow out at the mouth of the river. The swamp trees are similar in kind to those farther upstream, but they are dwarfed, and great tangles of roots have developed around their bases, an adaptation to the twice-daily lack of oxygen. Twice a day, pulses of high water replenish the swamp's nutrients, creating somewhat different growing conditions from those in other swamps. Like other deep-water swamps, this wetland is dominated by cypress and tupelo.

Still farther down the river is a freshwater tidal marsh, a system described in Chapter 6. Here, the pulsing, nutrient-rich water and abundant sun support the growth of masses of green herbs. The marsh plants die back to ground level in winter and start up again in spring. Finally, these freshwater systems give way to salt marshes (also described in Chapter 6).

Hydric Hammocks. Along the Gulf Coast of Florida from St. Marks to Aripeka north of Port Richey, a little-known natural community called hydric hammock lies between the salt marshes and mesic flatwoods along Florida's northeast coast. Other examples inhabit the St. Johns River floodplain and lie just inland of salt marshes along the northeast coast. Many smaller stands are scattered in the northern and central regions of peninsular Florida, particularly along spring runs. Hydric hammocks grow on low, flat, wet sites where limestone may be near the surface and where the soil moisture is maintained mainly by rainfall accumulating on poorly drained soils. Periodic flooding from rivers, seepage, and spring discharge may also contribute to hydric conditions.[12]

Hydric hammocks are dominated by palms and evergreen hardwoods—typically, cabbage palm, live and swamp laurel oaks, southern red-cedar, sweetgum, and hornbeam (see List 5-5). The soil is moist or wet for most of the year but floods are gentle and brief, and deposit little sediment.

A Hydric Hammock: A rare, nearly pure stand of cabbage palm in Wakulla County.

A **hydric hammock** is a well-developed hardwood and cabbage palm forest on a low, wet site.

LIST 5-5
Plants of hydric hammocks (examples)

<u>Canopy trees</u>
American elm
Cabbage palm
Live oak
Red cedar
Red maple
Sugarberry
Swamp laurel oak
Sweetbay
Sweetgum
Water oak

<u>Small trees and shrubs</u>
American beautyberry
American hornbeam
Common persimmon
Dwarf palmetto
Needle palm
Small-leaf viburnum
Swamp bay
Swamp dogwood
Wax myrtle

<u>Vines</u>
Climbing hydrangea
Eastern poison ivy
Greenbriers
Muscadine
Peppervine
Rattanvine
Summer grape
Trumpet creeper
Yellow jessamine

<u>Herbs and Ferns[a]</u>
Carolina scalystem
Cinnamon fern
Maiden ferns
Netted chain fern
Royal fern
Sedges
Smooth elephantsfoot
Toothed midsorus fern
Woodoats
Woodsgrass
. . . and others

Note: [a]Groundcover may be absent.
Source: Guide 2010, 181-184.

Some examples are dominated by large populations of the Florida State tree, the cabbage palm.

In earlier times, most of Florida's hydric hammocks occurred in the Gulf Hammock region, which was named for them, but before these swamp forests could be adequately studied, most were clearcut, bedded, and converted to commercial slash pine plantations.

FLOODPLAIN ANIMALS

The animals of a floodplain are even more diverse than the plants. Beneath the tall trees of this rich habitat, the base of the food web teems with bacteria, fungi, and invertebrates, most notably insects and spiders. Larger animals that rely on these creatures for food exist in large species populations that are packed into less acreage than in most other ecosystems. A few examples follow.

Insects and Other Invertebrates. Insects and small invertebrates are numerous in river floodplains, even in winter. Rotting logs house such masses of ants that they are a significant food source even for bears. Leaf litter dropped in fall nourishes an array of litter-decomposers and food webs based on them. A single pile of leaf litter might contain black flies, no-see-ums, mites, ticks, pill bugs, beetles, fireflies, and many other small invertebrates.

Many invertebrates live underground. Earthworms eat their way through the soil, gaining nourishment from the organic matter the river carries down in each flood. As they bore their burrows, they back out periodically,

Blue purse-web spider (*Sphodros abbotti*). This inch-long spider lives only near rivers in moist woodlands from Gainesville north into Georgia. It attaches its foot-long, tubular web, half above the ground and half below, to a sweetgum, oak, or southern magnolia, camouflages it with lichen and other materials, and closes both ends.

The spider never leaves the web. When an insect crawls on the outside of the web, the spider punches its fangs through the fabric, seizes the insect, pulls it inside, and eats it. Then in a few minutes it repairs the web with invisible weaving.

Top of tube

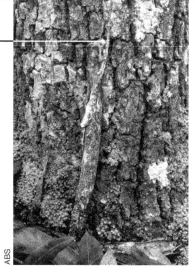

The spider's web. The tall tube, center, is the spider's hideout. It extends a foot below the ground.

Trap-door spider (*Cyclocosmia truncata*). This spider lives in the banks of ravines along the Apalachicola River. It builds a funnel-shaped underground trap, covers it with silk, and camouflages it with lichen as it is shown doing here. Then it hides in the trap to catch unwary small animals that fall in.

FIGURE 5—8

Two Swamp Spiders

Sources: For purse-web spider, Stiling 1989; for trap-door spider, Barry Mansell.

leaving tiny pellets of nutrient-rich earth behind. Mole crickets, crayfish, and other burrowers tunnel in bare soil, too, and lichens that look haphazardly scattered may conceal spider traps (Figure 5–8).

There are also permanently wet spots in floodplains. Along the valley sidewalls, seepage often keeps beds of decaying litter saturated the year around. Decomposer microorganisms turn the litter into muck pools: dark, soupy organic matter that is full of finely divided nutrients, and free of sand, silt, or clay. Muck pools form in many other places, but most of them quickly disappear. On soil with a high sand content, they quickly drain and dry up. In river bottomlands, they are frequently swept away by swiftly moving water. At higher elevations in a floodplain, though, on organic soil wet with seepage, muck pools persist reliably and make a fine habitat for small aquatic and wetland animals. Within them, microscopic organisms dine on the smallest muck particles; aquatic earthworms and other invertebrates eat the microbes; and larger animals eat the worms in turn. Among them are burrowing crayfish (see Figure 5–9) and the one-toed amphiuma.

Fish. During flood times, even fish, which normally swim only in the river's main channel, find habitat in floodplain swamps. When the river's water spreads across the floodplain, fish disperse among the trees together with frogs, turtles, water snakes, and other animals. "I done caught a plenty

Cambarus pyronotus. This crayfish digs its burrows in seeps along small streams that feed into the Apalachicola River.

Cambarus diogenes. This crayfish burrows in marshy areas near stream banks.

Procambarus peninsularis. This crayfish is widespread in wet sites across Florida.

FIGURE 5—9

Swamp Crayfishes

Of Florida's several dozen species of crayfish, eleven find habitats in stream floodplains—among them, these three.

a fish right around the roots a those trees," says an old timer. "The fish like to come all out in the woods and swim over the ground."

Given the opportunity to swim among the tree roots, fish hide in cavities like squirrels, breed and spawn, grow in size, and multiply . Many fish species depend absolutely on flooded swamp habitats for parts of their lives. As a flood is ending, they feed in quiet backwaters and breed. Their offspring grow for several weeks there, then swim out to the main stream as the high water recedes. List 5-6 focuses on some of the rare fish and other animals found in Florida's floodplain swamps.

Amphibians and Reptiles. Among the rare amphibians, one is the one-toed amphiuma, which lives in brown muck derived from a mixture of cypress and hardwood litter. Perpetual seepage into creek and river floodplains creates pools of this muck along the Gulf Coast from Tampa to Pensacola.

Figure 5—10 illustrates that salamanders find diverse living spaces in riverside wetlands, spaces with different soil types, stream types, and hydroperiods. In the Ochlockonee River basin alone, 17 different salamander species live and share resources.

Where litter, muck, insects, and other small invertebrates abound, frogs can also thrive, of course. The standing water in sloughs provides larval habitat for the green treefrog, leopard frog, bronze frog, spring peeper, southern cricket frog, and southern toad. Other frogs live along the river bank and the trees house treefrogs. The tiny, one-inch-long bird-voiced treefrog lives in the canopy of swamp trees. The bullfrog, a giant among frogs, readily eats fish, other frogs, and even baby ducks. Each frog has its own mating season, so the several species found in river floodplains do not compete for pools in which to mate. And each has its own call. The chorus in a large river floodplain at night is a cacophony of different songs,

One-toed amphiuma (*Amphiuma pholeter*). Shown here against a contrasting background, this animal actually lives in black muck, where it blends in almost invisibly. It thrives in muck pools in the Apalachicola ravines.

Cottonmouth (*Agkistrodon piscivorus*). Widespread across the southeastern United States, this venomous snake is found wherever there is water.

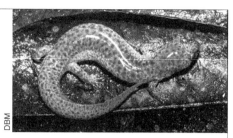

Apalachicola dusky salamander (*Desmognathus apalachicolae*), male and female

Two-lined salamander (*Eurycea cirrigera*), male and female

Red salamander (*Pseudotriton ruber*)

UPSTREAM SALAMANDERS The above three salamanders live near the origins of streams (that is, along first- and second-order streams) in the Apalachicola and Ochlockonee river watersheds. These are raviny areas where the water is shallow and well oxygenated. The three species coexist relatively peacefully because they are of different sizes and eat different-sized prey. The Apalachicola dusky salamander eats only animals in leaf litter above the water line—spiders, sow bugs, and dozens of others. The little two-lined salamander, which has a tiny mouth and a long tongue, eats a suite of things that are beneath the dusky's notice. The red salamander is so big that it eats all kinds of animals that are too big for the other two, including the other two salamanders.

Southern dusky salamander (*Desmognathus auriculatus*)

Three-lined salamander (*Eurycea guttolineata*)

Gulf coast mud salamander (*Pseudotriton montanus*)

DOWNSTREAM SALAMANDERS Each of the the species of salamanders in the second row is a very close relative of the one above it—a member of the same genus (the names, *Desmognathus*, *Eurycea*, and *Pseudotriton*, are the genus names). These three live in swampy floodplains along the same streams, but in their fourth-order or greater reaches, where the water is less well oxygenated. Sets of species like this, which perform the same roles but in different habitats, are known as geminate (paired) species.

FIGURE 5—10

Salamander Diversity

Salamanders began evolving in eastern North America some 150 to 200 million years ago and later colonized many other parts of the world. No mammal has existed over time spans as long as this. Six of the ten salamander families alive today have populations in Florida. (*Source:* Means 2000.)

each singer straining to outshout all the others of its own kind. Figure 5–11 presents a small sample of the many frogs that thrive in Florida's river floodplains.

Floodplain turtles include the Suwannee River cooter and alligator snapping turtle, the latter once rare due to overexploitation. Even more rare, and inhabiting only the Apalachicola River drainage basin, the very timid Barbour's map turtle lives in the water and suns along the shore (see Figure 5–12). Several species of snakes also occur in large populations. Among them are the cottonmouth and non-venomous snakes such as the

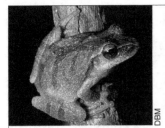

Spring peeper *(Pseud-acris crucifer)*. This treefrog emits a sweet, drawn-out whistle in the spring.

River frog *(Rana heck-sheri)*. This big, shy frog makes a snoring sound at night from the margins of streams and rivers.

Bullfrog *(Rana cates-beiana)*. This big frog's calls create a deep, bass drumbeat in Florida swamps at night.

Pig frog *(Rana grylio)*. This frog utters a loud, grunting call both day and night around ponds and floodplain lakes.

Eastern narrowmouth toad *(Gastrophryne caro-linensis)*. This animal goes "ba-a-a" like a sheep.

Northern cricket frog *(Acris crepitans)*. The call of the cricket frog is a treble "gick-gick-gick."

FIGURE 5—11

Six Florida Frogs

All of these frog species and many more thrive in Florida's river floodplains.

brown water snake and redbelly water snake. Two snake subspecies occur exclusively in the Gulf Hammock region, and both are unusual in having blue stripes: the blue-striped garter snake and the blue-striped ribbon snake.

Birds. Birds also flourish on the abundant fare in floodplains. According to researchers Larry D. Harris and others, more than nine-tenths of all bird species of eastern North America use bottomlands at one time or

Eastern river cooter *(Pseudemys con-cinna)*. This turtle spends its life in and near streams except when nesting.

Common musk turtle *(Sternotherus odoratus)*. This small turtle spends nearly all of its time in the water.

Barbour's map turtle *(Graptemys barbouri)*. This turtle occurs only in the Apalachicola River drainage basin, where it may have evolved.

FIGURE 5—12

Three River-Swamp Turtles

Two summer residents. Both of these birds spend their summers in Florida and breed there. LEFT: A flycatcher (*Myiarchus* species) seeks out moist woodlands and floodplain forests, where it spends most of its time in the canopy. RIGHT: The prothonotary warbler (*Protonotaria citrea*) nests over water in Florida swamps.

another. The deep, protected canopy attracts songbirds not seen elsewhere. Warblers and thrushes, passing through, rest and feed in the swamps and forests and fill them with song. American woodcocks make their homes deep in the forest. Birds of prey, including the osprey, bald eagle, barred owl, red-shouldered hawk, and the swallow-tailed and Mississippi kites, find abundant prey in floodplains.[13]

Many bird families are represented by several species in floodplains. For example, because there are so many insects devouring wood and litter on the floodplain, several species of woodpeckers can share the resource. The red-bellied woodpecker feeds on beetle larvae in live trees. The pileated woodpecker drills for grubs from deep in the wood of older, dead trees. The ivory-billed woodpecker (now presumed extinct) fed on grubs under the bark in newly dead trees. List 5—7 identifies a few of the birds of Florida's river floodplain swamps.

Shelter in a floodplain is as diverse and available as food. Tree branches at different levels offer a surfeit of nesting sites. Floodplain hardwoods develop cavities, rotted by many kinds of fungi. These make needed homes for the wood duck, eastern screech-owl, and others, as well as for small invertebrates, lizards, and mammals.

At river mouths near the coast, waterfowl abound: mallards, pintails, red-breasted mergansers, American black ducks, and gadwalls. Wading birds nesting over sloughs need only drop down and hop back up to feed their broods a bounty of nutritious morsels.[14]

Mammals. Finally, mammals, too, find ample fare in floodplains. Thanks to their abundant hickory nuts, mulberries, pecans, acorns, and other nourishing nuts and seeds (mast), floodplain forests support many more deer than do upland forests. The opossum and two species of squirrels also live on mast. Beavers work the trees and create pools in small tributaries where the sound of flowing water stimulates them to build dams. The

eastern woodrat and two species of mice have habitats in the floodplain; so do the Florida black bear, raccoon, long-tailed weasel, striped skunk, river otter, gray fox, and bobcat.

In sum, natural, forested river floodplains are rich habitats that are home to many animals. The invertebrate animals have never been completely inventoried for any floodplain, but the vertebrates around some rivers have been counted. The Suwannee River floodplain, for example, supports 385 species: 39 species of amphibians, 72 species and subspecies of reptiles, 232 species of birds, and 42 of mammals. How many snails, worms, spiders, insects, and soil organisms must there be? How many fungi? lichens? bacteria?[15]

* * *

Floodplain wetlands feed nutrients into downstream aquatic habitats. The floodwaters that sweep muck and litter from floodplains feed coastal and offshore ecosystems the materials on which they depend. Floodplain wetland organic matter by the tens of millions of tons fuels tremendous production of seafood in Florida's streams and offshore waters.

In concluding these four chapters on Florida's freshwater wetlands, it is important to bring the focus back to their intrinsic value. Wetlands, when functioning naturally, play crucial roles on the landscape. Florida is a flat land, and millions of acres are soggy for much of the year. Given this topography and climate, what will grow best over all those acres? The answer is native wetland plants. Each is adapted to a specific wetland environment, and native animals are, in turn, adapted to use the plants. For these reasons, the genetic information in native wetland species is valuable. After all, what other plants or animals are better adapted to occupy these lands and deliver their products and services, than those that have evolved here?

Bobcat (*Lynx rufus*). These wild cats thrive in swamps and their kittens are born skilled at climbing trees.

Golden mouse (*Ochrotomys nuttalli*). Seldom seen, this little rodent lives in many Florida environments from high, dry scrub to low, wet swamps. Because it nests in shrubs and trees, it survives periodic floods.

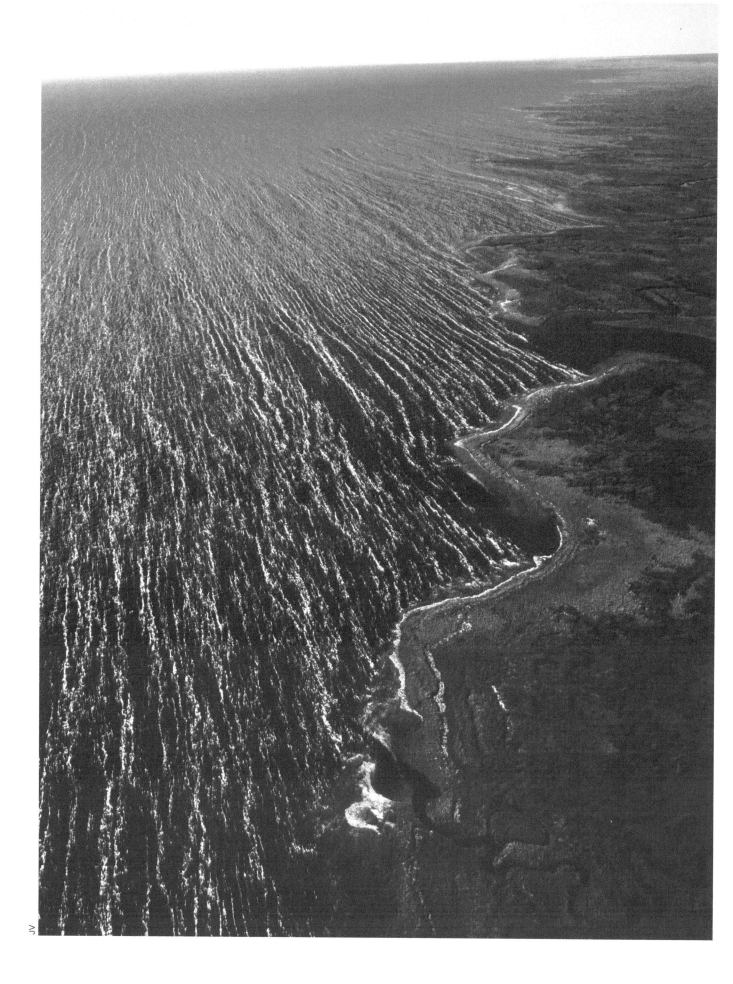

CHAPTER SIX

COASTAL INTERTIDAL ZONES

A profound and fascinating force affects the inhabitants of coastal zones: the tides. Coastal zone plants and animals all live by tidal rhythms, which have shaped their evolution for hundreds of millions of years. To survive in tidal zones, every plant and animal must have ways to withstand the constantly changing water level, and in most tidal wetlands, daily oscillations between salty and fresh water, as well.

Most of this chapter deals with tidal marshes, giving the lion's share of attention to salt marshes. However, the beach, too, has a zone between the tides, the foreshore, and this zone deserves a moment's attention. The foreshore is familiar to all beach visitors, and the life in that zone illustrates well the forces with which tidal creatures have to contend. This chapter, then, begins on the beach.

THE BEACH FORESHORE

The backshore is a windy, desertlike environment in which only a few species of plants and animals can survive. The foreshore, in contrast, is more supportive of life. It is familiar to beachgoers as the strip of beach where the sand is firm and walking is easy. High tides cover the foreshore with waves and surf, and low tides leave it above water. Daily flooding with salt water prohibits the growth of plants except for some inconspicuous algae, but animals do live along the foreshore, and they are highly specialized to exploit its dynamic high-energy environment. They occur nowhere else.

Many animals of the foreshore have bodies specially adapted for rapid digging, the only strategy that can keep them from being swept away by the waves. Beachgoers may be familiar with coquina clams, tiny colorful

RLH

Virginia saltmarsh mallow (*Kosteletzkya virginica*). This plant grows in salt and brackish tidal marshes as well as in freshwater wetlands.

An **intertidal zone** is a zone between the high and low tides. At high tide, it is covered by water. At low tide, it is exposed except when wet by incoming waves.

The **foreshore** is the beach intertidal zone. The backshore is the beach zone above the high-tide line.

OPPOSITE: Tidal marshes along the Panhandle's Big Bend. Along this coast, waves are so mild that fine particles of silt and sand remain as beds of mud that support salt marshes.

The beach foreshore. This is the beach intertidal zone.

Coquina clam (*Donax variabilis*). These lovely pastel-colored little clams live in the surf zone of Florida's sandy beaches. Generations of beachgoers have delighted in their varicolored shells and in the fast disappearing act they perform as they burrow down into the sand after each wave.

Over millennia in the past, coquina clam shells have piled up in such numbers that they now form significant beds of limestone. Coquina limestone is a popular building material, especially in central Florida.

Plankton are tiny organisms suspended or weakly swimming in the water. Some are plants (mostly algae), called **phytoplankton**. Some are animals: **zooplankton**.

bivalves that are exposed just as each wave recedes, but then quickly up-end themselves and burrow down into the wet sand, disappearing in the wink of an eye. The next wave exposes them again—and again they promptly disappear. They move up the beach as the tide comes in, and back toward the ocean as it goes out, positioning themselves where the sand is softest and where they can most rapidly sift phytoplankton from the water as it sinks into the sand.

Another rapid digger of the foreshore is the mole crab, an animal about an inch long that has a smooth, egg-shaped body and legs that fold tightly under it when it isn't digging into the sand. When the mole crab is buried and a wave passes overhead, the tailplate anchors it in position. As the wave washes back, the crab extends a pair of long antennae into the backwash, and the fine hairs on them sift food out of the water. The mole crab then folds the antennae back into its mouth to eat its catch. These animals of the foreshore are vigorous and active. They are dependent on the water's high oxygen concentration and will die quickly if kept in a bucket.

Besides visible species such as coquina clams and mole crabs, many smaller species live among the sand grains. Crustaceans and worms dominate, along with single-celled protozoans, and they comprise a whole food web that is invisible to the naked eye. Some animals graze on the algae that live among the sand grains. Others prey upon these grazers, and still

Mole crab (*Emerita talpoida*), a fast-digging resident of the foreshore.

others scavenge whatever is left behind. Pick up some wet sand after a wave, and you have an entire world in your hand.

Other animals that live higher on the beach visit the foreshore just to get wet enough to keep their tissues moist. Sand hoppers dig down into wet sand each day exactly at the high-tide mark, to keep themselves moist. Then they come out at night to rummage for food in the dark.

The very smallest members of this complex world are as sensitive to the tides as the larger members are. Even the algae migrate up and down in the sand—not with each wave, to be sure, but with each tide. They rise to the surface of the sand to catch the sun's light at each low tide and then, just before the next high tide, they bury themselves again and thus keep from being washed away. These algae actually anticipate the tides. They possess an internal clock that simply "knows" when the tides will be, and it continues to operate even when they are taken indoors, miles away.[1]

If the beach foreshore, where no plants grow, is rich in life, tidal wetlands along low-energy shores are infinitely more so. The rest of this chapter and all of the next one deal with tidal wetlands: tidal marshes in this chapter, tidal swamps in the next. First, though, a few introductory remarks that apply to both categories.

Florida visitor, winters: Short-billed dowitcher (*Limnodromus scolopaceus*). Shorebirds probe the sand to feel for the numerous, healthy creatures that live among the grains.

TIDAL WETLANDS

Tidal wetlands occupy stretches of the shoreline where the waves are not energetic enough to support beaches. They line lagoons, protected bays, and inlets; the mouths of rivers and streams; and other low-energy shores, including the lee shores of barrier islands. They are best developed where the land is most nearly flat and tidewaters travel long distances onto the land and back out onto the continental shelf. Along Florida's west coast, the terrain is so level that even a slightly rising tide crawls for miles across the land and the waves are gentle ripples, typically no more than two inches high. Florida's coastal marshes and swamps vary from about 1/2 to 4 1/2 miles in width; along coastal Citrus County, they are 7 1/2 miles across. Tidal marshes (this chapter) predominate in the northern half of Florida, and tidal swamps (mangrove swamps, next chapter) in the southern half.

Among the stresses faced by tidal wetland inhabitants are variations in salinity, oxygen levels, temperature, and wave energy. Although tidal wetlands are classed as salt, brackish, or freshwater systems, their salinity may vary from hour to hour, day to day, and season to season. Water flowing in from the ocean may be salty, but rains and runoff repeatedly dilute the salt with fresh water. Oxygen levels in the water and soil also vary both from place to place and from time to time. Because the waters

Tidal wetlands lie along the coast between the low and high-tide lines, and their water rises and falls with the tides.

Tidal wetlands include both marshes and swamps. Within each category, some are saltwater wetlands, some are brackish, and some are exposed only to fresh water.

Reminder: A *marsh* is a wetland dominated by herbs (grasses and forbs). A *swamp* is a wetland dominated by shrubs or trees.

The highest high tides of each month are **spring tides**. They occur when the sun, moon, and earth are aligned in space, that is, at the full and new moons.

The lowest high tides of the month are **neap tides**. They occur at half moons, when the sun and moon are at right angles to each other.

are shallow, their temperatures can vary from below freezing on a winter night to subtropical the next day at noon. Moreover, some days are utterly calm, whereas on others, fearsome winds blow in off the water. Any plant or animal living in a tidal wetland has to be able to contend with all these extremes.

Each tidal wetland has its own tidal pattern, and this distinguishes one from another. Some shores experience tides every twelve hours, others every six, and still others have a mixed pattern. These patterns are both stressful and reliable for living things: stressful, because they present such extremes; reliable, because they present them predictably. List 6—1 presents some of the characteristics of the tides along different parts of Florida's shore and the plants that are adapted to them.

Many animals and plants are unable to live in zones that are alternately in the air and under water, but some thrive there and depend on the tides to repeat without fail. Many animal species of tidal wetlands have, in fact, evolved to use the tides to advantage, particularly the very highest "spring" tides that occur twice a month, at the full and new moons. Currents are strongest at spring tides, when large volumes of water are moving. Marine animals commonly release their eggs at spring tides because they will achieve wide dispersal this way. Transport of planktonic offspring out and away from the parents allows attached species to colonize distant habitats and later reproduce with mates from other populations. As a result, the offspring are more genetically diverse and more fit than inbred offspring would be.

ZONES IN TIDAL MARSHES

For many Florida residents, a tidal marsh is a familiar sight: a ribbon of grassland between the forest and the sea, a place of severe simplicity. Figure 6—1 shows a photo of such a marsh, in this case a salt marsh, showing its zones. Closest to open water is the low marsh, behind it, the high marsh. The distinction between "low" and "high" marsh is determined by a difference of just an inch or less in elevation. An inch is all it takes to make a big difference in plant types.

Within the high and low marshes are special habitats. Sinuous tidal creeks penetrate the marshes like arteries and veins, carrying tidal waters, the life blood of the system, deep into the marshes and out again every few hours. There are also salt flats, sometimes called salt barrens; and there are rafts of tidal wrack—dead marsh plants heaped wherever high tides drop them.

This low marsh is usually a monoculture of one species of grass or grasslike plant. Growing luxuriantly, it forms a low canopy shading the

LIST 6–1
Tide patterns and plant life

Northeast marshes around Jacksonville

Tide pattern: Twice a day, the highest tides in Florida

Vegetation: A tall form of saltmarsh cordgrass

Marshes in the Indian River Lagoon (Volusia to Martin counties)

Tide pattern: Marshes confined behind a shoreside berm and inundated only during extreme high tides and when wind pushes water into them

Vegetation: Mostly high-marsh plants mixed with black mangrove

Panhandle marshes

Tide pattern: Tides higher or lower than the moon alone would dictate. In winter, winds commonly blow from the N and NE, pushing water out of most marshes. In summer, winds more often blow from the S and W, sometimes holding water in the marshes for a day or two.

Vegetation: Predominantly needle rush.

Sources: Coultas and Hsieh 1997, 16; Montague and Wiegert 1990, 487-490.

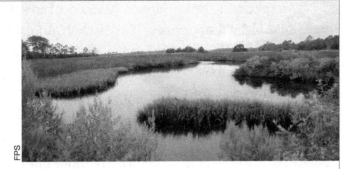

FIGURE 6–1

Zones in a Salt Marsh

Only a few species of plants dominate a salt marsh, as shown. Green ribbons of saltmarsh cordgrass twist along the banks of the salt creeks. This is the low marsh. Behind it, an expanse of needle rush sweeps across the higher marsh. Other small inconspicuous plant species, including Carolina sea lavender, grow scattered beneath the rushes. Farther back on the land is a coastal hammock with slash pine, cabbage palm, and other plants.

soil. Tidal currents are strong, and they sweep litter out from around the plants' roots; no litter accumulates in the low marsh. Tidal currents also bring nutrients into the low marsh, and remove wastes. The soil is often under water and evaporation occurs slowly, so the soil tends to remain waterlogged and oxygenless.

In the high marsh, additional plant species grow. Plant leaves and soil are warmer and drier than in the low marsh, and some shrubs may take hold temporarily, but high storm tides kill them off from time to time. Because tides penetrate the high marsh less often, litter does accumulate, fewer nutrients flow in, and more wastes build up. Higher soil temperatures and less frequent inundation speed evaporation, so salts tend to accumulate, raising the salinity.

Many more species of algae than of vascular plants are present in a salt marsh. A thick, gelatinous coating of microscopic algae grows on soil surfaces and on all the bits of plant litter suspended in the water. These algae are only one-tenth as massive as the vascular plants in the marsh, but they are ten times more energy-rich and nutritious for plant eaters such as fiddler crabs and snails, because they are eaten fresh rather than after being shed as litter.

Although their numbers vary, bacteria and algae are always growing vigorously within the marsh, where sunlight, water, and salts are always freely available. Incoming tides lift some of these organisms off the surfaces of litter and soil into the water. There, they become food for tiny, floating plankton that live out their entire lives in the marsh. Some Florida marshes host about 20 species of plankton, numbering 100,000 individuals per cubic meter of water although weighing just over an ounce.

Like the big plants, the microscopic plants are unevenly distributed

Algae include both single-celled and many-celled forms.

Unicellular and small multicellular algae are **microalgae**.

Large multicellular algae are **macroalgae**, or **seaweeds**.

The photosynthetic microorganisms that used to be called blue-green algae are now known as **cyanobacteria**.

over both space and time. Some species occur in saline habitats, others in brackish; some at the periphery of the marsh, and others nearer the interior. Huge surges of different populations occur as the seasons change. Patches of blue-green cyanobacteria are especially abundant after rains (see "Tidal Marsh Food Webs," following the next section).

Salt marshes present the most strenuous challenges to plants, brackish-water marshes are less stressful, and freshwater marshes are relatively benign environments in which many more plant species can grow. The next sections describe the plants in the various types of marshes.

PLANT LIFE IN TIDAL MARSHES

A tidal marsh looks monotonous to the untrained eye. Only a few species of grasslike plants (actually grasses, sedges, and rushes) may spread for miles across a land that looks as flat as a mirror. The only breaks in the vast, grassy plain are the tidal creeks that snake through the marsh, and the empty salt barrens.

In salt marshes, conditions vary between extremes of salt and fresh, wet and dry, hot and cold. Life in an environment of such extremes is so hard that only a few plants have mastered it. In fact, just one grass and one rush visually dominate some salt marshes so completely that they appear to be the only ones present. Along creek banks and levees and in the lower marsh is saltmarsh cordgrass, which is green. In the higher marsh grows needle rush, which is brown. Just these two plants may cover many square miles of marsh. A few other, less conspicuous species grow among them (see List 6–2 and Figure 6–2).

Along tidal creeks, borders of tall green vegetation thrive, thanks to the rising and falling tides that repeatedly bring in nutrients and carry away wastes. Minor creeks branch off the main creeks and different plant populations are found at each level of the hierarchy. Marsh plants along creeks also benefit from the abundance of fiddler crabs found there, which help to aerate and fertilize the soil.[2]

On relatively high ground within marshes, ground that is flushed by salt water only a few times a month, are salt flats. Between inundations, the sun bakes and simmers the evaporating water on the flats until the salts grow so concentrated that they crystallize, suppressing nearly all plant life. The little water that is there evaporates even faster thanks to the presence of fiddler crab burrows all over the flats, which keep the soil loose.[3] List 6–3 itemizes plants that grow on salt flats.

Tidal wrack, that is, heaps of dead plant material, can occupy large areas of the high marsh. Wrack consists mostly of dead shoots of needle

LIST 6–2
Salt marsh plants (examples)

Annual and perennial
 glasswort
Bushy seaside oxeye
Marshhay cordgrass
Needle rush
Saltgrass
Saltmarsh cordgrass
Saltwort
Sand cordgrass

Source: Adapted from Montague and Wiegert 1990, 485, table 14.1.

LIST 6–3
Plants on salt flats (examples)Annual glass-wort

Bushy seaside oxeye
Carolina sealavender
Keygrass
Perennial glasswort
Perennial saltmarsh aster
Saltgrass
Saltwort
Spikerush

Source: Clewell 1997, 82.

Bushy seaside oxeye (*Borrichia frutescens*).

Saltwort (*Batis maritima*).

Annual glasswort (*Salicornia bigelovii*).

FIGURE 6–2

Salt Marsh Plants

Saltwort tolerates ordinary salinity and grows well in salt marshes. Annual glasswort and sea oxeye are so salt tolerant that they can even grow on salt flats. Sand cordgrass grows not only in salt marshes but in brackish and freshwater marshes and along lake margins.

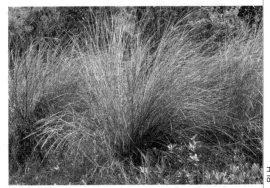

Sand cordgrass (*Spartina bakeri*).

The first three are succulents. They have thick, fleshy leaves and/or stems that are adapted for storing water and enable the plants to resist dehydration, which occurs readily in salty environments. Succulents typically grow in deserts (cactuses are examples) as well as in salty environments.

rush caught within the upper marsh. (Saltmarsh cordgrass, because it borders the creeks, is more likely to drop its litter into ebbing and flowing water that promptly transports it away.) When storm tides enter the high marsh, they lift and swirl the tidal wrack in eddies, then leave them heaped up again, elsewhere. A pile of tidal wrack may be many yards across and three or more feet deep. After it settles down, it may take a year or more to decompose, meanwhile killing all of the living vegetation beneath it. Another storm tide may lift the pile again and drop it farther up the marsh, killing more vegetation.

Where tidal wrack has lain, salt barrens may later develop and remain for long times. In one marsh, wrack killed more than a tenth of the vegetation before being moved again by tides. But wrack is not just dead material. Rather, as on the beach, it is a breeding ground for hosts of insects, arthropods, and others that become food for a myriad other animals.[4]

Brackish-Marsh Plants. Brackish marshes develop along river

Tidal wrack in a salt marsh. The base of the food web consists largely of dead needle rushes washed into the marsh and dropped there.

LIST 6–4
Plants in brackish marshes (examples)

Awlleaf arrowhead
Carolina sealavender
Climbing hempvine
Eastern grasswort
Gulf coast spikerush
Jamaica swamp
 sawgrass
Marsh fimbry
Needle rush
Saltgrass
String lily
Wand loosestrife

Source: Clewell 1997, 98. Clewell's list names 74 species in all.

LIST 6–5
Plants in freshwater tidal marshes (examples)

Fifteen miles upriver
Awlleaf arrowhead
Dotted smartweed
Eastern false
 dragonhead
Indian rice
Manyhead rush
Pickerelweed

At the border with the
river floodplain forest
Jamaica swamp
 sawgrass

In patches of marsh
and on river banks
Arrowhead (2 species)
Big cordgrass
Common reed
Southern cattail

Source: Clewell 1997, 102. These plants were noted along the St. Marks River.

deltas and wherever freshwater discharges are regular and substantial. The farther inland these marshes are, the less saline they are; and the lower the salt stress, the greater the variety of plants that can grow. List 6–4 itemizes some of the plants in brackish marshes along the St. Marks and Wakulla rivers; there are several dozen species in all.

Plants in a brackish marsh respond so sensitively to salinity that botanists can easily distinguish between two kinds of brackish marsh. The saltier type has three dominant plants: needle rush (as in salt marshes), big cordgrass, and bulrush, with little else. The fresher type of brackish marsh has several dozen additional species, including Jamaica swamp sawgrass.

Freshwater Tidal Marsh Plants. Freshwater tidal marshes occur still farther inland along tidal rivers. They are never saline except during tropical storms when extreme high tides penetrate far inland, but their waters rise and fall just as the tides do at the coast, although they may lag the tides by several hours.

Marsh plants have many advantages in a freshwater tidal setting. Free of salinity, they still reap the benefits conferred by the rising and falling waters: fresh nutrients come in with every flow of the tides, and wastes wash away with every ebb. The marsh soils are permanently waterlogged and therefore lack oxygen, so trees can seldom root there. Those that do, soon fall over. Also, fires occasionally burn into the marsh from neighboring forests and the fires, too, preclude tree growth. Accordingly, grasses and forbs in freshwater tidal marshes are more diverse than in salt or brackish marshes, with each plant tending to thrive in a particular part of the terrain (see List 6–5). Forests begin at the landward edges of tidal marshes, sometimes abruptly, sometimes gradually across broad zones of blending.[5]

As these descriptions show, tidal wetland plants are much more diverse than they look. Taken all together, plants both large and small and unseen organisms in the marsh water and soil support a vast food web on which all of the wetland's animals depend. The next section explores the food webs in tidal marshes, using the salt marsh as an example.

TIDAL MARSH FOOD WEBS

A salt marsh is thick with living things engaged in intense activity. All of the green plants, algae, and cyanobacteria constantly gather up water from the mud, oxygen from the air, and energy from light, making huge quantities of their own kind and pumping energy into the system. From them, and from the detritus they generate, hundreds of species take nourishment. Complicated webs of life tangle together in ways that change from morning to night, from season to season, and from one part of the marsh to the next.

Of all the masses of plant tissue in a coastal wetland, only a small fraction is eaten by insects and other herbivores while still alive. This fraction supports one system of consumers known as the grazing food web. The larger fraction of the plant tissue dies, is shed and ends up in the water and on the marsh floor as detritus—the main food for the major system of consumers, the detrital food web. The two chains interweave in complex patterns as energy moves from the wetland's primary producers, the plants, through the other organisms both small and large. Background Box 6–1 delves a little more deeply into the routes taken by water-borne detritus.

Animals are known as **fauna** (plants are **flora**).

The animals that live within the bottom sediments, straining their food from the sediments and water, are **infauna** (IN-faw-na).

The tiniest burrowing animals are **microfauna**.

The barely visible ones are **meiofauna** (MY-o-faw-na).

Those that are easy to see are **macrofauna**.

BACKGROUND 6–1

Nourishing Soup: Water-Borne Debris

Tidal marsh systems receive huge quantities of minerals (washed down from eroded mountain rock) and of plant and animal remains (washed out of interior forests, swamps, and marshes). The living organisms in the marshes combine these materials to make enormous quantities of living things.

Among the members of water-borne detritus are microbes so tiny, and present in such astronomical numbers, as to stagger the imagination. Microbes work on every particle of organic material that is carried into the water. Scientists have studied these organisms in Apalachicola Bay and have found them to be present in such numbers that, if it were possible to collect them in one place, their mass would equal that of all the bay's other creatures put together—shrimp, crabs, oysters, fish, and all the rest.

Consider what takes place on a single leaf as it floats down a river from some interior swamp. Microscopic organisms attach to the surface of the leaf in an ordered sequence. Bacteria first colonize the leaf, several species in succession, and work on it for several weeks. Then fungi take hold and spread their filaments into the leaf, digesting it further. Later, diatoms and algae take their turn. Then grazers move in to eat from the leaf surfaces, and by then they find there a highly nutritious diet. The grazers are tiny animals—mostly microscopic copepods, a highly varied group of crustaceans. As they grow, these leaf digesters also release waste materials that sink to the bottom sediments and serve as fertilizer for nearby plants.

Meanwhile, equally intense activity occurs in the bottom sediments. Myriad decomposer organisms live within the top few millimeters, coating every particle of sediment: bacteria, fungi, and other single-celled creatures. There are billions of these microfauna in every cubic inch of mud and their populations are layered vertically. Those in the top few millimeters use up all of the available oxygen, while those beneath use sulfur instead of oxygen to ferment the warm organic soup that filters down to them. (These latter organisms are responsible for the foul smell of hydrogen sulfide that sometimes arises from salt marshes when the soil is disturbed.) Together, these organisms gobble up detritus that has sunk to the bottom. They break it down, transform it, and return it to the detrital chain in new forms.

Salt marsh mosquito (an *Aedes* species). Among the innumerable tiny animals that live on the "soup" in salt marshes are the larvae of this mosquito.

Robber fly (*Efferia pogonias*). Dozens of species of two-winged insects are present in buzzing hordes in salt marshes.

(continued on next page)

The bacteria, fungi, and others in the soil feed still other tiny animals in the sediment, the meiofauna. Worms, mussels, clams, shrimps, minnows, oysters, and the young of hosts of other animals reside in the mud or roam its surface, chewing and scraping their tiny prey from the grains, sucking up water from which to strain more of the same.

Clearly, the reason why marsh plants grow so abundantly is that they receive abundant sunlight, water, and a rich fertilizer in the marsh mud, composed of detritus and the organisms that process it. The plants feed energy into hosts of tiny animals, and the larger animals of the marsh, those people can see, such as snails, crabs, and fish, are there because they can partake of that feast of tiny life. The relationships build from the bottom of the food web as shown in List 6–6.

It is in these ways that the detritus in salt marsh water and soil becomes huge quantities of animals of all descriptions. And since the detritus comes from living forests, swamps, and marshes in Florida's interior, it follows that the health of those communities supports the health and abundance of the offshore sea life.

Source: Succession of microscopic organisms from Livingston (R. J.) 1983, 32.

Although dead plant tissue is by far the larger contributor to salt marsh life, living plant tissue also feeds a host of insects and other herbivores. Plant hoppers, which feed on plant juice, are everywhere. So are grasshoppers, which eat plant tissue. Numerous spiders of many species spread their nets to capture these—what better place could there be for a spider to set up housekeeping than where so many small insects are on the move? Several species of wasps are parasites on the spiders. Mites, flies, a predatory beetle, butterflies, dragonflies, all abound in the marsh. List 6–7 mentions only a few of the more than 400 species of arthropods observed in one part of one marsh at one time.

These animals attract still others into the marsh to feed upon them. Birds fly in to catch insects and spiders, and fish swim in when the marshes are flooded. Fish catch the insects that fall into the water and even leap from the water to catch insects perched or flying above it. In each of Florida's tidal marshes, several dozen species of fish prey on insects, which they harvest with great efficiency. One observer saw a single killifish make nine successful strikes in just five minutes.[6]

* * *

The many small animals that live in tidal marshes support thriving populations of larger ones. The next sections of this chapter describe some of the large-animal residents of coastal marshes, as well as animals that visit from elsewhere.

RESIDENT SALT MARSH ANIMALS

At low tide, only a few types of animals are visible on the salt marsh floor, but they occur in large populations. A mob of fiddler crabs bustles among the fat red saltworts on an open sand flat. Thousands of periwinkle snails graze microalgae from the mud, five or six at the base of every blade of grass. Clicking and splashing noises suggest the presence of other animals, not seen.

Despite the bounteous feasts offered by a salt marsh, not many animals can stay there throughout their lives, because conditions alternate among such extremes. A few animals, however, can withstand the rigors of the marsh and therefore can take full advantage of its abundant resources. These year-round residents exhibit remarkable behavioral and physiological adaptations. Within an environment that swings from fresh to salty, airy to oxygenless, hot to cold, and high to low water and back again, they find food, attract mates, breed, and produce young that flourish and grow to adulthood, all in the marsh. One such animal is the fiddler crab, ubiquitous along Florida's coasts.

The Fiddler Crab. Millions of fiddler crabs inhabit every tidal marsh, digging burrows on salt flats, along creeks, and along marsh edges (see Figure 6–3). As the tide comes in, they scurry up the marsh, duck into their burrows, and plug them closed, remaining under water until the tide goes out again. Then they re-emerge to forage. Being aquatic animals, they breathe through gills as other crabs do, so when on land, they carry water with them in their gill chambers. They use this water also for evaporative cooling, and for sorting edible from inedible particles.

Different species of fiddler crabs live on muds and sands of different grain sizes. Each species has hairs in its mouth, whose spacing permits it to scrape microscopic diatoms off individual particles of sediment—more widely spaced for sand grains, more closely for grains of mud. The mouth parts are so specific to the type of soil in a given marsh, that they even permit the crab to sort its food, selecting the digestible parts to eat, and rolling up the rest into a ball which it replaces on the mud. (The large pellets that are everywhere in fiddler-crab colonies are mud balls, not fecal pellets.) The next high tide breaks these pellets up and gives the local microbes another go at digesting the detritus in them.

Fiddler crabs are keystone species. They prosper in a marsh ecosystem that is healthy, and they provide many services that keep it that way. They dig some 25 to 150 burrows per square yard of marsh, some only a fraction of an inch wide and deep, some an inch and a half wide and up to three feet deep. Thanks to these burrows, which aerate the soil, marsh plants can grow and decomposers can break down litter efficiently, freeing nutrients

LIST 6–7
(continued)

Cicadas, leafhoppers, and others, 17
Crickets, grasshoppers, mantises, stick insects, and others, 8
Earwigs, 1
Mites and ticks, 8
Net-winged insects (lacewings), 2
Spiders, 23
Springtails and relatives, 2
A strepsipteran, a tiny insect with twisted front wings whose larvae develop inside other insects
Thrips and relatives, 7
True bugs, including squash bugs, mealy bugs, and chinch bugs, 9
Two-winged insects including flies and gnats, 65

Source: Rey and McCoy 1997, 178–189, table 7.1.

Mantis shrimp (*Squilla empusa*). Named for its praying mantis–like appearance, this member of the infauna burrows in mud bottoms below the low-tide line and slashes at passing prey with its razor-sharp claws. At night it emerges to swim and in turn becomes food for fish, small sharks, sea turtles, and other large predators.

Male displaying
before female

FIGURE 6–3

Salt Marsh Fiddler Crab (*Uca pugilator*)

This is one of many fiddler crab species that occur in salt marshes. This particular species is a resident of Florida Gulf coast marshes, especially higher-elevation zones in needle-rush marshes.

The male crab has one oversized claw, sometimes the right and sometimes the left, which it waves to assert its claim to the territory around its burrow and to attract the female of the species. Crabs compete for sites near the upper border of the intertidal zone, where a burrow is most likely to stay wet at low tide yet not collapse at high tide. The best burrows attract the most females, which inspect many of them before deciding which to occupy. Crabs with the largest claws and best burrows are most likely to produce many offspring, so genes for the large-claw trait continue to be reproduced in each new crab population.

Fiddler crab species in general are famous for their internal biological clocks, which accurately calculate the times of the tides even when the crabs have been transported far from the ocean. They become active at low-tide times and somnolent at high-tide times, just as they did at the shore. Research on fiddler crabs has helped biologists to understand how biological clocks work.

Another fiddler crab, the Atlantic marsh fiddler *(Uca pugnax)*, occurs along Florida's east coast, where it conducts its life in a similar fashion. At the edges of its habitat, still another crab *(Sesarma reticulatum)*, the purple marsh crab, shares its territory but is active only at high tides when the Atlantic marsh fiddler crab is in its burrow. The two eat different foods and so do not compete. Meanwhile, dozens of other crabs occupy other habitats nearby.

Sources: Grimes 1989; Salmon 1988.

Empty fiddler holes. The fiddlers will retreat into these holes and cover them when the tide comes in.

that the plants can take up (and grow still faster). The crabs' wastes also serve as fertilizer while the plants' detritus becomes food for the crabs, a relationship that benefits both. Each year the crabs completely turn over the top half inch of marsh mud, returning buried nitrogen to the surface.[7]

Fiddler crabs also break up the algae that grow on the surface of the mud. If undisturbed, algae would soon form a carpet so thick that it would halt other growth, but the fiddlers mix the surface at every low tide. In the process, they bury some algae, which smother, die, and become food for recyclers and fertilizer for marsh plants. The algae that remain on top are given space to keep on multiplying.

The crabs are not the kings of the marsh; rather, they are the prey of fish, birds, raccoons, and other eaters. From the hungry human point of view, this becomes of special interest when fishing boats using crab as bait return to shore loaded with red drum, sheepshead, and other prized catches. The white ibis, clapper rail, and many egrets and herons also thrive on

fiddler crabs. So do other fiddler crabs, blue crabs, and a dozen or so small hangers-on, including both harmful parasites and harmless freeloaders.

The Periwinkle Snail. While the fiddler crab copes with life in an alternately submerged and exposed environment by ducking into its burrow at high tide, the periwinkle snail stays just above the ebbing and flowing water by using plants as escape towers. The snail slowly climbs a plant, keeping just ahead of the incoming tide, which carries in hungry, shell-crushing blue crabs and other marine predators. At high tide, the snails all crowd at the tips of the plants, looking like a crop of white berries. They can thrive on the plants because a lush lawn of algae grows there.

Small Fish. An incredible abundance of small fish, specially adapted to salt marsh extremes, grow in the murky tidal creeks. More than 90 percent of the fish in tidal creeks and pools are tiny killifishes, mummichogs, and other minnows. Scoop up a net full of marsh water and you will find it jumping with little silver fish.

Killifishes can handle salt, brackish, and even nearly fresh water equally well. Storm surges inundate their habitat with pure salt water and they survive. Rainstorms pour in fresh water and they still survive. During hard freezes, they burrow into the mud, lie still, and await the next thaw to resume their busy lives. In Florida salt marshes a dozen or more species of killifish may occupy different aquatic habitats and live on different prey. They make excellent bait fish, because they are the normal food of the larger fish, and they are reliably there for belted kingfishers, great blue herons, and other fishing birds.

Amphibians and Reptiles. No amphibian can tolerate salt marsh environments the year around, but two species of frogs can conduct their life cycles in brackish and freshwater tidal marshes: the green treefrog and the southern leopard frog. Among reptiles, two snake species are especially well adapted for life in a tidal marsh environment. The rough green snake feeds and lives in brackish and freshwater tidal marshes along both coasts and eats soft-bodied invertebrates. The salt marsh snake lives in tidal marshes and mangrove swamps around the Gulf and along Florida's Atlantic coast. It is almost never seen: it is active only at night. It drinks only when fresh water is available as rain or dew. When there is no fresh water, the snake resists water loss and survives anyway. It feeds primarily on small fish, occasional crabs, and other small invertebrates.[8]

Other snakes, such as the banded water snake and the cottonmouth, cannot tolerate salt water but do live in brackish and freshwater tidal marshes. Three species of turtles also occur in Florida tidal marshes: the Alabama redbelly turtle, the diamondback terrapin, and the Florida cooter.

Birds. Three bird species also feed and breed in Florida salt marshes: the clapper rail, the marsh wren, and the seaside sparrow. All three also nest

RW

Periwinkle snail (*Littorina irrorata*). This animal finds a fresh crop of nourishing algae every time it re-climbs the stem of a marsh plant.

in the marsh, but do not compete for space. They require salt marshes, and in the case of the seaside sparrow, salt marshes with a certain hydroperiod and frequent burns. The seaside sparrow cannot live in any other habitat.

VISITORS TO THE MARSH

Visitors to the salt marsh far outnumber the permanent residents just described. They come in when the marsh can meet their needs and depart when conditions become inhospitable.

Visitors from the Sea. Gulf coast marshes support immense numbers of young ocean fish. In Florida's needle-rush marshes alone, a total of 90 species are reported. Fish find diverse food sources in the marsh's varied aquatic habitats: algae along plant stems, plankton and insect larvae in the water column, detritus on the bottom, and small animal prey both swimming and in burrows. Shrimp use the marsh as a nursery ground. Juvenile white shrimp enter tidal creeks, remain until they are about two inches long, then move offshore to spawn. Then the larvae reappear in the marsh.[9]

Figure 6–4 illustrates a few of the fish that depend on salt marshes for parts of their lives. For red drum, striped mullet, and many other fish, tidal creeks offer much more food than do neighboring coastal waters. After swimming up the creeks, red drum push their way over the berms and through the grasses to feed in the interior of the marsh, probing the bottom to extract fiddler crabs from their burrows, their tails thrashing the surface as they go.

Striped (black) mullet swim far up tidal creeks and feed on algae, detritus, and other tiny organisms. They remain in the marsh for most of their lives, going offshore only to spawn. They are major converters of plant detritus and algae to fish protein within the salt marsh and near-coastal system, and they occur in such large numbers that their collective impact is enormous. They can live in very low-oxygen systems, they stir up the bottom, assisting other fish in finding food, and they are eaten by most of the other fish in the system. They are also a major food source for dolphins and wading birds.

Like all others, fish populations in the salt marsh vary over both time and space. Fish diversity peaks in late summer and early fall. Populations in winter are different from those in summer. Migrants come through at some times of year and not at others. For example, in the marshes adjacent to one barrier island, Live Oak Island, five species were year-round residents, three were winter-spring residents, and three others were summer-fall residents. Day-night differences also occur, and so do high- and low-tide

Tarpon (*Megalops atlanticus*). A striking fish with huge scales, the tarpon spawns offshore but lives primarily inshore. Often some 50 pounds when caught, it can grow to nearly 250 pounds.

Striped mullet (*Mugil cephalus*). Striped mullet spawn offshore but the juveniles soon swim into salt marshes in enormous numbers when only an inch long. They feed on detritus and ultimately attain a size of about 3 to 6 pounds.

Gray snapper (*Lutjanus griseus*). Juveniles stay inshore in tidal creeks, mangroves, and grass beds. Adults move offshore over reefs and rock bottoms. Commonly 8 to 10 pounds, these fish can grow to about 15 pounds.

Red drum (*Sciaenops ocellatus*). Red drum stay inshore in estuaries until they are about 30 inches long, then move out to spawn offshore. At 30 inches they weigh about 8 pounds; they can grow to more than 50 pounds.

Gulf flounder (*Paralichthys albigutta*). Usually found inshore partly buried in sandy or mud bottoms, these fish probably spawn offshore. After the fish hatches, the right eye migrates over to the left side early in life. Gulf flounder typically weigh up to 2 pounds.

FIGURE 6–4

Fish that Depend on Salt Marshes (Examples)

These are only a few of the 100 or so species of ocean fish that depend on Florida salt marshes for parts of their lives.

Sources: Kruczynski and Ruth 1997; Anon. c. 1994 (*Fishing Lines*); drawings by Diane Peebles.

differences. Every fish species has its own behavior pattern and timing.

Wet-dry cycles also affect populations of animals such as fish and shrimp. Rainy times can turn the waters of a salt marsh completely fresh. Small fish and freshwater shrimp increase when marshes are flooded by rains. Then as water levels fall, the animals become highly concentrated in the remaining water. This makes them easy to catch, an advantage to birds that are rearing their nestlings at these times. But, thanks to their abundance, these times of intense predation do not present a great disadvantage to them. Many young survive, swim out of the marsh, and grow to maturity offshore. These dry times are not a great disadvantage to the species of fish and shrimp. Many young survive to swim out of the marsh and grow to maturity.

Other, larger ocean visitors that occasionally appear in tidal marshes. The West Indian manatee sometimes swims up tidal creeks to forage there; so do the bottlenose dolphin and the Atlantic ridley sea turtle. Two sharks, the sandbar shark and the bull shark, make thousand-mile migrations along the east coast, using salt marshes all along the way.

Visitors from the Air. Although the salt marsh is a required habitat for only three bird species, others can nest and feed there, and numerous visitors drop in. From nests in nearby forests, long-legged wood storks, ibises, herons, egrets, and in south Florida roseate spoonbills fly in to fish in the creeks and probe the bottom mud. Gulls, terns, and other shorebirds flock to the salt barrens to rest and feed. Hawks soar over the marsh and dive to catch small birds and rodents. Fish crows prey on the eggs of nesting birds such as seaside sparrows. Migratory bird populations peak in spring and fall when insects and spiders are most numerous. List 6–8 identifies a few of the species of birds that frequent Florida salt marshes and Figure 6–5 displays three of them.

Visitors from the Uplands. While fish and shellfish visit the marsh from the ocean, and birds visit from the air, terrestrial vertebrates visit from the landward edge of the marsh. The raccoon, river otter, southern mink, long-tailed weasel, marsh rabbit, marsh rice rat, cotton rat, and cotton

LIST 6–8
Bird visitors to salt marshes (examples)

More than 60 species of birds visit salt marshes.

Black-crowned
 night-heron[a]
Clapper rail[a]
Fish crow
Green heron[a]
Laughing gull[a]
Least bittern[a]
Marsh wren[a]
Northern harrier
Red-winged blackbird

(continued on next page)

Snowy egret (*Egretta thula*). This fish eater is a frequent visitor to salt marshes.

Black-necked stilt (*Himantopus mexicanus*). The stilt nests just above the high-water line in both interior and coastal marshes. When the waters rise, it frantically adds nesting material to keep its eggs above water.

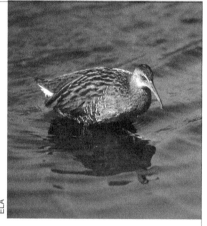

Clapper rail (*Rallus longirostris*). This bird feeds on fiddler crabs, worms, snails, insects, and other tidbits from the mud and grass. Its constant, loud, nonmusical *ticket, ticket, ticket* is plainly audible all over the marsh. It nests in medium-height vegetation at the high-tide line and when threatened it runs silently through the marsh grass, seldom rising to take flight.

FIGURE 6–5

Bird Visitors to Florida Salt Marshes

Black skimmer (*Rynchops niger*). Skimmers and their close relatives are the only birds with the lower mandible longer than the upper. They fly low, skimming the surface, and when they contact small fish, snap their bills shut. That they flourish around tidal marshes bespeaks the abundance of fish there.

mouse come in from coastal fields and forests. The eastern diamondback rattlesnake crosses tidal marshes and even open marine water to hunt for prey off the mainland and can swim as far as to offshore islands. The alligator swims from one water body to the next, stops to feed in tidal channels, and suns itself along the banks. The white-tailed deer crosses on its way from here to there, and nibbles on salty vegetation. The bobcat prowls into the marsh on occasion to ambush unsuspecting rats, mice, and birds.

TIDAL MARSH VALUES

Of all the ecosystems so far described, tidal marshes are among the richest in numbers and kinds of living things. Tremendous amounts of resources concentrate there. Rivers discharge fresh water and sediments into them, and together with ocean water, contribute many nutrients. Wind, waves, tides, and sunlight inject energy. The result is production of living matter that is among the highest per unit area for any known grassland.[10]

Salt marshes are as productive naturally as the agricultural fields that people cultivate most intensively, fields such as rice paddies and sugarcane fields. The ultimate harvest of marshes, though, is in the form of animals—not large grazers as in a terrestrial grassland, but small marine species that mostly stay hidden.

Salt marshes are critical to the survival of marine animals. Most are legally protected. Fisheries scientists vouch for their importance to sports and commercial fishermen. Between two thirds and nine tenths of all fish caught, as well as important shellfish such as shrimp and crab, are species that live in salt marshes for part of their lives, mostly as juveniles. Florida's marshes are especially significant to sea life because they are so vast (see Figure 6–6).

Besides their high rate of productivity and their importance as nurseries, tidal wetlands also serve as a natural defense system, protecting coastal land from high tides, winds, and waves. A hurricane may smash seawalls,

LIST 6–7 (continued)

Saltmarsh sharp-tailed
 sparrow
Seaside sparrow[a]
Snowy egret
Sora
Tricolored heron[a]
Virginia rail[a]

Note: [a]These birds occasionally nest in salt marshes. Others usually nest elsewhere and visit salt marshes to forage.

Source: Hubbard and Gidden 1997, 334–336.

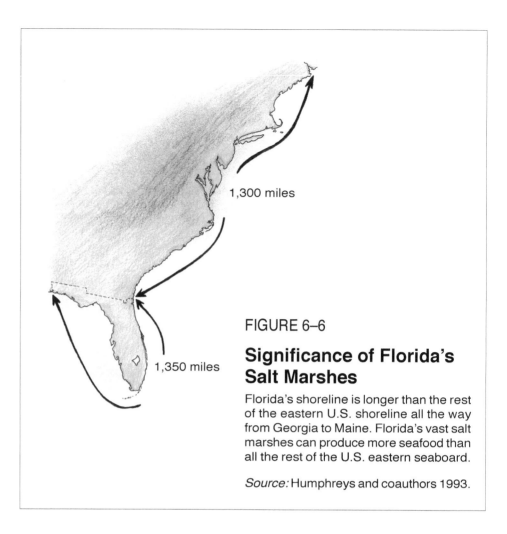

1,300 miles

1,350 miles

FIGURE 6–6

Significance of Florida's Salt Marshes

Florida's shoreline is longer than the rest of the eastern U.S. shoreline all the way from Georgia to Maine. Florida's vast salt marshes can produce more seafood than all the rest of the U.S. eastern seaboard.

Source: Humphreys and coauthors 1993.

rip out dikes, and knock down whole forests, but a natural salt marsh may barely be disturbed. It quietly goes on creating and recycling detritus and, in the process, feeding and sheltering a myriad of marine organisms.

Tidal marshes are also natural purifiers and recyclers. They filter water that runs off the land, releasing it clean to seagrass beds and estuaries. On a global scale, they help return sulfur and nitrogen to the atmosphere in the mighty cycles that keep these elements available to the planet's living systems. And they export materials to adjacent marine habitats. Although some materials settle into sediments and some are taken up by the marsh's own plants, animals, and microscopic organisms, other materials depart with outgoing tides and become important resources in seagrass beds and open marine waters (next chapters). The value of seawrack on beaches has already been described—and seawrack, of course, comes mostly from tidal marshes. Tides lift from the marsh floor fine particles of detritus from needle-rush and cordgrass decomposition and carry them away on the surface as an oily slick to nourish estuarine and marine life farther offshore.[11]

Salt marsh, St. Marks National Wildlife Refuge, Wakulla County. The moon, high in the sky, looks tiny, but together with the sun it governs the tides, which in turn govern all life in the marsh.

To contemplate a tidal marsh with understanding is to be awed at its antiquity, at all the interdependent relationships within it, and at its connections with other ecosystems. To preserve a tidal marsh, it is necessary to maintain the health of the whole landscape mosaic of which it is a part, both terrestrial and marine. The rewards are many, not least the bounteous harvest of seafood that results.

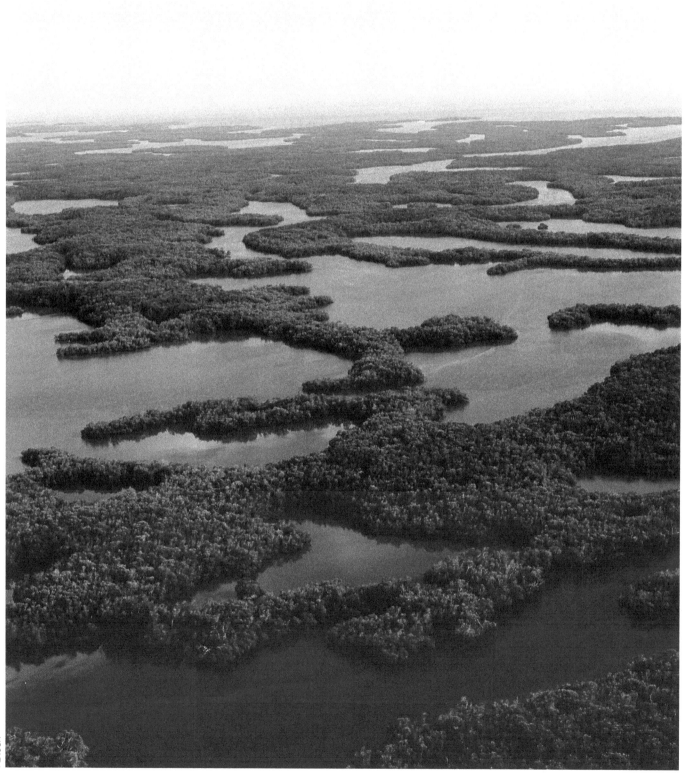

CHAPTER SEVEN

MANGROVE SWAMPS

Something green is bobbing up and down in gentle, shallow swells off a peaceful south Florida shore. It looks like a long, fat cigar floating one end up, with the other end ten inches below the surface. What is it? Where did it come from? Is it alive?

In another month, the answers will be clear: it is a mangrove embryo, dropped from a tree along the shore. As it drifts in shallow water on the outgoing tide, its tip punctures the bottom sediments and sticks there, perhaps stabilized by a bed of marsh or seagrass already present. In the next days it sprouts arching roots and fat, succulent leaves, and begins to become a tree. Floating debris snags among its roots and an island begins to form.

After several hundred years, the original tree will be surrounded by a big mangrove island on a deep bed of silt and peat.. The island may be several hundred acres in size and hold many brackish lakes in its interior. Hundreds of species of bacteria, fungi, algae, and tiny invertebrates will busily process detritus from the leaves, stems, and roots of the mangroves and from the droppings of crabs, snails, snakes, and birds that live in the trees. Numerous, diverse fish will dart and dodge among the underwater roots, and hordes of worms and other unseen creatures will sift their livelihoods from the sediments below. Besides supporting myriad residents, the swamp will also serve as nursery grounds for a host of fish and birds who emigrate to the outside world to live out most of their lives.

Mangroves grow along tropical shores the world over. They thrive where the land is level or gently sloping, the waves are insignificant, and the tidewaters flow far in and far out every half day. Gentle waves permit mangrove seedlings to root, and leave fine sediments in place, whereas rough waves snatch up seedlings before they can take hold and wash away fine sediments. Figure 7–1 shows the Florida distribution of mangroves and Figure 7–2 shows the types of communities they form.

A **succulent** plant is one that has thick, fleshy leaves and/or stems that are adapted for storing water. Succulents typically grow in deserts (cactuses are examples) and in salty environments (saltwort and glasswort are examples).

Black mangrove (*Avicennia germinans*). The seedling has just broken through its case and begun to sprout. The "cigar" lying in front of it is a red mangrove seedling that did not survive.

OPPOSITE: The Ten Thousand Islands along the southwest coast of Florida. Exploring these mangrove islands can entail a several-day canoe trip.

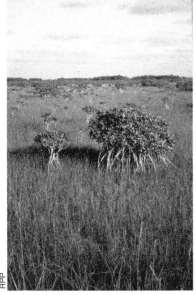

Red mangroves in the Ever-glades. Where fresh water first begins to encounter salt water, sawgrass begins to give way to mangroves.

FIGURE 7–1

Florida's Mangrove Swamps

Mangroves grow wherever wave action is moderate: along low-energy coastlines and in inlets along rivers inshore from high-energy coastlines. Temperatures below freezing and temperatures above 100 degrees inhibit their growth. They grow as shrubs along short stretches of the Florida Panhandle, but flourish as trees south of Cedar Key on Florida's west coast and south of Cape Canaveral on the east. Along these shores, they form a band that occupies some 470 to 675 thousand acres, and some stretches are twenty miles wide.

Cedar Key

Cape Canaveral

Sources: Toops 1998, 17; Odum and coauthors 1982, 1–2; Odum and McIvor 1990.

The term **mangrove** can refer to any of some 50 species of trees and shrubs that grow in saline soil world-wide. Three are common in Florida: red, black, and white mangrove. A fourth, buttonwood, is sometimes counted as a mangrove, also. A *mangrove swamp* is a tidal wetland dominated by saline-tolerant trees and/or shrubs.

MANGROVES: MASTERS OF ADAPTATION

Mangroves are especially notable among trees for their adaptations to saline soil, but they contend with many other challenges in their environment. Like the plants in salt marshes, they grow on shifting, sulfurous, waterlogged ground, in water that rises and falls daily and in some areas oscillates between salty and fresh. The water is often low in nutrients and oxygen, and often stained dark, especially following storms.

Two mangrove species dominate Florida's tidal swamps: red mangrove and black mangrove. They hold on well in shifting substrates and thrive despite the oxygen-poor soil. Because lack of oxygen limits root growth to within a few feet of the surface, they have no deep taproots to help them withstand hurricanes, but they produce extensive, interlaced, horizontal root nets that keep them anchored in all but the most powerful winds and waves. Each species also grows special organs that enhance its oxygen-gathering ability (see Figures 7–3 and 7–4).

Survival in salt water is a mangrove's specialty. No mangrove can exclude salt perfectly, and salt does accumulate in the trees' tissues, but the plants

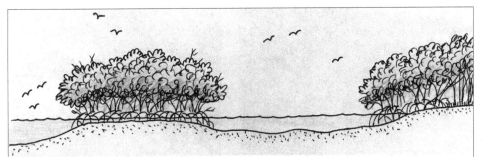

Overwash forest. Some mangroves grow on bars and islands, and water washes over their roots at every high tide.

Fringe forest. Some mangroves grow on the fringes of the land in the intertidal zone.

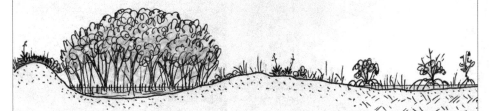

Basin forest. Some mangroves grow along coastlines in basins that are frequently washed out by tides.

Scrub forest. Some mangroves grow in interior basins whose water is seldom washed out by tides. These become sparse, dwarf mangroves.

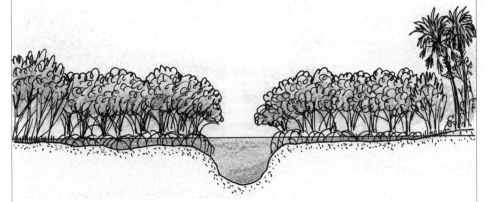

Riverine (rhymes with *fine*) forest. The most extensive mangrove swamps grow along river estuaries on level land where tides travel far in and far out every day.

FIGURE 7–2

Mangrove Community Types

Mangrove communities vary in appearance. Along the Shark River in the southeastern Everglades, red, black, and white mangroves together with buttonwood trees grow to more than 60 feet in height and form a dense, dark forest. On marl prairies in the same part of Florida, dwarf mangroves are less than 5 feet tall and sparse, even though they may be more than 50 years old.

Sources: Drawing adapted from Odum and coauthors 1982, 8, fig. 4; information from Odum and McIvor 1990; Kangas 1994.

concentrate salt in their leaves and then discard the leaves one by one, all year long, returning salt to the environment. Continuous evaporation of water from the leaves draws fresh water up from below. Each species also has additional strategies to manage salt. For instance, the red mangrove

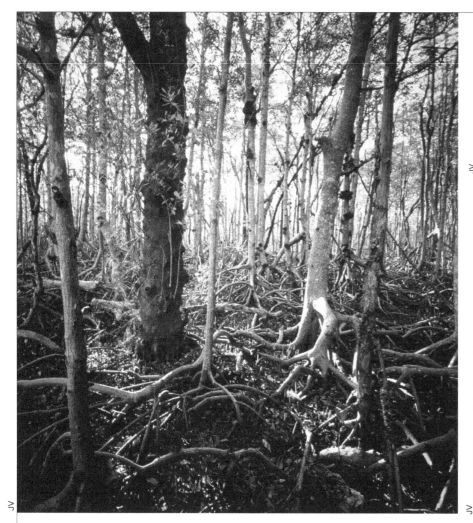

Red mangrove prop roots.

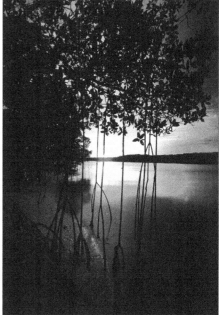

Red mangrove drop roots.

FIGURE 7–3

Red Mangrove (*Rhizophora mangle*)

The large tree (in the mid-left) is a black mangrove; the others are red mangroves. Red mangrove grows best in frequently flooded, "low marsh" zones, although it can tolerate long dry spells during the seasonally low waters that occur in south Florida in spring. It grows to some 80 feet in height and its trunk may be 7 feet around.

Red mangrove roots form a tangle that holds the tree fast to the ground. The tree's prolific "prop roots" arch from its base to three feet above the bottom mud and extend out around the trunk well beyond the branches. Roots from its branches, "drop roots," penetrate just an inch or two into the soil. These aerial roots have spongelike internal tissues that allow oxygen to diffuse downward to the lower roots. Red mangrove also has breathing pores (lenticels) in its lower trunk like those in freshwater wetland plants. The lenticels let oxygen in at low tide, and exclude water at high tide.

Sources: Toops 1998, 72; Odum and coauthors 1982, 1–2.

A mangrove seed becomes a seedling before it leaves the parent tree. It is called a **propagule** (PROP-a-gyule), because it propagates the species through dispersal.

excludes the most salt at its root surfaces by means of a powerful filtration system. The salt in red mangrove sap is at 1/70th the concentration in the surrounding water, but ten times that in land plants. In contrast, black mangroves reduce their salinity by secreting a white bloom of salt crystals from the undersides of their leaves. You can rub your finger across a leaf and taste the salt. The salt concentration in their sap is 1/7 that in sea water. Still, the salt burden becomes too heavy in some places, even for

Black mangrove leaves. The leaves constantly pump salt out of their tissues, reducing the salt concentration of the tree's internal fluids.

FIGURE 7–4

Black Mangrove (*Avicennia germinans*)

Black mangrove grows best in infrequently flooded, "high marsh" habitats, although it can tolerate season-long flooding during fall's high waters in south Florida. It grows to some 60 feet in height. The tree has long "cable roots," that extend outward from the trunk some two to three feet down into the bottom sediments. The cable roots put up a bristly miniature forest of many vertical, pencil-thin poles which not only conduct air to the lower roots but help to aerate the surrounding substrate.

The breathing pores are called pneumatophores (new-MAT-o-fors). Pneumatophores greatly inhibit pedestrian explorations, especially when the explorer is trying to wade through the swamp at high tide.

Sources: Douglas 1947; Toops 1998, 72; Odum and coauthors 1982, 1–2.

mangroves to tolerate. There are salt barrens among mangroves as there are in salt marshes.

Just as adaptations of the roots and leaves enable mangroves to flourish, the design of their offspring enables them to begin to grow in the withering brine where they must take root. Mangroves don't produce seeds as such, they produce propagules—whole embryos, buoyant and succulent, that are nearly ready to root even before they leave the parent tree.

Thanks to these adaptations, mangroves not only thrive in their present habitat but take over new territory wherever it becomes available. Like seaoats on beaches and dunes, mangroves help to form and stabilize the land they grow on. New seedlings start up most easily on silt or clay that already contains organic matter, but they can do without it at first.

After taking hold, mangroves demonstrate still more competitiveness by altering the ground they have claimed, making it less hospitable to other species. They shed abundant litter, including some of their fine rootlets, which break off in the shifting substrate and partially decompose in the wet sediment, turning to peat. The acidic peat then dissolves the underlying limestone rock, so the peat layer grows both downwards and upwards. As

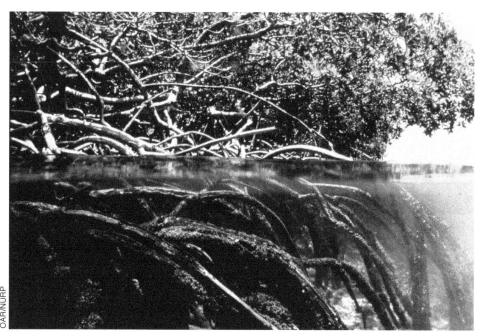

Mangrove ecosystem. The whole system, visible here, is part under water and part above, with rising and falling water connecting the two parts.

a mangrove island enlarges over time, its peaty substrate becomes a layer several meters deep.

Once mangroves have begun to take over a site, their elaborate, widespread root systems trap additional sediments. The litter they drop continuously releases nutrients as it decomposes. The branches attract birds and other animals to roost and nest, and their droppings add fertilizer to the soil.

The substrate is further altered by algae, bacteria, fungi, and small invertebrates. These organisms devour oxygen, nitrogen, and phosphate, making the sediment low in oxygen, acidic, sour with hydrogen sulfide, and hot: essentially, a place only a mangrove would love.

Once they have altered the environment, mangroves live easily between the high and low tides—and the tides do a lot for them. As in tidal marshes, alternate wetting and drying helps to eliminate less well-adapted species. Tides bring in fresh nutrients, wash away wastes, refresh water that has grown salty from evaporation, and carry off detritus that would otherwise accumulate in excess. Incoming tides push floating mangrove propagules up river estuaries where they can lodge and enlarge riverine forests. Outgoing tides disperse them along estuarine shores, where they form fringing forests. Ocean currents may carry them far from Florida. They may float for as long as a year and travel for thousands of miles, finally taking hold on tropical shores in Africa or South or Central America.

ENERGY FLOW THROUGH THE MANGROVE COMMUNITY

The physical structure of a mangrove swamp creates a rich environment in which many other living things can find niches. Leaves, bark, branches, prop roots, underground roots, and the sediments surrounding them all offer different kinds of spaces. Thanks to their complex geometry, mangrove communities are among the most densely populated ecosystems on earth. An ecologist says, "It's all about structure." And where many creatures can reside, a complex food web can develop. This section first examines the role of detritus in the mangrove ecosystem, then moves on to explore the mangrove swamp's living creatures, both small and large.

As in salt marshes, detritus drives the ecosystem—in this case, from tree litter: leaves, bark, and wood. Litter decays fast in brackish and salt water. The process is jump-started by shredder organisms such as crabs and amphipods, and is accelerated by alternate wetting and drying conferred by the tides. The result is tons of plant material mixed with the droppings of insects and other animals. Not all swamps have been studied, but red mangrove swamps along rivers produce two pounds of detritus per square meter every year, or about 4 tons per acre. This detritus is the main material in a food web that, as in salt marshes to the north, is believed to nourish up to 90 percent of the area's sports and commercial fisheries.[1]

Microscopic Life among Mangroves. Detritus fluxes through the unseen life of mangrove systems very much as it does through tidal marshes. Each time a mangrove leaf drops into the water, fungi attach to it and grow a network of fine filaments all through its tissues, where they digest its stored carbohydrates. Multitudes of algae, bacteria, fungi, and other microscopic organisms soon mingle with the fungi on the leaf and form a community in which each finds the nourishment it needs and each produces wastes that another can use. A crowd of small animals joins in, and the leaf becomes a slime-coated raft carrying tiny worms and crustaceans—minute animals that an observer describes as "little more than huge stomach pouches attached to eyespots and mouths," an efficient microscopic disassembly line. The names of the workers read like the cast of characters in a Greek opera, but with a cast of thousands. To provide just a glimpse of the system's complexity and order, List 7–1 presents just the marine fungi that digest shed mangrove leaves. Other fungi with equally exotic names coat living leaves, stems, branches, and submerged roots at each stage of a mangrove tree's life.

Communities of algae in the mangrove system are equally orderly and complex. Coats of algae on prop roots and on the swamp floor mud are so thick that the Florida Natural Areas Inventory considers them communities, equal in status to tidal marshes and swamps. They have their own

Detritus. The base of the food web in a mangrove system is the shed parts of trees. Here, red mangrove leaves are decaying; and a smooth bubble alga (in the exact center of the photo) is growing on some of the products.

Brown shrimp (*Penaeus aztecus*). The young shrimp can make a good living amidst mangrove debris.

predictable structures. In sunny locations on the swamp's ocean-side edges, each prop root may support nearly a pound of algae arranged in strata. Starting at the top of a tree, four genera (which may include dozens of species of algae) grow on the exposed, above-water trunk and branches. Algae that are members of another genus make up that bright green band (which everyone sees, but no one notices) that grows around the roots at the high-water line. Below that line, between the high- and low-tide lines, are algae of three other genera. Last, on the roots that are in permanent water below the low-tide line, still other algae grow. It is clear that each algal species has its own preferred habitat and plays particular roles in the complex living system that surrounds mangrove roots.

And that is by no means the end of the cast of algal characters. Red mangroves have one team of algae; black mangroves have another. The prop roots (as distinct from the tree trunk and roots) have their own team—in fact, several teams of algae: some on the permanently submerged portions, some on the moist parts, some on the sediments around the roots. These algal teams include diatoms, dinoflagellates, filamentous green algae, and blue-green cyanobacteria. Black mangroves have other algae on their roots. Away from the roots, on shoals, floors of shallow bays, and creek bottoms near mangrove swamps, are still other algae. Their proportions differ regionally from Tampa Bay to south Florida. In sum, the distribution of these plants, although not simple, is very orderly.

Floating algae (phytoplankton), too, are numerous and diverse. Waves and currents mix marine, estuarine, and freshwater phytoplankton all together, permitting energy to flow efficiently through the food web.[2]

Invertebrates. Many kinds of invertebrates use mangrove communities to meet their needs: sea worms, sea snails, shrimp, crabs, and others. Some live in the muddy substrate; some on or in the mangroves' prop roots. Some live above the water's surface among the branches and leaves; and some high in the treetops. Some come out at high tide; others, at low tide. Some emerge only by night; others, by day; and still others, not at all. Each contributes uniquely to the energy economy of the mangrove system.

Hordes of insects populate the mangrove swamp. The red mangrove is the larval host plant of the mangrove skipper butterfly. The red mangrove gets nothing in return for providing the larva with food, but after the caterpillar metamorphoses into a butterfly, it pollinates the tree's flowers. This is one of many instances of coevolution—the process by which advantages accrue to both: the flowers get pollinated and their insect pollinators get food, so that both acquire advantages over their competitors. Other pollinators include moth and butterfly larvae, grasshoppers, and crickets. On some overwash mangrove islands in the Keys, more than 200 species of insects have been counted. These insects busily cut leaves, eat leaves, eat

each other, and export frass (insect droppings). One kind of moth larva develops entirely within the mangrove leaf (at the expense of the leaf). One kind of beetle attacks propagules while they are attached to the tree.

Some invertebrates dwell within the living prop roots of mangroves. The wood-boring isopod, a species of crustacean, inhabits red mangrove roots. It lays its eggs and its juveniles develop, all within the roots. Fungi and bacteria follow this invasion, and the roots may ultimately be severed. On occasion, this will kill a whole tree, but sometimes it stimulates root branching and makes the tree stronger. Either way, the community benefits, because both dead and live mangroves contribute products and services of value to the community.[3]

On and around the prop roots are other invertebrates. Coffee bean snails average 150 individuals per square yard, but may number 500 per square yard among frequently inundated red mangroves. Other snails number at least 400 per square yard among black mangroves. The prop root complex also serves as a spiny lobster nursery. The young lobsters settle in among the roots and grow there until they are about two inches long.

The substrate around the prop roots supports other thriving communities. Fiddler crabs and several other crab species dwell in the bottom sediments and creep out to forage on exposed mud flats when the tide is out (see Figure 7–5). Others emerge while the tide is in, particularly at night.

Medusa worm (*Eteone hetero-poda*). This worm obtains its nourishment by filtering detritus from the water.

Mud crab (*Scylla serrata*).

Great land crab (*Cardisoma guanhumi*).

Purple marsh crab (*Sesarma reticulatum*).

FIGURE 7–5

Crabs among Mangroves

These are hree of many crab species that use the mangrove habitat.

Some invertebrates climb to, or live in, the canopy to feed or escape high tides. The mangrove tree crab climbs red mangroves—a surprise to unwary explorers who don't expect to see crabs at eye level. About a dozen mangrove tree crabs occupy each square yard at the edges of mangrove swamps; about half that many in the interior. The crabs are omnivorous, eating insects such as caterpillars and beetles, as well as living mangrove leaves. Mangrove tree crabs are an important food source for birds, fish, and other predators. Finally, of course, many invertebrates swim and drift in the water column: crabs, shrimp, and their larvae; worms and worm larvae; and infant fish.

In sum, the community includes a tremendous mixture of invertebrates—even more than in salt marshes, thanks to the more complex structure of the vegetation which provides more microhabitats and niches to occupy. Some of these animals graze on the mangroves, some filter the water, and some sneak up on others and snatch them up as snacks. With all the life milling about beneath the mangroves, it should come as no surprise that fish are numerous, too.

Fish among Mangroves. An astonishing 220 species of fish use mangrove communities; Figure 7–6 shows just six of them. The mangrove swamp serves fish in two main ways. Prop roots provide protected habitat for juveniles; and the leaves, together with phytoplankton, algae, seagrass litter, and litter running off the land, support a giant food web for them. Silvery schools of striped mullet swim through the detritus-laden waters and suck mouthfuls in, converting the detritus to masses of mullet. Larger fish, such as snook, snapper, and spotted seatrout, eat the mullet. Fish populations among mangroves vary with substrate (clay versus sand), salinity, temperature, and frequency of flushing.

Fish populations of different kinds of mangrove swamps differ in composition. In basin mangrove forests on the southeast coast, where black mangroves predominate and the substrate is clay, several species of small fish live out their entire lives in waters so acidic and so seldom refreshed by tides that most fish would perish there (see List 7–2). Occasionally, high spring tides or seasonally heavy rains wash tons of these little fish out into coastal ecosystems, where they become food for snook, ladyfish, tarpon, gar, and mangrove snapper. At the opposite extreme, when the fishes' pools shrink, herons, ibis, wood storks, raccoons, mink, and others prey on them.

In contrast, riverine mangrove forests on the southeast coast, where red mangroves predominate and renewing tides flow far in and out twice daily, support ladyfish, striped mullet, and others. These forests lie between south Florida's freshwater marshes and the shallow brackish and saltwater bays and lagoons along the coast. They vary greatly in salinity and in fish populations. In wet seasons come rains that make them altogether fresh. Fish swim in from interior sawgrass and needle-rush marshes and swim

LIST 7–2
Fish among mangroves (examples)

In basin mangroves

Killifish and relatives
Goldspotted killifish
Mangrove killifish
Marsh killifish
Sheepshead minnow

Livebearers
Mosquitofish
Sailfin molly

In riverine mangrove swamps

Year-round
Ladyfish (a tarpon)
Striped mullet
Yellowfin mojarra

In wet seasons
Florida gar
Freshwater catfishes
Freshwater killifishes
Largemouth bass
Sunfishes

In dry seasons
Goliath grouper
Great barracuda
Jacks
Needlefishes
Stingrays

Source: Adapted from Odum and coauthors 1982, 51.

Cobia (*Rachycentron canadum*). Cobia swim inshore and near the shore in inlets, bays, and mangrove swamps, feeding on crabs, squid, and small fish. They commonly grow to 40 pounds or more.

Fat snook (*Centropomus parallelus*). These fish stay inshore among mangroves, which are their nursery grounds, seeking weakly brackish to fresh water. They seldom grow to more than 20 inches in length.

Mutton snapper (*Lutjanus analis*). Young snappers stay inshore, in mangroves and grassbeds, feeding on fish, crustaceans, and snails. Adults move to offshore reefs and commonly grow to about 15 pounds.

Common snook (*Centropomus undecimalis*). Snook swim inshore in fresh, brackish, and saline coastal waters along mangrove shorelines from central Florida south. They feed on fish and large crustaceans and weigh 5 to 8 pounds when mature. They can continue to grow to more than 50 pounds.

Tarpon snook (*Centropomus pectinatus*). These snook swim inshore in south Florida, frequently in fresh water, feeding on small fish and larger crustaceans. The young fishes' nursery grounds lie along mangrove shorelines. They grow to about a pound or less.

Swordspine snook (*Centropomus ensiferus*). These snook inhabit Florida's east-coast estuaries as far north as the St Lucie inlet, seeking weakly brackish and fresh water. Mangrove shorelines are their nursery grounds. They weigh less than 1 pound when mature.

FIGURE 7–6

Marine Fish among Mangroves

These fish spend their young lives in mangrove communities.

Source: Anon. c. 1994 (*Fishing Lines*); drawings by Diane Peebles.

among the mangroves: Florida gar, sunfishes, and others. Dry seasons reverse the water from fresh to salty, and then saltwater species come in from offshore: grouper, stingrays, needlefishes, jacks, and barracuda. (Many whole families, whole sets of genera, of fish live in riverine mangrove communities and associated tidal streams and rivers.)

In the mangrove forests on the western shore of Biscayne Bay, seagrasses grow densely, the water is more saline, and there are coral reefs nearby. Fishermen catch grunt, bonefish, snook, and snappers.

Fish populations in mangrove communities change from season to season with the water's temperature. Cold water drives some fish offshore to deep waters: lined sole, hogchoker, big-head sea robin, and striped mullet. Warming waters of spring and summer bring a rise in juveniles following offshore spawning: striped mullet, gray snapper, sheepshead, spotted sea trout, red drum, and silver perch. Riverine mangrove forests are the fishiest of mangrove habitats, supporting a large standing crop of fish the year around. Any single tidal stream in a mangrove swamp supports about 50 different species over the year, and taken together, all the tidal streams host 111 species. (Recall that all of this begins with mangrove detritus.)

Source: Adapted
from Odum and
coauthors 1982, 61–71,
appendix d.

Fringing forests along estuarine bays and lagoons, fringes along ocean bays and lagoons, and overwash islands, all are slightly different. All produce many fish of importance to local food webs as well as to sports and commercial fisheries.

Bird Life in the Canopy. When birds eat fish, detritus energy becomes airborne—many times transformed and no longer recognizable as rotten leaves from tidal swamps. It becomes pelicans, herons, ospreys, eagles, and more. The fruits and insects in the mangrove swamp, as well as the trees' tangled, strong branches, attract numerous birds to feed, to breed, and to rear their young. What better place could there be for a family of nestlings than a thick clump of sturdy trees underlain by water, where predators find hard going? List 7–3 hints at their diversity, but no single page can do them justice. Figure 7–7 shows only three of them.

Earlier chapters showed what great rookeries freshwater swamps can support. The same is true of mangrove swamps. The many roosting and nesting places they provide, together with the gentle, shallow waters beneath them, invite all manner of birds to probe, wade, surface-feed, dive, perch, and fly about. On Lee County's Sanibel island alone, 92 bird species have been recorded among the mangroves, and altogether, some 181 species use Florida mangroves in one way or another. Clearly, mangrove communities can support a great mob of winged creatures.

Mangrove-clad ocean islands make bird sanctuaries that are far superior to the tree islands in the Everglades. The Everglades tree islands lie in a freshwater marsh, which is accessible to snakes, raccoons, alligators, and other predators, but the mangrove islands are surrounded by ocean water. As a result, they are largely predator free, a great advantage in a bird nursery. Wading birds maintain giant nesting grounds on some mangrove

USFWS

Snowy egret (*Egretta thula*). Thick mangrove greenery provides excellent shelter for breeding birds as well as fruits and insects for food.

American white pelican (*Pelecanus erythrorhynchos*).

FIGURE 7–7

Birds among Mangroves

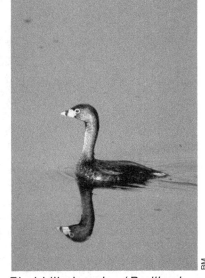

Pied-billed grebe (*Podilymbus podiceps*).

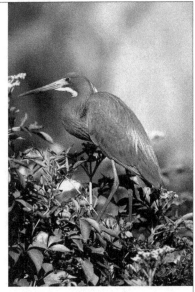

Tricolored heron (*Egretta tricolor*), an adult in breeding plumage.

islands. There may be thousands of roseate spoonbills, herons, and egrets all clustered together in a single swamp.[4]

Wading bird rookeries are messy, noisy places. Huge nests are stacked all over the treetops where a confusion of comings, goings, and awkward landings prevails. Masses of guano carpet the ground. The stink of regurgitated food and of the decomposing bodies of fallen baby birds is everywhere. The air is loud with the din of squawking, hungry youngsters and the buzz of busy flies. But they are safe nurseries, and parent birds fight aggressively to secure nesting places in them.

Mangrove islands offer another major advantage to parent birds: they can feed nearby in the shallow bays and lagoons. Low tides expose abundant fish that make easy prey. Fiddler crabs swarm over the mud flats. The birds share the resources. Brown pelicans eat estuarine fish; great blue herons eat fiddler crabs, sardines, herrings, and mullet. White-crowned pigeons nest on small mangrove islands in Florida Bay and nearby, and breed and feed in the Florida Keys and on the extreme southern tip of Florida. They seek out large hardwood hammocks where they can feed unmolested on the seeds and fruits of tropical trees and shrubs.

The integrity of the landscape—or, in this case, the land-and-seascape—proves a crucial factor to breeding birds. To succeed at growing up, breeding, and raising the next generation of their kind, birds need protected nesting places and nearby feeding grounds just as people need crime-free neighborhoods near grocery stores and shopping. Try to establish the birds where one of these parts of the landscape mosaic is missing, and their survival will be at risk..

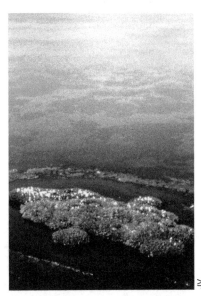

Egret rookery, Cuthbert Island, Monroe County. Nesting birds are so numerous, they look like a dusting of snow.

Ornate diamondback terrapin (*Malaclemys terrapin macrospilota*). The terrapin nests on sandy berms in tidal wetlands and buries its eggs at the high-tide line. When the tide is in, it scouts watery channels, feeding on carrion, green shoots, fiddler crabs, and other crustaceans. At night, it completely buries itself in the sand.

FIGURE 7–8

Amphibians and Reptiles in Mangroves

Mangrove salt marsh snake (*Nerodia fasciata compressicauda*).

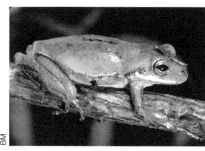

Squirrel treefrog (*Hyla squirella*).

Migratory raptors also use mangrove swamps, and for the same reasons. The peregrine falcon, red-shouldered hawk, red-tailed hawk, American kestrel, and others all find indispensable food, shelter, and rest in stopover places in the Keys.

Other Animals. To complete the array of animals using mangrove swamps, 24 species of amphibians and reptiles and 18 species of mammals are common (see List 7–4, List 7–5, and Figure 7–8). Amphibians are rare because they cannot withstand the dessicating effects of salt water. However, the squirrel treefrog occurs in some mangrove swamps. Young loggerhead and Atlantic ridley sea turtles hide among mangrove roots during their early lives. Green turtles feed on roots and leaves. Hawksbill turtles eat all parts of red mangroves: fruits, leaves, bark, and roots.

Among reptiles, the green anole lives on trunks and in treetops and six species of snakes glide among the roots. One, the mangrove salt marsh snake, is completely dependent on mangrove habitats. In addition,

The American crocodile (*Crocodylus acutus*)

American crocodile (*Crocodylus acutus*). Crocodiles inhabit brackish, mangrove-lined waterways at Florida's southern tip. After laying her eggs, the female stays nearby, and both male and female guard the hatchlings. Young crocodiles die in salt water, but adults swim long distances in the ocean.

Crocodiles and alligators are both reptiles, but differ in many ways. Most obviously, the alligator's snout is broad and flat, whereas the crocodile's is longer and narrows to a point at the tip. The crocodile is endangered: fewer than a thousand remain in the wild in Florida. The wild alligator population is estimated at about 1.5 million.

both the alligator and the crocodile use mangrove swamps. While the alligator is common throughout Florida, the crocodile is increasingly rare. Undisturbed red and black mangrove thickets may be critical breeding places for the crocodile.

As for mammals, you might not think that foxes, bears, and skunks would find it easy to maneuver among tangled mangrove roots, but the eating is so good as to make it worth the trouble. Some panther sightings occur in mangrove swamps, too. Even the white-tailed deer often visits, picking its way daintily among the roots and feasting on the leaves.

Value of Mangrove Communities

Imagine what Florida's southern shores would be like without mangroves. Without mangrove trees to nest in, the diverse arrays of birds that raise their young in the swamps would be gone. Without the rich detrital soup made from mangrove roots and leaves, uncountable tiny recyclers would die out, depriving hordes of shellfish and fish of their nourishment, so that they too would disappear. When storms swept the coast, the great peat beds on which the mangroves grow would be eroded away. Winds and waves would scour the coast and eat into the interior. Faraway ecosystems, too, would be disrupted. The Everglades marshes in the interior would suffer saltwater intrusion and the offshore waters of Florida Bay would be less well protected from pollution. The once-great schools of mullet, snook, snapper, and red drum would dwindle and life around south Florida's coral reefs would lose diversity. Fishermen and tourists would not longer be attracted there.

Ecologists say that to manage mangroves wisely means simply to let them grow: "Bottom line: don't trim mangroves at all."[5] Mangroves themselves, undisturbed, are better managers of south Florida's coastal and offshore environments than any human-contrived system could be.

Passage into Florida Bay through overarching mangroves.

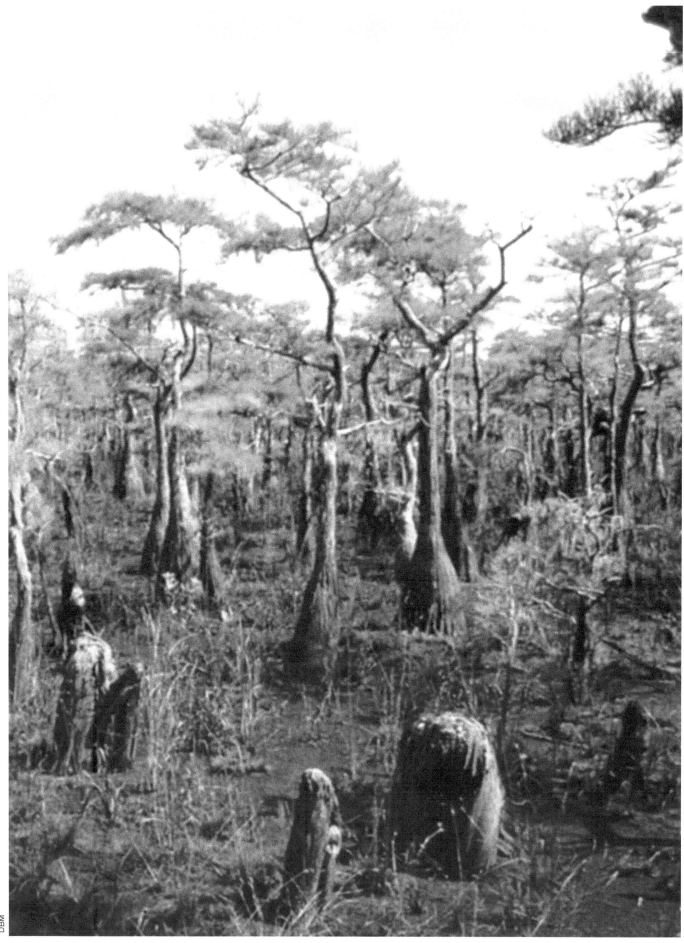

CHAPTER EIGHT

THE PAST AND THE FUTURE

Florida today has thousands of species of plants, animals, and other living things in dozens of living communities. How did they all get here? To trace them to their origins, we must travel back many millions of years—a journey worth taking, because it reveals how immensely valuable and irreplaceable they are. Some of the photos in this chapter depict "next generation" members of native Florida species—the eggs of a salamander, the seeds of a mangrove, and the like. The intent is to call attention to the vulnerability of our native species and the importance of taking care of their environments.

Where should we begin this journey? Must we go back 25 or 35 million years, to the time when Florida first appeared above sea level at its present location? Or 65 million years, when a tremendous extinction opened the way for the evolution of so many of today's species? Or 250 million years, when the Florida platform was forming beneath the sea on the northwest corner of Africa? Or 550 million years ago, when the first, many-celled ancestors of our Florida species, were swarming in the oceans?

The story goes back farther. Living things were present in the early seas at least three *billion* years ago and every organism now alive has a history that begins with the origin of life on Earth. In fact, everything alive today takes its start from the explosion-into-being of the entire Universe, some *fourteen* billion years ago, when the atoms and molecules of which everything is made were formed.

This narrative skips those early stages and begins at the start of the Cenozoic Era, the era in which we live. Background Box 8-1 shows how the Cenozoic is divided into periods of significance to Florida history. By any standard, it is clear that Florida's rich heritage of natural ecosystems and native species has a history millions of years long.

DBM

Coralroot orchid (a *Corallorhiza* species). This very rare, terrestrial orchid, photographed in the Apalachicola National Forest, is part of Florida's rich inheritance from the past.

OPPOSITE: Stunted cypresses on silty soil in Franklin County. Wetlands like this have ancient origins.

Historians of Earth's long time periods use **mya** to refer to "million years ago." Once the times involved become numbered in the thousands of years, they use **ybp**, meaning "years before the present."

Time Periods since the First Many-Celled Organisms (550 mya)

Three eras span the last 550 million years—the Paleozoic, Mesozoic, and Cenozoic eras. Details are shown only for the last of the three, "our" era. Florida's terrestrial history begins in the late Oligocene and continues through the Miocene, Pliocene, and Pleistocene epochs.

All spans of time used here are rounded off roughly. For purposes of this treatment, only the durations and approximate starting and ending times are important.

PALEOZOIC ERA (540 to 250 mya)

MESOZOIC ERA (250 to 66 mya)

CENOZOIC ERA (66 mya to the present)

Tertiary Period	Millions of years ago (mya)
Paleocene epoch	66–56
Eocene epoch	56–34
Oligocene epoch	34–23
Miocene epoch	23–5
Pliocene epoch	5–2.6

Quaternary Period

Pleistocene epoch (2.6 mya to 11,700 ybp)

Holocene (Recent) epoch (11,700 ybp to the present)

Sources: U.S. Geological Survey Fact Sheet, 2010; Hayes 1996; Mojsis and coauthors 1996.

Florida native, next generation: Flatwoods salamander (*Ambystoma cingulatum*) larva. The adult lays its eggs in depressions at the bases of clumps of wiregrass in October. Then the winter rains follow and fill these depressions with water. The larvae hatch and grow, metamorphosing to adults in April or May as the dry season begins.

Flatwoods salamander adults

An event of immense importance marks the start of the Cenozoic Era. A giant asteroid slammed into the floor of the Caribbean Sea, splattering magma onto what is now Haiti and the Texas Gulf coast, spewing sulfurous ejecta all over the planet, and destroying the ozone layer in the outer atmosphere. This terrifying event, known as the Cretaceous cataclysm, delivered a death blow to all of the dinosaurs that were then roaming the earth, and drastically altered the environment for the next tens of millions of years.

Without the ozone layer to screen out the sun's harsh ultraviolet rays, photosynthesis drastically slowed, and most of the earth's plant life was extinguished. Not only did all of the dinosaurs die; so did 70 percent of all the living things on earth. No land animals remained that weighed more than 50 pounds. The only survivors were those that could escape the killing light: nocturnal animals, burrowing animals, animals in lakes, streams, and the ocean. But even though most plants had died, their seeds remained alive—especially fern spores and the seeds within the fruits of flowering plants.

The world changed dramatically as the effects of the Cretaceous cataclysm waned. Most groups of organisms on land and in the sea made new beginnings and the earth took on a new look. By 53 million years ago, the clouds had cleared. Sunlight was again shining down. The earth grew warm again, plants flourished anew, and their metabolism restored ozone to the atmosphere, recreating conditions in which life could thrive. The age of gymnosperms and reptiles was giving way to the age of angiosperms and mammals.

Although Florida remained under water until about 35 million years ago, species and communities were evolving on exposed land nearby that would migrate into Florida when the seas receded. The stage was set for the widespread dominance of the plants and animals that populate our world today. Temperate parts of the nearby coastal plain supported many trees we would recognize such as oak, elm, maple, and others. Warm areas held tupelo, magnolia, and sweetgum, and tropical coastlines sported seagrapes and figs.

At 37 million years ago, the end of the Eocene, the planet was so warm that crocodiles were roaming as far north as Wyoming. Roaming the Great Plains were many peculiar-looking creatures related to today's camels, horses, giraffes, elephants, bears, wolves, and many others. Some lines went extinct, other lines branched and prospered. Then another major extinction event occurred and many of the peculiar-looking animals of the Plains went extinct. It may be that the deep ocean circulation changed at about this time. Whatever the reason, massive ice sheets accumulated on top of Antarctica. The climate grew much cooler, ice sheets locked up large volumes of water, the sea level dropped dramatically, and Florida was born.

An **angiosperm** is a flowering plant, which reproduces by means of seeds contained in closed ovaries.

A **gymnosperm** (for example, a pine or other conifer) reproduces by means of naked seeds contained in cones.

Among trees, the gymnosperms are often called "softwoods" and the angiosperms "hardwoods." In general, the distinction holds true.

FLORIDA'S DEBUT

At about 35 million years ago, a few of the highest parts of Florida-to-be broke the ocean surface for the first time in millions of years. Immediately, the newly exposed land began to receive plants and animals immigrating from nearby terrestrial areas, but soon the sea rose and washed the developing ecosystems away again. These events were repeated many times over, but by about 25 million years ago, the ocean had receded from the Panhandle's northern highlands, leaving them above water until today. As for the Florida peninsula, with falling and rising sea levels, it grew, then shrank, then grew, but since 23 million years ago it has never again disappeared completely beneath the ocean.[1] Figure 8-1 shows that at times Florida was a group of islands, at times a peninsula.

Florida appeared at a time when flowering plants were diversifying greatly. Composites, grasses, and legumes flourished on land, aquatic

Sweet pinxter azalea (*Rhododendron canescens*), a wetland species.

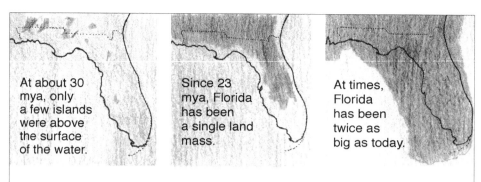

At about 30 mya, only a few islands were above the surface of the water.

Since 23 mya, Florida has been a single land mass.

At times, Florida has been twice as big as today.

FIGURE 8-1

After 35 mya: Florida Emerges from the Sea

Green areas represent the land mass(es) of Florida at various earlier times. Black lines show the contours of today's Florida.

The exact shapes that Florida assumed from its first emergence to the present will never, of course, be known. However, geologists can easily tell whether sediments were deposited above or below sea level and make maps approximating the dynamic history of shifting shorelines. Some layers accumulated on top of the land during times when it was below sea level, as currents carrying heavy loads of sediments slowed down and dropped them in piles on the ocean floor. Then they were scrubbed off and sometimes completely washed away by erosion when sea level fell again.

Above sea level, the land performed many disappearing acts, as its limestone layers dissolved and were carried to the sea by underground rivers. The land sank down as this dissolution took place, but then in some areas, as its overburden of sediments grew lighter, deeper layers heaved upwards, raising the surface again. Florida's geographical history is pieced together through the use of geological clues—and importantly, from fossils entombed in the rocks.

A **composite** is a special kind of flowering plant that belongs to the family Compositae or Asteraceae (daisies, sunflowers). What looks like a flower is actually a composite of ray flowers around the flower head and disc flowers clumped in the middle. Composites are the flowers that butterflies like best, because they can drink nectar from many different blossoms without having to spend energy flying from one to the next.

Bushy seaside oxeye (*Borrichia frutescens*), a composite, and a facultative wetland plant. It grows as an emergent along the edges of salt and brackish marshes and can also grow on sand dunes.

plants thrived in lakes and streams, and seagrasses spread beneath coastal waters. Herbivores flourished, eating all these plants. Carnivores diversified, finding abundant herbivores to eat. *La Florida*, the Land of the Flowers, was born at an auspicious time to develop immense diversity.

Fossil finds are available from different geologic times and offer richly detailed scenarios from past epochs. The discoveries described below are separated by spans of at least *several million years*—long enough times to bring about drastic changes in species and ecosystems. For perspective, keep in mind that only *two* million years ago, early hominids were just beginning to learn to use tools in Africa.

FLORIDA'S EARLY NATIVE PLANTS AND ANIMALS

To capture the thrill of discovery of Florida's ancient history, let us pretend that, instead of being paleontologists of today digging up fossils, we are time travelers who can actually visit sites in Florida millions of years ago when the fossils were first laid down. The entries that follow are written as if in the voices of people who can *see* the ancient plants and animals

still alive. For scholarship's sake, though, references for each entry point to reports of the actual fossil finds.

The Late Oligocene (25 to 23 mya). Our time machine first takes us back 25 million years, to a site near Gainesville (the "I-10 site"), close to the very beginning of Florida's terrestrial history. We might write in our journal as follows:

Route I-10, 25 mya. We have pitched our tent by a sinkhole in a mesic forest. We spy many animals, and some are vaguely familiar. A tribe of beaverlike animals is at work felling trees nearby to dam a stream and we see a hedgehog amble by. Turtles are numerous. Other animals are of recognizable groups—there are rodents and a rabbit that look like those of today; lizards, snakes, and frogs that seem very different. There's a tortoise that may be a distant relative of today's gopher tortoise. At night, we see flocks of bats of at least five different species, and peccaries (piglike animals with boar tusks). There is an insect-eating animal rather like an anteater, and a primitive opossum.

One day we explore a savanna inland from our campsite, and find a thrilling assortment of large mammals, somewhat like horses, deer, and goats. Fires obviously burn frequently across this grassy plain. The plants nearly all grow low to the ground and signs of a recent fire are apparent as blackened twigs of shrubby growth.

On another day we hike to the shore. There, too, we see creatures we can almost name—seven different species of sharks, a sting ray, and a bony fish. Birds of all kinds are numerous, but we cannot get good impressions of them—literally: they have left few and faint fossil traces.

There is danger here—there are large and small carnivores. We know there are sabercats at other sites nearby.

If this campsite is typical, and we hope it is, then we can correctly describe the Florida of this time. Mesic forest predominates, with animals that are adapted to it, and they are so well distributed into the many available habitats that we think they have been evolving here for a long time. We will be back to see how well they persist, but we won't find another informative site until the early Miocene.[2]

The Miocene (23 to 5 mya). Early in the Miocene, communities north and south of the Suwannee River are developing differences that have persisted to the present. Many trees found north and west of the Suwannee seem never to have crossed that river to occupy peninsular Florida.

In central Florida, special scrub communities are developing, each on its own "island"—that is, on a high sand hill surrounded by mesic forests that most of its plants and animals cannot cross. Special freshwater communities are developing, too. Many freshwater mollusks of central Florida are endemic, as are many freshwater fishes.[3]

Of our first visit, which takes us to Gilchrist County early in the Miocene, we might write:

Thomas Farm, 18.5 mya: We are camping in a patch of deciduous forest complete with ponds, sinks, and caves, where we can observe a tremendous number of animals. Turtles and frogs are numerous in the

Reminder: A *mesic* forest is one with moist soil.

Virginia opossum (*Didelphis marsupialis*). Forebears of today's 'possums were already roaming in Florida more than 25 million years ago.

ponds, and the caves are full of bats of many species. On the ground and in the trees we recognize many cousins of today's treefrogs, squirrels, turkeys, and deer . Peccaries and opossums are still here. Songbirds are calling in the branches above our campsite.

Our reptile specialist is excited to discover half a dozen snakes including a racer; a tree boa, and a vine snake. There are various lizards: a skink, a gecko, and others. The amphibians are exceedingly diverse and most are of the same genera as today—sirens, newts, salamanders, and many frogs and toads.[4]

From others' observations, we know that many animals are endemic to the Gulf coast along Florida and Texas. They do not occur in the interior of the continent, probably because the Great Plains are too dry. Among the endemics are three cameloids and a rhinocerotid.

This appears to be a well-established community. All of the animals show adaptations to forest life. Many are browsers, rather than grazers; and most, such as the bush hogs, have short legs that enable them to run through undergrowth.[5]

Other investigators have hiked eastward and report vast savannas that support great herds of grazing animals. Three-toed horses are especially numerous and make up 80 percent of our sample. Other grazers are even-toed: camelids, deerlike ruminants, an oreodont, and a cameloid with a peculiar "slingshot" horn above its nose. This strange beast will soon go extinct—soon, meaning within less than ten million years. A grazing tortoise also thrives on the savanna's herbs and forbs, and little pocket mice are scurrying about in the grasses collecting seeds. Several kinds of kites fly over the grasses searching out small animals.

Preying on all the small herbivores are diverse types of bears, wolves, and cats—some large, some medium, some small—at least ten distinct species. The most astonishing discovery comes at dusk when huge flights of bats emerge from caves deep in the woods. Some of these bats are large nectar feeders; others are small, swiftly-soaring insect feeders; and there are at least three of intermediate size, food habits unknown.[6]

We think these sites are typical of Early Miocene Florida. It is a patchwork of mesic forest and savanna, somewhat more tropical than today.[7]

Our time machine next takes us to Alachua County, later in the Miocene. We might write in our journal:

Love Bone Bed, about 10 mya: Again we are near the Gulf of Mexico. A stream runs out here and we have pitched tents on platforms over a freshwater marsh where the water rises and falls in concert with the tides. This is the richest Late Miocene vertebrate site in eastern North America. The marsh holds chicken turtles, soft-shell turtles, garfish, and alligators. Every time the tide rises, sharks, whales, and other swimmers move inland in great schools. Along the stream bank a lush forest rings with the songs of numerous birds.

Vast grasslands have opened up across North America and grazing animals find abundant food. Herbivores, including many species of horses, have grown large. We hike inland to explore a grassy savanna and find a stupendous number of species. The samples are so numerous that we have had to resort to a list to convey their extent (see List 8–1).[8]

Southern leopard frog (*Lithobates sphenocephala*), an inhabitant of lakes, ponds, marshes, and streams across the U.S. southeast. The protective coloration of this frog reflects millions of years of evolution within its habitat.

LIST 8–1
Vertebrates found at the Love Bone Bed, 10 mya

<u>Mammals still here as at earlier sites</u>
Giraffelike animals, a new species (*Pediomeryx*)
Grazing rodent, small (*Mylagaulus*)
Horses—many species
Peccaries
Pronghorn antelope
Rhinoceroslike animals, 2 kinds
Tapirs
. . . and other animals

(continued on next page)

The ground sloths are from South America and the temptation to speculate on how they got here is too great to resist. We imagine they may have floated in on a great pile of debris washed down a South American river into the Gulf of Mexico. As for the sabercats and bears, they must have come from Eurasia across a land bridge in the vicinity of Alaska or Greenland.

While we are exploring the Love Bone Bed, news arrives from some botanists who are camping in the Panhandle. They stumbled upon a botanically rich site at Alum Bluff on the Apalachicola River, at the north border of Liberty County. They have found several tropical plant assemblages growing along the river including palms, figs, breadfruit, orchids, and camphortrees. The gopherwood will persist at Alum Bluff for at least 13 million years, all the way to the 21st century.

The Pliocene (5 to 2.6 mya). We return later, again by time machine. The western Great Plains are now very dry, predominantly grasslands. Many grazers have gone extinct in the middle of the continent, but in Florida, enough watering holes remain on the savannas to support huge herds of large animals. We make these observations in Polk County:

Bone Valley, 5 mya: The climate is now very dry. Florida is a larger exposed landmass. Browsing animals are present (such as a large browsing horse) but grazing animals greatly outnumber them—there are ten species of grazing horses. Giant mammals include three elephant genera (mastodons, mammoths, gomphatheres). And if these weren't enough, other large grazers and browsers are also present including a large camelid, a medium-sized giraffoid, and a tapir.

This vast panorama reminds us of the Serengeti Plain of Africa today. It has numerous hoofed animals resembling zebras, gazelles, giraffes, and others; and it has catlike and doglike carnivores similar to cheetahs, leopards, lions, and others). We are staggered by its richness.[9]

Subtropical forests also remain in central Florida, where we see a large flying squirrel, an early version of the white-tailed deer, and a long-nosed peccary.

This is the last trip we make in our time machine and the last entry in our imaginary journal. For several million years, we can make no more observations, because the seas rise dramatically and remain high from 5 to 2.6 million years ago, eroding the perimeter of the highlands. Henceforth, Florida remains a single land mass. And although we have no opportunity to observe it, the continents of North and South America are becoming connected by the Isthmus of Panama, and when sea level falls, a land bridge will emerge between the two and animals will be able to migrate north and south across it.

Our narrative now resumes as regular text.

The Pleistocene (beginning about 2.6 mya). By the early Pleistocene as South America became joined to North America, profound impacts became apparent. The land bridge between North and South America

(continued from previous page)

Mammals not seen earlier
Bears, primitive—from the Old World
Ground sloths, 2, from South America
Sabercats—from the Old World

Birds
(Stream, streambank, pond, marsh, and wet prairie specimens, 284 species!)
Anhingas
Coots
Cormorants
Ducks
Flamingos
Geese
Grebes
Herons
Limpkins
Ospreys
Rails
Shorebirds
Storks

Reptiles
(Much like those of today)
Alligator
Land tortoises, 2
Turtles, several
Crocodile with a narrow snout for catching fish, 20 feet long! (*Gavialosuchus*)
Snakes—several
(Boa-type constrictors are no longer present.)

Amphibians
(Salamanders and frogs much like those of today.)

Sources: Webb and coauthors 1981; Meylan 1984.

separated the Atlantic and Pacific oceans, forcing global ocean currents to change course. As a result, Atlantic and Pacific shrimp, once all of the same species, diverged to become distinct species.

After the upheaval of Panama, an Atlantic current washed into the Gulf, circulated clockwise around it, and exited at the tip of Florida to flow up the east coast—in short, the Gulf Stream began to circulate as it does today. The warm, shallow Gulf waters became nutrient poor, a quality that is ideal for the growth of coral reefs. A dozen earlier genera of corals went extinct, but 21 new ones evolved, including beautiful staghorn and elkhorn corals. The reefs off the Florida Keys became unlike any others in the world.[10]

As the warm Gulf Stream flowed north, it encountered cold Arctic air and the cooling created rain. Rain on the poles turned to ice, and polar ice spread over the continents. Repeated ice ages followed.

The Great American Interchange. During each ice age, ocean water became tied up in land ice and the seas fell dramatically. Land areas expanded, and new land routes became available to and from distant places. Now the Isthmus of Panama was a broad land bridge above water. North and South America's plants and animals, which had evolved independently for nearly 200 million years, began crossing that bridge, invading each other's territory, and mingling (see Figure 8-2). New relationships evolved as predators and prey began to mix in new combinations.

Florida's appearance changed dramatically. When it first appeared above sea level some 35 to 25 million years ago, Florida was clad predominantly in hardwood forests in which patches of pine forest and savanna lay scattered. At 2.6 million years ago, the pattern was reversed: pine forest and savanna were continuous and the hardwood forests had broken up into patches. A major new, dry-adapted ecosystem was now in evidence in southern Levy County: coastal longleaf pine savanna, the precursor of today's fire-dependent pine grasslands.

During drying cycles, plants and animals that preferred mesic habitats became confined to deep, moist ravines, especially along the valley sidewalls of the major rivers of the Panhandle and along the shaded, moist sidewalls of deep sinkholes. Today, most of Florida's ancient endemic plants are found in such habitats along the Apalachicola River.

The fossil record shows that many major species of animals vanished from North America during the Pleistocene Epoch. In their place were many others, never seen there before. New animals were present from South America, the Far West, and the northern mountains. Again, an abbreviated record has to serve (see List 8-2).

As the climate warmed, the ice sheets retreated, and huge volumes of melt water roared down North American rivers, widening their channels

Florida native, next generation: Apple snail (*Pomacea palludosus*) eggs. The snail lays its big, shiny, pea-sized eggs on streamside vegetation and cypress trees just above the water line. When young snails emerge, they go under water promptly to escape predation. They graze on algae and other periphyton, visit the surface periodically, and during the dry season bury themselves in the bottom sediments and go dormant.

SFWMD

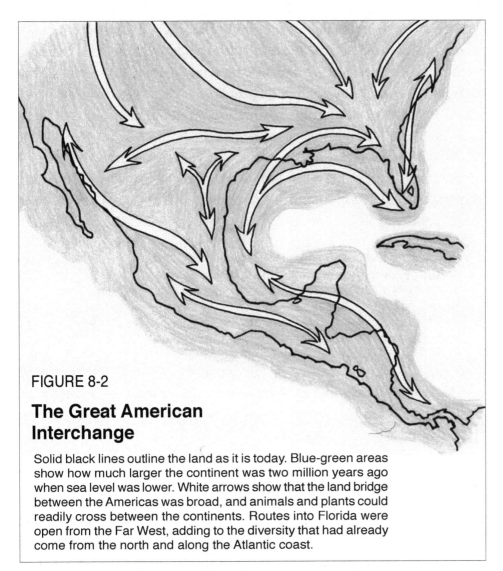

FIGURE 8-2

The Great American Interchange

Solid black lines outline the land as it is today. Blue-green areas
show how much larger the continent was two million years ago
when sea level was lower. White arrows show that the land bridge
between the Americas was broad, and animals and plants could
readily cross between the continents. Routes into Florida were
open from the Far West, adding to the diversity that had already
come from the north and along the Atlantic coast.

and delivering sediment that built broad deltas at their mouths. On the
Mississippi delta, vast wetlands developed, too wide for most plants and
animals and even some birds to cross. Florida's connection with the west
weakened and many groups split into eastern and western subpopulations.

At least ten more cycles of cooling and warming followed during the
Pleistocene's last million years. The climate cooled and warmed about
every 100,000 years and sea level fell and rose along with it. Whenever sea
level fell, Florida became very arid, favoring savanna and high pine com-
munities. Whenever sea level rose again, hardwood forests expanded their
ranges, wetlands enlarged, and lakes became numerous. At 18,000 years
before the present, when the Wisconsinan ice age was most intensely cold
and Florida was drier, the sea level was lower, and the peninsula was twice
as broad as it is today. The whole continental shelf lay exposed. A vast, dry
pine savanna flourished over a hundred million acres, patchily decorated
with hardwood forests, mostly oak, including turkey oak. Thousands of
acres of wet flatwoods and seepage bogs were ablaze with wildflowers and
carnivorous plants.[11]

Animals were again migrating into North America from Asia over the land bridge between Siberia and Alaska. Some long-horned bison migrated from Asia into Alaska, then crossed the entire span of the Great Plains and entered Florida to gradually become today's familiar short-horned bison. Herds of giant animals roamed from one water hole to the next: mammoths, mastodons, camels, sabertooth cats, dire wolves, giant sloths, armadillos, tapirs, peccaries, bison, giant land tortoises, glyptodonts, horses, giant beavers, capybaras, and short-faced bears.[12] Naturalist Archie Carr, contemplating what Florida must have been like at that time, marveled at the sights we might have seen:

> _Right in the middle of Paynes Prairie itself there used to be creatures that would stand your hair on end. Pachyderms vaster than any now alive grazed the tall brakes or pruned the thin-spread trees. There were llamas and camels of half a dozen kinds; and bison and sloths and glyptodonts; bands of ancestral horses; and grazing tortoises as big as the bulls . . . making mammal landscapes that, you can see in even the dim evidence of bones, were the equal of any the world has known.[13]_

Figure 8-3, on the next two-page spread, shows what Florida's great savannas might have looked like when those great animals were here. Only a few remain from that time, and the figure legend identifies only those that have since gone extinct.

THE COMING OF HUMANS

After about 15,000 ybp, another warming trend began. The ice sheet began to melt and the first bands of nomadic hunters migrated from Alaska down an ice-free corridor of land east of the Canadian Rockies (Figure

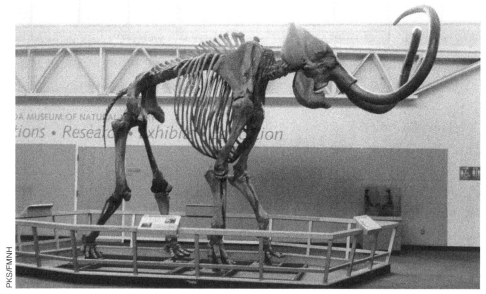

Florida native, now extinct: Mammoth _(Mammuthus colombi)_. River divers discovered this skeleton in the bottom of the Aucilla River in 1968. It is more than 12 feet tall at the shoulder and 16,000 years old by radiocarbon dating.

8-4). At 14,425 ybp, Florida's earliest dated human-occupied site was the Page-Ladson Site on the Aucilla River.

As on the Plains, the giant animals all died off at about the time the humans arrived (see List 8–3). In Florida's case, however, human hunters are not thought to be the only agent causing the extinctions. In Florida, small mammals as well as big ones went extinct, often just as other similar animals migrated in, suggesting that newcomers were displacing residents. Moreover, some of Florida's extinctions predated human arrival. Perhaps climate change pushed the animals to the brink and human hunters struck the last blow in some cases. Whatever the reason, only the fossils of those giant animals remain.

Like all prior comers, Florida's first people became part of its ecosystems. They selected certain wild plants to eat, they hunted, and they cleared some forests for hunting, sometimes by burning them. Once the large game animals of the past were extinct, they adapted to eating snails, then oysters, scallops, and sea turtles. By 5,000 ybp, they were making pottery, and by 1,000 ybp they were engaging in corn agriculture.

Meanwhile, coastal wetlands were swamped by rising seas and Florida shrank to half its former area. Cypress and other wetland species escaped extinction by finding refuge in deep, wet habitats in the interior. They persisted there, as if awaiting the next climatic turn to recolonize coastal lowlands. Seepage bogs dwindled in size and separated into remnants, the Everglades marsh developed, and mangroves began to grow along the coast.

THE EUROPEANS (500 YBP)

When the Europeans arrived, the pace of change quickened. In the early 1500s, the Spanish "discovered" Florida and preempted it as their own. Spanish aggression and diseases decimated the native peoples, and by about 1700, had largely wiped them out or driven them from Florida. (A few tribes returned to Florida later, notably in the mid to late 1700s, members of the Mikasuki and Creek tribes—the latter renamed Seminole.)[14]

Other Europeans followed the Spanish and established forts, settlements, and citrus plantations along the coasts, on the rivers, and on the highlands. By 1775, St. Augustine, St. Marks, and Pensacola were major Florida towns. Then, in the 1800s, industry came to Florida, and in the 1900s, roads, cars, and some 17 million people.

Today, human uses of the land are fragmenting and destroying natural habitats. Moreover, global gas concentrations are changing, the earth's temperature is rising, and ultraviolet rays are increasingly penetrating the atmosphere. As a result, the earth's biodiversity is diminishing. But those natural ecosystems that remain are the once-on-a-planet, once-in-

LIST 8–3
Changes in the fossil record since 13,000 ybp

Extinct in North America
Large mammals, 35 genera
Large birds, 2 (*Gymnogyps, Teratornis*)
Giant tortoise (*Geochelone*)

Gone, E of the Mississippi[a]
Jack rabbits
Pronghorn antelopes

Gone from Florida[b]
Bog lemming (*Synaptomus*)
Porcupine (*Erythizon*)
Muskrat (*Ondatra*)

Split into two populations E and W of Mississippi River
Cactuses, 8 genera
Scrub-jay
Whip scorpions

Remaining
Reptiles: Of 31 species that came in from the Far West, 24 are still here in dry savannas and high pinelands

Notes:
[a]Eastern North America became too wet for these desert animals.
[b]Summers became too hot and wet in Florida and these animals moved north.

Source: Adapted from Webb 1990.

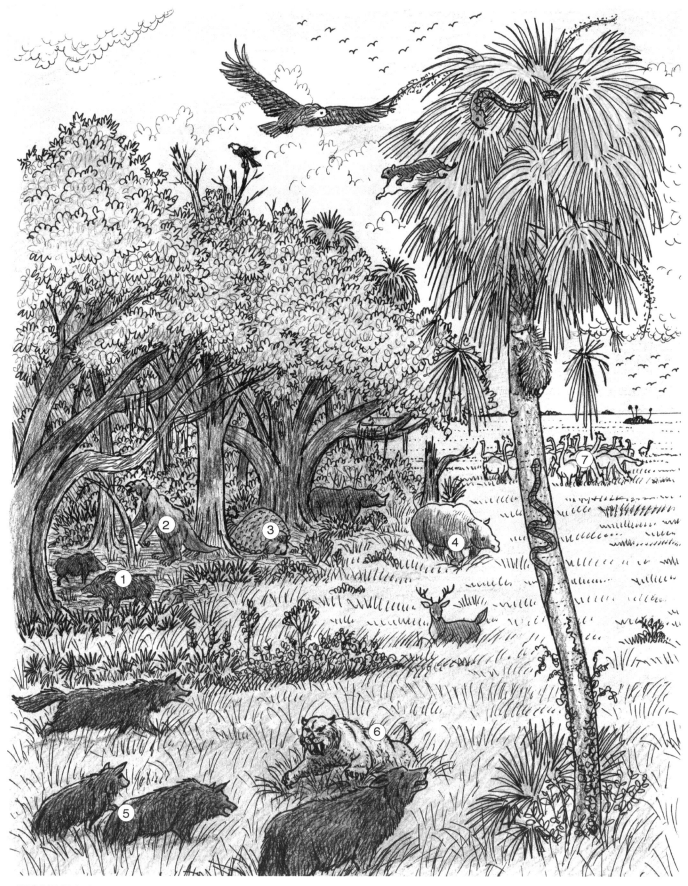

FIGURE 8-3

Pleistocene Giant Animals in Florida

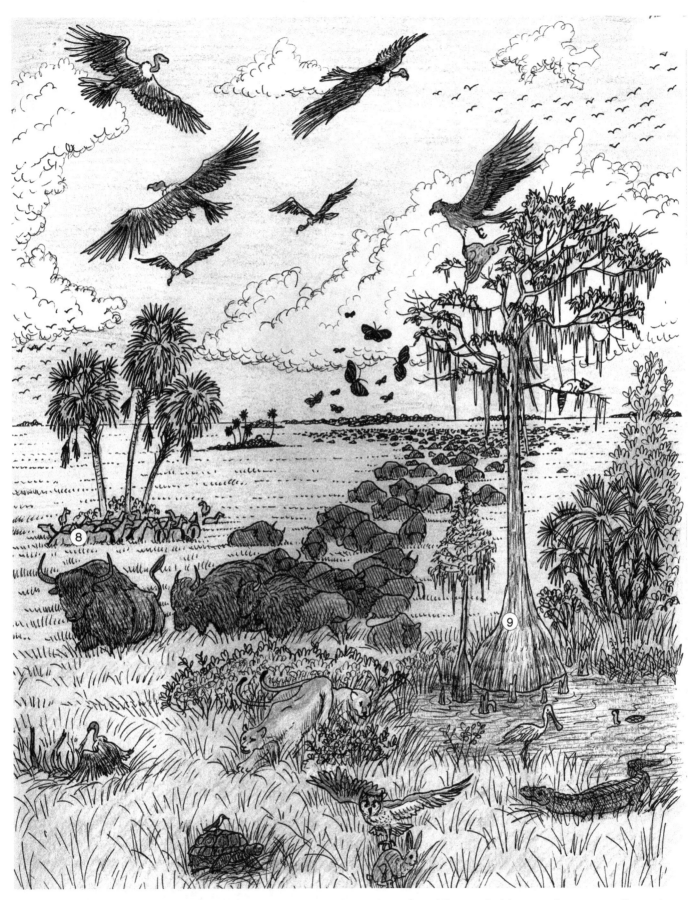

At left is a mesic forest with peccaries (1), a giant sloth (2), a glyptodont (3), a tapir (4), as well as some dire wolves (5) and a sabercat (6). At center and right is a savanna of the type that probably occupied most of Florida during much of the Pleistocene. Roaming the savanna are herds of giraffe-camels (7), horses (8), and bison (9).

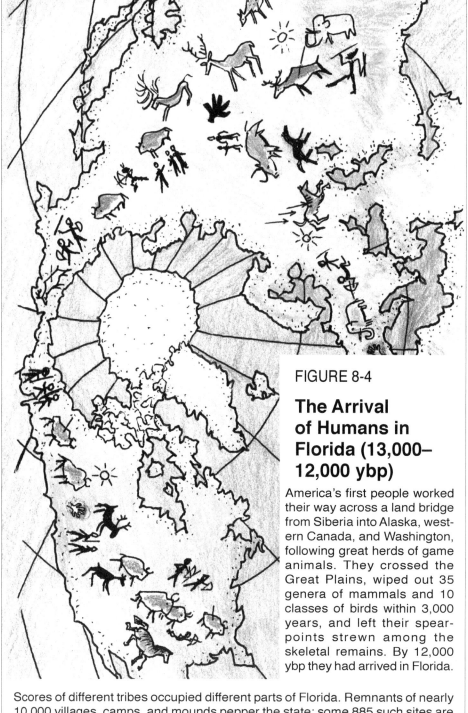

FIGURE 8-4

The Arrival of Humans in Florida (13,000–12,000 ybp)

America's first people worked their way across a land bridge from Siberia into Alaska, western Canada, and Washington, following great herds of game animals. They crossed the Great Plains, wiped out 35 genera of mammals and 10 classes of birds within 3,000 years, and left their spearpoints strewn among the skeletal remains. By 12,000 ybp they had arrived in Florida.

Scores of different tribes occupied different parts of Florida. Remnants of nearly 10,000 villages, camps, and mounds pepper the state; some 885 such sites are on Eglin Air Force Base alone (in Santa Rosa, Okaloosa, and Walton Counties).

Source: Anon. 1991 (Survey unearths Eglin's past).

the-universe products of a history hundreds of millions of years long, and they still hold an enormous and diverse legacy from the past.

A Treasure Trove of Information

An immense amount of information is stored in each of Florida's species. Some of that information is a set of "directions for life," such as how to respire, grow, and repair injuries. Some is specific and provides instructions for adapting to natural, local environments: cypress trees to swamps; mussels to river beds; caterpillars to their host plants; corals to their sites on the continental shelf. Taken all together, the quantity of detail in each species is staggering. Even a single bacterial "cell," which is smaller and simpler than a "true" cell, is built according to a blueprint of some 3,000 genes, each of which in turn is composed of tens of thousands of atoms. A more complex organism, such as a microscopic worm, inherits and passes on much more information—some 19,000 genes. A common mold may have as many as 100,000 genes.

Florida native, next generation: The eggs of an Apalachicola dusky salamander (*Desmognathus apalachicolae*). These develop best in muck formed by seepage in a steephead ravine near the Apalachicola River.

If each "simple" species uses thousands of genes to direct the development of its members, how much more information must the tiger salamander, zigzag bladderwort, pink sundew, and great blue heron have? How much information is contained in a whole ecosystem, or in the dozens of ecosystems that we have in Florida? To convey how awesome such a quantity is, biologist E. O. Wilson offers this description of a single, tiny ecosystem in soil:

> *A handful of soil and leaf litter . . . contains more order and richness of structure . . . than the entire surface of all the other (lifeless) planets . . . Every species in it is the product of millions of years of history. . . . Each organism is the repository of an immense amount of genetic information.*
>
> *For the sake of illustration, let us use the "bit," the smallest unit of information content used in computer science, to measure the amount of genetic information contained in an organism. . . . A single bacterium possesses about ten million bits of genetic information, a fungus one billion, and an insect from one to ten billion bits according to species. . . .*
>
> *If the amount of information in just one insect—say an ant or a beetle— were to be translated into a code of English words and printed in letters of standard size, the string would stretch over a thousand miles. The life in our one little sample of litter and soil would just about fill all the published editions of the Encyclopedia Britannica.[15]*

In light of the time and information each one represents, then, Florida's natural ecosystems are of great value. One aspect of that value is that natural ecosystems perform services useful to life and society.

Ecosystem Services

Ecosystem "services," meaning natural processes that support life on earth, were referred to in the first chapter, and succeeding chapters pointed out some of them. To bring them back into focus, a brief summary follows.

First, consider what green plants do for life on earth. Green plant-based

Florida native, next generation: Red maple seeds (*Acer rubrum*). Red maple grows well in many kinds of habitats with both dry and moist soils.

ecosystems capture the sun's energy and bind it into fuels and building materials. All living communities and all human societies depend on these ecosystem products. The more green there is, the more total living material there can be. Green plants also consume carbon dioxide and release oxygen, thereby supporting oxygen-breathing animals and oxygen-consuming activities such as the burning of fossil fuels. Healthy plants also purify air. They absorb sulfur and nitrogen compounds, ozone, and heavy metals into their tissues, leaving the air clean, breathable by animals, and freer of tissue-burning acid rain.

Then there is the contribution of green plants to the health of the planet. Oxygen released by plants forms ozone in the outer atmosphere, and ozone screens out wavelengths of sunlight that, if they penetrated freely to the earth's surface, would destroy all exposed life. Moreover, green plants consume carbon dioxide (which holds heat in the atmosphere), thereby helping to keep the global temperature within limits suitable for life. At the same time, green plants and their organic residues in ecosystems hold huge volumes of carbon out of the atmosphere and thereby prevent overheating of the globe. Among carbon-holding systems, the ocean's communities of algae, the earth's soil communities, and the plant populations of wetlands and forests are especially important.

Earlier chapters have already enumerated many other ecosystem services: water purification, soil conservation, erosion control, flood abatement, recycling of nutrients and minerals, aeration of soil, disposal of wastes. Finally (and this has been the focus of this book), natural ecosystems provide habitat: nurseries, feeding and breeding grounds, and shelter that permit native species populations to conduct all phases of their life cycles unaided by us.[16]

SPECIES DIVERSITY

Species diversity greatly enhances ecosystem value. The greater the number of species in an ecosystem, the greater the system's productivity and resilience. In a grassland, for example, a mixture of different grasses can produce a greater mass of living material than a crop of any one grass, and species-rich grasslands can withstand and recover from stresses such as drought much more successfully than can low-diversity systems.[17]

By the same token, the loss of just one species can weaken a whole ecosystem. Species diversity is expressed most fully in large, ancient, undisturbed ecosystems like the Apalachicola River floodplain and the Everglades, whose component plant and animal populations have evolved and interacted for millions of years. In contrast, less biodiversity is seen in small, isolated patches of habitat and in modified communities such as

Florida native, next generation: Red mangrove *(Rhizophera mangle)* propagules.

parks and farms, which are of more recent origin and are usually much less complex than natural communities.[18]

What will it take to ensure that the priceless biodiversity of this corner of the continent will be preserved? Florida's species are adapted to local conditions, and Florida is the best place to preserve them. To take on the care of a species outside of its natural habitat is costly, burdensome, energy-intensive, time consuming, and unlikely to succeed. Small sets of specimens can at best be maintained for short times under controlled conditions in greenhouses and zoos, but they cannot perpetuate themselves without help except under natural conditions. The best site in which to conserve each species is its own natural habitat.

Beyond the value of diversity, beyond the utilitarian value of ecosystem services, and beyond their beauty and fascination, the other creatures, plants as well as animals, simply have the right to be here. They have traversed the same long, evolutionary path, the same bumpy road of life and death through myriad generations, as we have. They share with us the eloquent language of DNA; they are our kin. They need us to pay attention to their plight in the wake of our hurtling journey into the future. And indeed, if we don't pay attention and safeguard them against the repercussions of our own pursuits, we will learn too late that we needed them, too, more than we knew.

DBM

The Florida sandhill crane (*Grus canadensis pratensis*). One of Florida's largest native birds, the crane uses a mosaic of habitats in the Okefenokee Swamp, in basin wetlands such as Paynes Prairie near Gainesville, and in parts of the Kissimmee Prairie north of Lake Okeechobee. These ecosystems offer both shallow ponds, in which the crane builds large, conspicuous nests, and expanses of dry prairie where it forages.

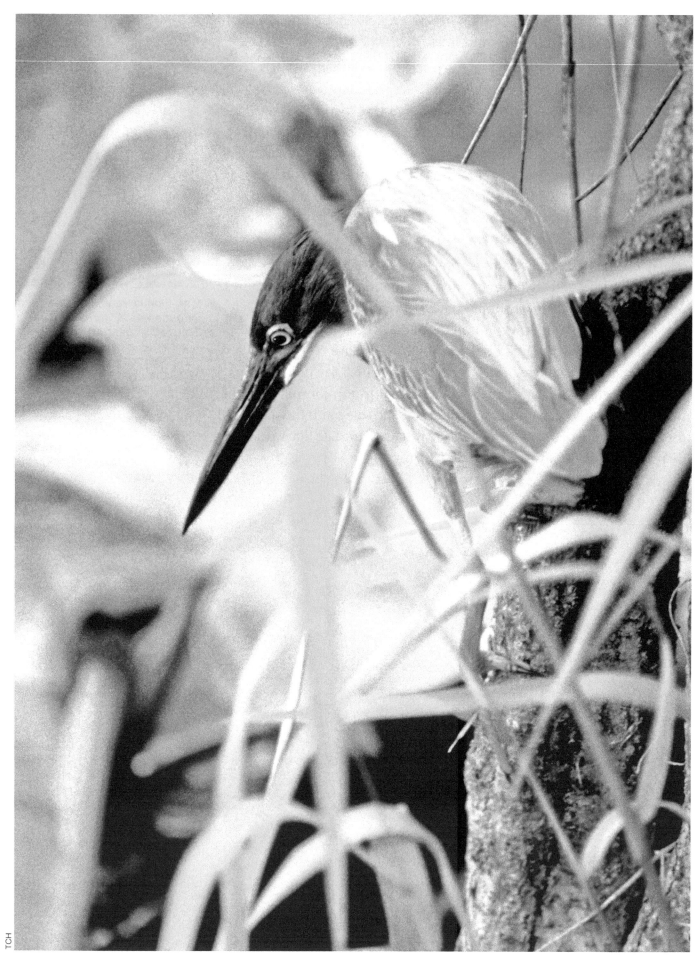

Green heron *(Butorides virescens)*, stalking prey by a Florida stream.

REFERENCE NOTES

CHAPTER 1—NATURAL ECOSYSTEMS AND NATIVE SPECIES

1. *Guide* 1990, iv; *Guide* 2010, 7-8.

2. Discussion of the term *natural* inspired by Clewell 2000.

3. A species may exist as several populations occupying separated habitats, but for as long as the individuals readily breed with one another, they are considered to be members of one species. If two populations of organisms are similar but display no tendency to interbreed when brought together, they are distinct species. (Under abnormal circumstances, members of two different species may mate and produce hybrids, but then the hybrids are sterile.) Mode of speciation from Palumbi 2002; rate from Norton 1986, 121–122; mechanisms from McCook 2002.

4. Species names for plants are from Wunderlin and Hanson 2003; for freshwater fish from Eddy and Underhill 1978, for marine fish from Anon. c. 1994 (*Fishing Lines*), for amphibians and reptiles from Collins and Taggart 2002, and for birds, Robbins, Bruun, and Zim 2001.

CHAPTER 2—INTERIOR WETLANDS INTRODUCED

1. Gilbert, Tobe, Cantrell, Sweeley, and Cooper 1995, 12.

2. Willoughby 1897.

3. Statistic from Loftin 1992.

4. Grow 1984.

5. Clewell 1990.

6. Grow 1984.

7. Douglas 1994.

CHAPTER 3—SEEPAGE WETLANDS

1. Walker and Peet 1983 published the record for flowering plant species in a seepage bog in the Green Swamp of North Carolina: 47 species per square meter. Numbers of species in north Florida seepage bogs may be even greater.

2. Species numbers from Hermann 1995, 78.

3. Information on the moth from T. E. Miller, letter to Ellie Whitney, 7 April 1998. The moth is a member of the genus *Exyra*.

4. Information on the maggot from Miller, letter, 1998; other inhabitants from Carr 1994, 150–151; Hermann 1995, 83; information on aquatic insects from Fish and Hall 1978; and on dividing the resource from Folkerts 1982.

5. Wolfe, Reidenauer, and Means 1988, 154.

6. A couple of these giant cedars still stand along the upper Escambia River. Ward and Clewell 1989, 19, 29.

7. Ward and Clewell 1989, 36–38.

CHAPTER 4—INTERIOR MARSHES

1. Barada 1983.

2. Kushlan 1990, 325.

3. Kushlan 1990, 327.

4. *Guide* 1990, 40.

5. Kushlan 1990, 336–337.

6. Toops 1998, 21.

7. Means 1990 (Temporary ponds).

8. The published world record is for the the flatwoods of North Carolina's Green Swamp; Walker and Peet 1992. Records for Florida flatwoods remain to be published.

9. There are 20 crayfish species, and one has 3 variants, so some say 22 altogether. Hobbs 1942, 19–21.

10. Dwarf cypress from Mitsch and Gosselink 1986, 321–322.

11. Tilt angle from Kushlan 1990, 329–330: 3 cm per km over the entire original 10,000 sq km of the Everglades.

12. Urquhart 1994.

13. Hinrichsen 1995.

14. Urquhart 1994.

15. Hurchalla 1998.

16. Toops 1998, 27.

17. Toops 1998, 44.

18. Sharing system from Toops 1998, 31–41.

CHAPTER 5—INTERIOR SWAMPS

1. Lickey and Walker 2002.

2. Cypress root adaptations from Clewell 1981/1996, 132.

3. Clewell 1981/1996, 131–132.

4. Disease resistance from Ward and Clewell 1989, 38.

5. Clewell 1981/1996, 137.

6. Andre F. Clewell, letter to Ellie Whitney, 14 July, 2000.

7. Toops 1998, 44, 46.

8. Strahler 1964.

9. Clewell 1991 (Physical environment) and Clewell 1991 (Vegetational mosaic).

10. Leitman, Sohm, and Franklin 1983, A44–A45.

11. Barry, Garlo, and Wood 1996.

12. Vince et al. 1989.

13. That the distribution of tree species changes along the river is from Leitman, Sohm, and Franklin 1983.

14. Statistic from Harris, Sullivan, and Badger 1984.

15. Southall 1986.

16. Animal count from Suwannee River Task Force 1989, 9.

CHAPTER 6—COASTAL INTERTIDAL ZONES

1. Palmer 1975.

2. Coultas and Hsieh 1997, 18–19.

3. Clewell 1976, 25.

4. Plant mortality due to salt wrack from Clewell 1997, 97.

5. Clewell 1997, 101–103; Odum 1993, 237.

6. Rey and McCoy 1997, 200.

7. Montague and Wiegert 1990, 497, 503.

8. Salt marsh snake from Moler 1992.

9. Montague and Wiegert 1990, 504.

10. Coultas and Hsieh 1997, 14.

11. Clewell 1997, 89.

CHAPTER 7—MANGROVE SWAMPS

1. Toops 1998, 72.

2. Odum, McIvor, and Smith, 47; isopod from Estevez 1978.

3. Toops 1998, 83.

4. Donaldson and Ratterman 1996.

CHAPTER 8—THE PAST AND THE FUTURE

1. S. David Webb, letter to Ellie Whitney, 22 December 1998.

2. Patton 1969.

3. Webb 1990, 90, 95, 100.

4. Meylan 1984.

5. Pratt 1990.

6. S. David Webb, letter to Ellie Whitney, 22 December 1998.

7. Webb 1981; Meylan 1984.

8. Webb, MacFadden, and Baskin 1981; Hulbert 1982.

9. Webb and Crissinger 1983.

10. Ross 1996.

11. Turkey oak was probably already present at 18,000 BC. Andre C. Clewell, letter to Ellie Whitney, 10 July 2000.

12. Osborne and Tarling 1996; Wisenbaker 1988; Wisenbaker 1989.

13. Carr 1994, 19.

14. Hiaasen 1993.

15. Wilson 1983.

16. The value of nature's services was estimated by Daily, ed. 1997.

17. Yoon 1994.

18. Roush 1982; May 1993; Raven, Berg, and Johnson 1993, 344.

BIBLIOGRAPHY

Anon. 1991. Survey unearths Eglin's past. *Tallahassee Democrat*, 25 August.

Anon. c. 1994. *Fishing Lines*. Tallahassee: Department of Environmental Protection.

Barada, B. 1983. The human impact on Florida's weather. *ENFO* (October): 1-10.

Barry, W. J., A. S. Garlo, and C. A. Wood. 1996. Duplicating the mound-and-pool microtopography of forested wetlands. *Restoration and Management Notes* (Summer): 15-21.

Carr, A. 1994. *A Naturalist in Florida*. New Haven, Conn.: Yale University Press.

Clewell, A.E.. 1976. Coastal wetlands (unpublished manuscript).

———. 1981/1996. *Natural Setting and Vegetation of Panhandle Florida*. U.S. Army Corps of Engineers, Mobile District, Report No. COESAM/PDEI-86/001.

———. 1990. Cited by B. Orth. 1990. Clewell's world. *Builder/Developer* (January): 10-11.

———. 1991. Florida rivers (The physical environment). In Livingston 1991 (q.v.), 17-30.

———. 1991. Florida rivers (The vegetational mosaic). In Livingston 1991 (q.v.), 47-63.

———. 1997. Vegetation. In Coultas and Hsieh 1997 (q.v.), 77-109.

———. 2000. Restoring for natural authenticity. *Ecological Restoration* 18 (Winter): 216-217.

Collins, J. T., and T. W. Taggart. 2002. *Standard Common and Current Scientific Names for North American Amphibians, Turtles, Reptiles, & Crocodilians*. 5th ed. Hays, Kansas: Center for North American Herpetology.

Coultas, C. L., and Y.-P. Hsieh, eds. 1997. *Ecology and Management of Tidal Marshes*. Delray Beach, Fla.: St. Lucie Press.

Daily, G. C., ed. 1997. *Nature's Services*. Washington: Island Press

Donaldson, C., and L. Ratterman. 1996. Quotables to remember. *Palmetto* (Summer): 7, 12.

Douglas, M. S. 1947. *The Everglades* (50th anniversary edition 1997). Sarasota: Pineapple Press.

———. 1994. Cited by B. O'Donnell. 1994. The Everglades. *Florida Wildlife* 48 (July-August): 2-6.

Dunkle, S. W. 1991. Florida's dragonflies. *Florida Wildlife* 45 (July-August): 38-40.

Eddy, S., and J. C. Underhill. 1978. *How to Know the Freshwater Fishes*. 3d ed. Boston: McGraw-Hill.

Fish, D., and D. W. Hall. 1978. Succession and stratification of aquatic insects inhabiting the leaves of the insectivorous pitcher plant, *Sarracenia purpurea*. *American Midland Naturalist* 99(7): 172-183.

Flohrschutz, E.W. 1978. Dwarf cypress in the Big Cypress Swamp of southwestern Florida. Thesis, University of Florida, Gainesville, in turn from *Guide* 2010.

Folkerts, G. W. 1982. The Gulf coast pitcher plant bogs. *American Scientist* 70 (May-June): 259-267.

Gilbert, K. M., J. D. Tobe, R. W. Cantrell, M. E. Sweeley, and J. R. Cooper. 1995. *The Florida Wetlands Delineation Manual*. Tallahassee: Florida Department of Environmental Protection and the South Florida, St. Johns River, Suwannee River, Southwest Florida, and Northwest Florida Water Management Districts.

Grimes, B. H. 1989. *Species Profiles* (Atlantic marsh fiddler). Raleigh, N.C.: U.S. Fish and Wildlife Service, North Carolina Cooperative Fishery Research Unit and North Carolina State University.

Grow, G. 1984. What are wetlands good for? *ENFO* (February): 3, 5.

Gunderson, L.H. and L.L. Loope. 1982. An inventory of the plant communities within the Deep Lake Strand area, Big Cypress National Preserve. South Florida Research Center T-666. Everglades National Park, Homestead, Florida. In turn from *Guide* 2010.

Harris, L. D., with R. Sullivan and L. Badger. 1984. *Bottomland Hardwoods*. IFAS document 8-20M-84. Gainesville: IFAS.

Hayes, J. M. 1996. The earliest memories of life on earth. *Nature* 384 (7 November): 21-22.

Hermann, S. M. 1995. *Status and Management of Florida's*

Carnivorous Plant Communities. Nongame Wildlife Program Project Report GFC084-033 (December). Tallahassee: Florida Game and Fresh Water Fish Commission.

Hiaasen, C. 1993. The Miccosukee: The Seminoles and the Glades. *Tallahassee Democrat*, 4 April.

Hinrichsen, D. 1995. Waterworld. *Amicus Journal* (Summer): 23-27.

Hobbs, H. H., Jr. 1942. The crayfishes of Florida. *University of Florida Biological Series* 3:2 (November).

Hubbard, M. D., and C. S. Gidden. 1997. Terrestrial vertebrates of Florida's Gulf coast tidal marshes. In Coultas and Hsieh 1997 (q.v.), 331-338.

———. 1998. Saving the Florida Keys. *Florida Wildlife* 52 (May-June): 16-19.

Hulbert, R.C., Jr. 1982. Population ecology of Neohipparion (Mammalia, Equidae) from the late Miocene Love Bone Bed of Florida. *Paleobiology,* 8(2): 159–167.

Humphreys, J., S. Franz, and B. Seaman. 1993. *Florida's Estuaries*. Sea Grant Extension Bulletin #23. Gainesville: Florida Sea Grant College Program and Tallahassee: Department of Community Affairs.

Hurchalla, M. 1998. Crossing the Everglades. *Palmetto* (Summer): 16-19.

Kangas, P. 1994. Dwarf mangrove forests and savannas of south Florida. In *Proceedings of the North American Conference on Barrens and Savannas*, ed. J. S. Fralish, R. C. Anderson, J. E. Ebinger, and R. Szafoni, 375. Normal, Ill.: Illinois State University, October 15-16. Environmental Protection Agency, Great Lakes National Program Office.

Kruczynski, W. L., and B. F. Ruth. 1997. Fishes and invertebrates. In Coultas and Hsieh 1997 (q.v.), 131-173.

Kushlan, J. A. 1990. Freshwater marshes. In Myers and Ewel 1990 (q.v.), 324-363.

Leitman, H. M., J. E. Sohm, and M. A. Franklin. 1983. *Wetland Hydrology and Tree Distribution of the Apalachicola River Flood Plain*. Water-Supply Paper 2196. Tallahassee: U.S. Geological Survey.

Lickey, E. B., and G. L. Walker. 2002. Population genetic structure of baldcypress and pondcypress. *Southeastern Naturalist* 1 (2): 131-148.

Livingston, R. J. 1983. *Resource Atlas of the Apalachicola Estuary*. Sea Grant Project No. T/P-1. Tallahassee: Florida Sea Grant College Program.

Loftin, J. P. 1992. Rediscovering the value of wetlands. *Florida Water* (Fall): 16-23.

May, R. M. 1993. The end of biological history? (a review of E. O. Wilson's book *The Diversity of Life*, 1992). *Scientific American* (March): 146-149.

McCook, A. 2002. You snooze, you lose. *Scientific American,* April: 31.

Means, D. B. 1990. Temporary ponds. *Florida Wildlife* 44 (November-December): 12-16.

———. 2000. Southeastern U.S. coastal plain habitats of the Plethodontidae. In *Biology of Plethodontid Salamanders*, ed. R. C. Bruce, R. G. Jaeger, and L. D. Houck, 287-302. New York: Kluwer Academic/Plenum Publishers.

Means, D. B., and P. E. Moler. 1979. The pine barrens treefrog. In *Proceedings of the Rare and Endangered Wildlife Symposium, Technical Bulletin WL-4,* ed. R. R. Odum and J. L. Landers, Athens, Georgia, August 3-4, 77-83. Georgia Department of Natural Resources.

Meylan, P. A. 1984. A history of fossil amphibians and reptiles in Florida. *Plaster Jacket* 44 (February): 5-29.

Mitsch, W., and J. Gosselink. 1986. *Wetlands*. 2d ed. New York: Van Nostrand-Reinhold.

Mojsis, S. J., G. Arrhenius, K. D. McKeegan, T. M. Harrison, A. P. Nutman, and C. R. L. Friend. 1996. Evidence for life on earth before 3,800 million years ago. *Nature* 384 (7 November): 55-59.

Moler, P. 1992. Salt marsh survivors. *Skimmer* 8:2 (Summer), 3, 7.

Montague, C. L., and R. G. Wiegert. 1990. Salt marshes. In Myers and Ewel 1990 (q.v.), 481-516.

Norton, B. G., ed. 1986. *The Preservation of Species*. Princeton, N.J.: Princeton University Press.

Odum, E. P. 1993. *Ecology and Our Endangered Life Support Systems*. 2d ed. Sunderland, Mass.: Sinauer Associates.

Odum, W. E., and C. C. McIvor. 1990. Mangroves. In Myers and Ewel 1990 (q.v.), 517-548.

Odum, W. E., C. C. McIvor, and T. J. Smith, III. 1982. *The Ecology of the Mangroves of South Florida*. Report number FWS/OBS 81/24. Washington: U.S. Fish and Wildlife Service, Office of Biological Services.

Osborne, R., and D. Tarling. 1996. Human origins and migration. *Historical Atlas of the Earth*, 156-157. New York: Holt.

Palumbi, S. 2000. Evolution, synthesized. *Harvard Magazine* (March-April): 26-30.

Palmer, J. D. 1975. Biological clocks of the tidal zone. *Scientific American* (February): 70-79.

Patton, T. H. 1969. An Oligocene land vertebrate fauna from Florida. *Journal of Paleontology* 43:2 (March): 543-546.

Porter, C. L., Jr. 1967. Composition and productivity of a subtropical prairie. *Ecology* 48: 937–942. In turn from *Guide* 2010.

Pratt, A. E. 1990. Taphonomy of the large vertebrate fauna from the Thomas Farm locality (Miocene, Hemingfordian), Gilchrist County, Florida. *Bulletin of the Florida Museum of Natural History, Biological Sciences* 35(2): 35-130.

Raven, P. H., L. R. Berg, and G. B. Johnson. 1993. *Environment*. Fort Worth, Texas: Saunders.

Rey, J. R., and E. D. McCoy. 1997. Terrestrial arthropods. In Coultas and Hsieh 1997 (q.v.), 175-208.

Robbins, C. S., B. Bruun, and H. S. Zim. 1983. *Birds of North America*. Racine, Wisc.: Western Publishing.

———. . 2001. *Birds of North America*. Rev. ed. New York: St. Martin's Press.

Ross, J. F. 1996. A few miles of land arose from the sea—and the world changed. *Smithsonian* (December): 112-121.

Roush, J. 1982. On saving diversity. *Nature Conservancy News* (January-February): 4-10.

Salmon, M. 1988. Ecology and behavior of fiddler crabs. *Florida Naturalist* (Summer): 5-7.

Southall, P. D. 1986. Living resources of the Suwannee. *ENFO* (September): 13-14.

Stiling, P. 1989. Delicate balance (Purse-web spider). *Florida Wildlife* 43 (Jul-August): 9.

Strahl, S. D. 1997. Florida's Everglades. *Florida Naturalist* (Spring): 6-7.

Strahler, A. N. 1964. Quantitative geomorphology of drainage basins and channel networks. In *Handbook of Applied Hydrology*, ed. Ven te Chow, 4-39 to 4-76. New York: McGraw-Hill.

Suwannee River Task Force. 1989. Report pursuant to Governor Bob Martinez's executive order 88-246. Issues and Draft Recommendations. Tallahassee: State of Florida, Office of the Governor, 21 July. Photocopy.

Toops, C. 1998. *The Florida Everglades*. Rev. ed. Stillwater, Minn.: Voyageur Press.

Urquhart, J. C. 1994. Everglades National Park. In *Our Inviting Eastern Parklands*, 112-157. Washington: National Geographic Society.

U.S. Geological Survey Fact Sheet 2007–3059, "Divisions of Geologic Time—Major Chronostratigraphic and Geochronologic Units." 2010.

Vince, S. W., S. R. Humphrey, and R.W. Simons. 1989. The Ecology of Hydric Hammocks: A Community Profile. Biological Report 85 (7.26), September 1989, U.S. Fish and Wildlife Service, Department of the Interior, http://www.nwrc.usgs.gov/techrpt/85-7-26.pdf.

Walker, J., and R. K. Peet. 1983. Composition and species diversity of pine-wiregrass savannas of the Green Swamp, North Carolina. *Vegetatio* 55: 163-179.

Ward, D. B., and A. F. Clewell. 1989. Atlantic White Cedar (*Chamaecyparis thyoides*) in the Southern states. *Florida Scientist* 52(1): 8-47.

Webb, S. D. 1981. The Thomas Farm fossil vertebrate site. *Plaster Jacket* 37 (July): 6-25.

———. 1990. Historical biogeography. In Myers and Ewel 1990 (q.v.), 70-100.

Webb, S. D., and D. B. Crissinger. 1983. Stratigraphy and vertebrate paleontology of the central and southern phosphate districts of Florida. Geology Society of America, Southeast Section Meeting, *Field Trip Guidebook*: 28-72.

Webb, S. D., B. J. MacFadden, and J. A. Baskin. 1981. Geology and paleontology of the Love Bone Bed from the late Miocene of Florida. *American Journal of Science* 281(5): (May), 513-544.

Willoughby, H. 1897. Cited by Lt. J. Huffstodt. 1997. Across the Everglades by canoe. *Florida Wildlife* 51 (November-December): 25-27.

Wilson, E. O. 1983. An introduction. *Nature Conservancy News* (November/December): 344-346.

Wisenbaker, M. 1988. Florida's true natives. *Florida Naturalist* (Spring): 2-5.

———. 1989. Sinkholes. *Florida Naturalist* (Winter): 3-6.

Wolfe, S. H., J. A. Reidenauer, and D. B. Means. 1988. *An Ecological Characterization of the Florida Panhandle*. Biological Report 88(12). Washington: U.S. Fish and Wildlife Service and New Orleans, La.: Minerals Management Service.

Wunderlin, R.P., and B.F. Hanson. 2003. *Guide to the Vascular Plants of Florida*. 2d ed. Gainesville:

Yoon, C.K. 1994. Do ecosystems need biodiversity? Drugs from bugs. *Garbage* (Summer): 22-29

APPENDIX

Interior Florida's Freshwater Wetlands

Reference Notes

[a]The term "Bog" was used earlier to refer to any site where the ground was wet and spongy, and wetlands known as bogs might have predominantly herbs or shrubs. However, the category "Bog" does not appear in FNAI's 2010 *Guide to the Natural Communities of Florida*. Shrub bogs are the only communities called bogs. Wetlands supporting herbs that are continuously kept wet by seepage or by the presence of a hardpan preventing the downward percolation of water are known as "Seepage slopes" and "Wet prairies" respectively.

[b]A coastal interdunal swale is a linear depression that may support wetland vegetation between successive dune ridges at the coast. As coastal sands shift around, the composition of this community varies greatly; it is not treated in this book.

[c]"Glades marsh" and "Slough marsh" have replaced the 1990 "Swale" community. "Glades marsh" refers to marshes with a substrate of peat or peat/marl directly overlying limestone in the Everglades and Big Cypress regions. "Slough marsh" refers to a drainageway marsh on peat overlying sand substrates in flat topography.

[d]Formerly known as a "Floodplain forest," this community has been renamed "Alluvial forest" to emphasize the influence of active floodplain dynamics on the structure and function of the community. The term "Floodplain forest" is no longer in use.

INTERIOR FLORIDA'S FRESHWATER WETLANDS

FNAI TERMS (2010) TERMS USED IN THIS BOOK

Freshwater Nonforested Wetlands

Prairies/Bogs

Seepage slope[a] ... Seepage bog; Seepage slope; Herb bog; Cutthroat seep; Pitcherplant bog; Flatwoods bog—Ch 2, 3, 4

Wet prairie[a] ... Wet prairie; Wet flatwoods; Wet flats—Ch 4

Marl prairie .. Marl prairie—Ch 4

Shrub bog[a] .. Shrub bog—Ch 3

Marshes

Depression marsh .. Depression marsh; Temporary pond; Ephemeral pond—Ch 2, 4

Basin marsh .. Basin marsh; Waterlily marsh; Cattail marsh; Flag marsh; Sawgrass marsh—Ch 4

Floodplain marsh ... Floodplain marsh—Ch 4

Slough marsh[c] .. Slough marsh—Ch 4

Glades marsh[c] .. Glades marsh—Ch 4

Slough ... Slough—Ch 4, 5

Freshwater Forested Wetlands

Cypress/tupelo .. Cypress swamp; Cypress/tupelo swamp; Cypress strand —Ch 2, 3, 5

Basin swamp ... Basin wetland—Ch 2

Strand swamp .. Strand swamp—Ch 5

Floodplain swamp ... Floodplain swamp—Ch2, 5

Freshwater tidal swamp Freshwater tidal swamp—Ch 5

Hardwood Forested Wetlands

Baygall .. Bay swamp/branch; Bayhead; Baygall—Ch 3

Hydric hammock .. Hydric hammock—Ch 5

Bottomland forest .. Bottomland forest; Bottomland hardwood forest—Ch 5

Alluvial forest[d] .. Alluvial forest—Ch 5

Source: FNAI 2010, 112-189.

PHOTOGRAPHY CREDITS

ABS = Allen Blake Sheldon

BAR/TNC = Barry A. Rice for The Nature Conservancy

BC = Bruce Colin Photography

BM = Barry Mansell

CC/NOAA = C. Clark for the National Oceanic and Atmospheric Administration

DA = Doug Alderson

DBM = D. Bruce Means, Coastal Plains Institute and Land Conservancy

DN/GSML = David Norris for the Gulf Specimen Marine Laboratory

ELA = Emi and Larry Allen

FLAUSA = Visit Florida

FMNH = Florida Museum of Natural History, Exhibits and Public Programs Department

FPS = Florida Park Service (www.FloridaStateParks.org)

GB = Giff Beaton, www.giffbeaton.com

GB/FFWCC = Gray Bass for Florida Fish and Wildlife Conservation Commission

GN = Gil Nelson, Ph.D., Botanist/Author/Photographer

GSML = Gulf Specimen Marine Laboratory

JCN/FPS = J.C. Norton for the Florida Park Service

JD/FFWCC = Jay DeLong for the Florida Fish and Wildlife Conservation Commission

JS/RP = John Sullivan, Ribbit Photography

KD/BPS = Kerry Dressler of Bio-Photo Services, Inc.

KLP/FPS= www.KeniLeePhotos.com for the Florida Park Service

KME = Kevin M. Enge

LB = Larry Busby, Ranger, Waccasassa Bay State Preserve

LF = Lois Fletcher, Executive Director, Gilchrist County Chamber

LH = Lisa K. Horth, Ph.D, Biologist, University of Virginia

MJA = Matthew Aresco, Biologist, Florida State University

NB = Nancy Bissett, Green Horizon Land Trust

NB/USGS = Noah Burkhalter for the U.S. Geological Survey

NURP = National Undersea Research Program

OAR = Oceanographic and Atmospheric Research, National Oceanographic and Atmospheric Administration

PKS = Pam Sikes, Photographer, P.O. Box 997 Folkston, GA, stpsikes@alltel.net

PS = Peter Stiling

RLH = Roger L. Hammer

RPP = Rick Poley Photography, 12410 Green Oak Ln, Dade City, FL 33525

SC = Stephen Coleman, Nature Photographer, sdcme1@juno.com

SFWMD = South Florida Water Management District

TCH = Terrence Hitt, Nature Coast Expeditions, P.O. Box 218, Cedar Key, FL 32625

USFWS = United States Fish and Wildlife Service

WBSP = Waccasassa Bay State Preserve

INDEX TO SPECIES

The several hundred plants, animals, and other living things that appear in this book's photos and lists are indexed here by their common names, followed by their scientific names. Photos are indicated by italics (eg., *60*).

Finding species by their common names is often difficult because, although there are standards for common names, names in popular use do vary and also change over time. Should it be difficult to locate a species by a familiar name such as "sunflower," try prefacing the name with "American," "Common," "Eastern," "Florida," "Northern," "Southeastern," "Southern," or "Swamp." The common name of the familiar sunflower, for example, is "Southeastern sunflower."

Most scientific names are italicized two-word phrases. The first word refers to the genus (a category that includes several or many closely-related species). The genus name is capitalized and the species name is always lower case even if it is a country or a person's last name. The second word identifies the species. Thus the sacred lotus is identified as "Sacred lotus, *Nelumbo nucifera.*" In some instances, species are divided into several varieties. Variety names follow species names thus: "Royal fern, *Osmundia regalis* var. *spectabilis.*"

In some instances, an organism is identified only down to the genus level. In that case, the entry reads like this: "Bogbutton, *Lachnocaulon* species."

All listings are of native species unless identified as "alien" or "introduced." For example, the listing of the cane toad reads: "Cane toad (alien), *Bufo marinus.*"

The authorities used here for common and scientific names are listed in the Reference Notes for Chapter 1 (note 4).

L

Ladyfish, *Elops saurus,* 124
Large gallberry, *Ilex coriacea,* 43, 45
Largeleaf grass-of-Parnassus, *Parnassia grandifolia, 47*
Largemouth bass, *Micropterus salmoides,* 124
Laughing gull, *Larus atricilla,* 110, 126
Laurel greenbrier, *Smilax laurifolia,* 43, 45
Least bittern, *Ixobrychus exilis,* 110
Lesser siren, *Siren intermedia,* 54
Limpkin, *Aramus guarauna,* 91
Little blue heron, *Egretta caerulea,* 54
Little grass frog, *Pseudacris occularis,* 57
Live oak, *Quercus virginiana,* 86, 87
Lizard's tail, *Saururus cernuus, v,* 82
Loblolly bay, *Gordonia lasianthus,* 43, 46
Loblolly pine, *Pinus taeda,* 43, 45, 86
Loggerhead sea turtle, *Caretta caretta,* 128
Lowland topminnow, *Fundulus blairae,* 91
Lyreleaf sage, *Salvia lyrata, 6*

M

Magnificent frigatebird, *Fregata magnificens,* 126
Maiden ferns, *Thelypteris* species, 87
 Maidencane, *Panicum hemitomon,* 52
Mammoth, *Mammuthus colombi, 140*
Mangrove cuckoo (genus *Rhizophora* and others), 126
Mangrove killifish, *Rivulus marmoratus,* 124
Mangrove salt marsh snake, *Nerodia fasciata compressicauda, 128,* 128
Mantis shrimp, Squilla empusa, 105
Manyhead rush, *Juncus polycephalos,* 102
Marsh fimbry, *Fimbristylis spadicea,* 102
Marsh killifish, *Fundulus confluentus,* 124
Marsh rabbit, *Sylvilagus palustris, 7,* 128
Marsh rice rat, *Oryzomys palustris natator,* 128
Marsh wren, *Cistothorus palustris,* 108, 110
Marshhay cordgrass, *Spartina patens,* 100
Medusa worm, *Eteone heteropoda, 123*
Melaleuca, *Melaleuca quinquenerva,* 65
Mexican primrosewillow, *Ludwigia octovalvis, 27*
Milkweed, *Asclepias species,* 86
Mimic glass lizard, *Ophisaurus mimicus, 41*
Mississippi green water snake, *Nerodia cyclopion,* 91
Mole crab, *Emerita talpoida,* 96
Mosquitofish, *Gambusia affinis, 67*
Mosquitofish, *Gambusia holbrooki, 67*
Mosquitofish, *Gambusia* species, 124
Mourning dove, *Zenaida macroura,* 126
Mud crab, *Scylla serrata, 123*

Mud snake, *Farancia abacura,* 54
 Muhly, *Muhlenbergia capillaris,* 52
Muscadine, *Vitis rotundifolia,* 45, 87
Mutton snapper, *Lutjanus analis, 125*
Myrsine, *Rapanea punctata, 77*
Myrtle dahoon, *Ilex cassine* var. *myrtifolia,* 43, 45

N

Narrowleaf yellowtops, *Flaveria linearis,* 60
Needle palm, *Rhapidophyllum hystrix,* 87
Needle rush, *Juncus roemerianua,* 100, *101,* 102
Needlefishes (many different genera), 124
Netted chain fern, *Woodwardia areolata,* 45, 87
Northern cricket frog, *Acris crepitans, 91*
Northern harrier, *Circus cyaneus,* 110
Northern long-eared myotis, *Myotis septentrionalis,* 91
Northern needleleaf, *Tillandsia balbisiana, 78*

O

Ogeechee tupelo, *Nyssa ogeche,* 21, 74, *75,* 82
One-toed amphiuma, *Amphiuma pholeter, 89,* 91
Ornate diamondback terrapin, *Malaclemys terrapin macrospilota,* 128, *128*
Overcup oak, *Quercus lyrata,* 82

P

Panhandle lily, *Lilium iridollae, 39*
Peppervine, *Ampelopsis arborea,* 87
Perennial glasswort, *Salicornia perennis,* 100
Perennial saltmarsh aster, *Symphyotrichum tenuifolium,* 100
Periwinkle snail, *Littorina irrorata, 107*
Pickerelweed, *Pontederia cordata,* 19, *48,* 52, 102
Pied-billed grebe, *Podilimbus podiceps,* 126, *127*
Pig frog, *Rana grylio,* 54, *91*
Pine Barrens treefrog, *Hyla andersonii,* 40-41, *41*
Pine lily, *Lilium catesbaei, 58*
Pine woods treefrog, *Hyla femoralis, ix, 38*
Pink sundew, *Drosera capillaris,* 36, *37*
Pitcherplants, Sarracenia species, 19, 43
Planer tree, *Planera aquatica,* 82
Plumed beaksedge, *Rhynchospora plumosa,* 36
Pond apple, *Annona glabra,* 77, *77*
Pond cypress, *Taxodium ascendens,* 43, 45, 60, 77, *77*
Pond pine, *Pinus serotina,* 20, 43, 45
Pond slider, *Trachemys scripta, 57*
Possumhaw, *Ilex deciduas,* 86
Powdery strap airplant, *Catopsis berteroniana, 78*
Prothonotary warbler, *Protonotaria citrea, 92*

Punktree, *Melaleuca quinquenerva*, 65
Purple marsh crab, *Sesarma reticulatum, 123*

R

Raccoon, *Procyon lotor,* 128
Rattanvine, *Berchemia scandens,* 87
Red cedar, *Juniperus virginiana,* 87
Red chokeberry, *Photinia pyrifolia,* 43
Red drum, *Sciaenops ocellatus,* 109
Red mangrove, *Rhizophora mangle, 116, 118, 146*
Red maple, *Acer rubrum,* 43, 45, *71,* 77, 82, 86, 87, *146*
Red mulberry, *Morus rubra,* 86
Red salamander, *Pseudotriton ruber, 90*
Redtop panicum, *Panicum rigidulum,* 86
Red-winged blackbird, *Agelaius phoeniceus,* 110
Ring-billed gull, *Larus delawarensis,* 126
River frog, *Rana hecksheri, 91*
River otter, *Lutra canadensis,* 128
Robber fly, *Efferia pogonias,* 103
Rosy camphorweed, *Pluchea rosea,* 60
Round-tailed muskrat, *Neofiber alleni, iv*
Royal fern, *Osmunda regalis var. spectabilis,* 82, 87
Royal river cruiser, *Macromia taeniolata,* 53

S

Sacred lotus, *Nelumbo nucifera, 5*
Sailfin molly, *Poecilia latipinna,* 124
Salt marsh fiddler crab, *Uca pugilator, 106*
Salt marsh mosquito, *Aedes* species, *103*
Saltgrass, *Distichlis spicata,* 100, 102
Saltmarsh cordgrass, *Spartina alterniflora,* 100
Saltmarsh sharp-tailed sparrow, *Ammodramus caudaculua,* 111
Saltwort, *Batis maritima,* 100, *101*
Sand cordgrass, *Spartina bakeri,* 52, 60, 100, *101*
Sandweed, *Hypericum fasciculatum,* 52
Savannah meadowbeauty, *Rhexia alifanus,* 36
Savannah panicum, *Phanopyrum gymnocarpon,* 82
Sawgrass. *See* Jamaica swamp sawgrass
Seaside sparrow, *Ammodramus maritimus,* 108, 111
Sedges, *Carex* species, 87
Seminole killifish, *Fundulus seminolis, 67*
Semipalmated plover, *Charadrius semipalmatus,* 126
Sharp-shinned hawk, *Accipiter striatus,* 126
Sheepshead minnow, *Cyprinodon variegatus,* 124
 Shortbeak beaksedge, *Rhynchospora nitens,* 52
Short-billed dowitcher, *Limnodromus scolopaceus, 97*
Short-tailed shrew, *Blarina carolinensis,* 128
Silverbell, *Halesia species,* 86
Slash pine, *Pinus elliottii,* 43, 45

Small-leaf viburnum, *Viburnum obovatum,* 87
Smooth elephantsfoot, *Elephantopus nudatus,* 87
Smoothbark St. John's-wort, *Hypericum lissophloeus,* 19
Snail kite. *See* Everglade snail kite
Snowy egret, *Egretta thula, 54, 110,* 111, 126, *126*
Sora, *Porzana carolina,* 111, 126
Sourgum, *Nyssa biflora* var. *biflora,* 76. *See also* Swamp tupelo
South Florida rainbow snake, *Farancia erytrogramma seminola,* 91
Southeastern bat, *Myotis austroriparius,* 91
Southeastern sunflower, *Helianthus agrestis,* 63
Southeastern weasel, *Mustela frenata olivacea,* 91
Southern beaksedge, *Rhynchospora microcarpa,* 60
Southern cattail, *Typha domingensis,* 102
Southern dusky salamander, *Desmognathus auriculatus,* 90
Southern leopard frog, *Lithobates sphenocephala, 136*
Southern mink, *Mustela vison,* 128
Sphagnum moss, *Sphagnum species,* 19, 45
Spiderlily species, *Hymenocallis* species, 19
Spikerush, *Eleocharis* species, 52, 100
Spotted turtle, *Clemmys guttata,* 91
Spreading beaksedge, *Rhynchospora divergens,* 60
Spring peeper, *Pseudacris crucifer, 91*
Spruce pine, *Pinus glabra,* 86
Squirrel treefrog, *Hyla squirella, 41, 128,* 128
Starrush whitetop, *Rhynchospora colorata,* 52, 60
Stingrays, *Dasyatis species,* 124
Strangler fig, *Ficus aurea,* 77
String lily, *Crinum americanum, vii, 16, 50,* 77, 82, 102
Striped mud turtle, *Kinosternon baurii,* 128
Striped mullet, *Mugil cephalus, 113,* 128
Striped skunk, *Mephitis mephitis,* 128
Sugarberry, *Celtis laevigata,* 86, 87
Summer grape, *Vitis aestivalis,* 87
Sunfishes (Family Centrarchidae), 124
Swallow-tailed kite, *Elanoides forficatus, 64,* 91, 126
Swamp bay, *Persea palustris,* 43, 45, 46, 77, 86, 87, 91
Swamp chestnut oak, *Quercus michauxii,* 86
Swamp crayfishes, *Cambarus pyronotus, Cambarus diogenes, Procambarus peninsularis,* 89
Swamp doghobble, *Leucothoe racemosa,* 43, 45
Swamp dogwood, *Cornus foemina,* 86, 87
Swamp laurel oak, *Quercus laurifolia,* 77, 82, 86, 87
Swamp rose, *Rosa palustris,* 19
Swamp thistle, *Cirsium muticum, 83*
Swamp titi, *Cyrilla racemiflora,* 43, 44, 45, 82
Swamp tupelo, *Nyssa sylvatica* var. *biflora,* 21, 45, 76, 82
Sweet pepperbush, *Clethra alnifolia,* 43
Sweet pinxter azalea, *Rhododendron canescens, 10, 42, 133*

Sweetbay, *Magnolia virginiana*, 19, 43, 45, 46, 77, 86, 87
Sweetgum, *Liquidambar styraciflua*, 19, 45, 76, 86, 87
Swordspine snook, *Centropomus ensiferus*, 125
Sycamore, *Ficus sycomorus*, 19, 80, 83, 85

T

Tarpon snook, *Centropomus pectinatus*, 125
Tarpon, *Megalops atlanticus*, 109
Tenangle pipewort, *Eriocaulon decangulare*, 43
Thickleaf waterwillow, *Justicia crassifolia*, 8
Threadleaf sundew, *Drosera filiformis*, 33
Three-lined salamander, *Eurycea guttolineata*, 90
Tiger salamander, *Ambystoma tigrinum*, 26
Toothache grass, *Ctenium aromaticum*, 36
Toothed midsorus fern, *Blechnum serrulatum*, 77, 87
Tracy's beaksedge, *Rhynchospora tracyi*, 52
Tracy's sundew, *Drosera tracei*, 37
Trap-door spider, *Cyclocosmia truncata*, 88
Tricolored heron, *Egretta tricolor*, 54, 111, *127*
Trumpet creeper, *Campsis radicans*, 87
Tuliptree, *Liriodendron tulipifera*, 19, 47
Turkey vulture, *Cathartes aura*, 126
Turkey-tail mushroom, *Trametes versicolor*, 11
Two-lined salamander, *Eurycea cirrigera*, 90
Two-toed amphiuma, *Amphiuma means*, 54

U

Upland chorus frog, *Pseudacris feriarum*, 31

V

Variable witchgrass, *Dicanthelium commulatum*, 86
Variable-leaf sunflower, *Helianthus heterophyllus*, 36
Virginia chain fern, *Woodwardia virginica*, 43, 45
Virginia iris, Iris virginica, 20
Virginia opossum, *Didelphis virginiana*, 128, *135*
Virginia rail, *Rallus limicola*, 111, 126
Virginia saltmarsh mallow, *Kosteletzkya virginica*, *95*
Virginia willow, Itea virginica, 43, 45, 82

W

Wand loosestrife, *Lythrum lineare*, 102
Water hickory, *Carya aquatica*, 82, 86
Water hyssops, *Bacopa species*, 77
Water locust, *Gleditsia aquatica*, 86
Water oak, *Quercus nigra*, 86, 87
Water tupelo, *Nyssa aquatica*, *71*, 76, 82, 84
Waternymph, *Najas species*, 52
Wax myrtle, *Myrica cerifera*, 43, 45, 77, 86, 87

West Indian manatee, *Trichecus manatus*, 128
West Indian tufted airplant, *Guzmania monostachia*, *78*
White-crowned pigeon, *Columbia leucocephala*, 126
White-tailed deer, *Odocoileus virginianus*, 128
Whitetop pitcherplant, *Sarracenia leucophylla*, *32*, *37*
Wild grape, *Vitis species*, 86
Wiregrass, *Aristida stricta*, 36
Witchhazel, *Hamamelis virginiana*, 86
Wood stork, *Mycteria americana*, *55*, 91
Woodoats, *Chasmanthium species*, 87
Woodsgrass, *Oplismenus hirtellus*, 87

Y

Yellow jessamine, *Gelsemium sempervirens*, 87
Yellow (trumpet) pitcherplant, *Sarracenia flava*, 36, *38*
Yellow warbler, *Dendroica petechia*, 126
Yellow-billed cuckoo, *Coccyzus americanus*, 126
Yellow-crowned night-heron, *Nyctanassa violacea*, 91
Yellowfin mojarra, *Gerres cinereus*, 124

Z

Zigzag bladderwort, *Utricularia subulata*, 30

General Index

All species mentioned or shown in this book are listed by common name in the Index to species, which precedes this index. The particular species for which photos are shown are also listed here with italic page numbers (eg., *60*).

Pages where definitions are given are indicated by boldface numbers (eg., **60**)

OTHER TITLES FROM PINEAPPLE PRESS

Here are some other books from Pineapple Press on related topics.

For a complete catalog, write to Pineapple Press, P.O. Box 3889, Sarasota, Florida 34230-3889, or call (800) 746-3275. Or visit our website at www.pineapplepress.com.

The other two books in this series of Florida's Natural Ecosystems and Native Species:

Florida's Uplands by Ellie Whitney and D. Bruce Means.
Covers the ecosystems and species of Florida's high pine grasslands, flatwoods and prairies, interior scrub, temperate hardwood hammocks, rocklands and terrestrial caves, and beach-dune systems.

Florida's Waters by Ellie Whitney, D. Bruce Means and Anne Rudloe.
Covers the ecosystems and species of Florida's lakes and ponds; alluvial, backwater, and seepage streams; aquatic caves, sinks, springs, and spring runs; coastal estuaries and seafloors; submarine meadows; sponge, rock, and reef communities; and the gulf and ocean.

Florida's Magnificent Coast by James Valentine and D. Bruce Means.
Stunning photography by James Valentine of the coasts from the Georgia border on the Atlantic around the peninsula and through the Keys along the Gulf of Mexico to the Alabama border in the panhandle. Text on the magnificent ecology of Florida's coasts by D. Bruce Means.

Florida's Magnificent Land by James Valentine and D. Bruce Means.
Stunning photography of the wild areas of the state's panhandle and peninsula by James Valentine. Text on the magnificent ecology of Florida's land by D. Bruce Means.

Florida's Magnificent Water by James Valentine and D. Bruce Means.
Stunning photography by James Valentine, both above and below the many forms of the state's waters, and the wild creatures that live in and near them. Text on the magnificent ecology of Florida's waters by D. Bruce Means.

Florida's Living Beaches: A Guide for the Curious Beachcomber by Blair and Dawn Witherington.
Comprehensive accounts of over 800 species, with photos for each, found on 700 miles of Florida's sandy beaches.

Everglades: River of Grass, 60th Anniversary Edition by Marjory Stoneman Douglas with an update by Michael Grunwald.
Before 1947, when Marjory Stoneman Douglas named the Everglades a "river of grass," most people considered the area worthless. She brought the world's attention to the need to preserve the Everglades. In the Afterword, Michael Grunwald tells us what has happened to them since then.

Florida's Rivers by Charles R. Boning.
An overview of Florida's waterways and detailed information on 60 of Florida's rivers, covering each from its source to the end. From the Blackwater River in the western panhandle to the Miami River in the southern peninsula.

Florida's Birds, 2nd Edition by David S. Maehr and Herbert W. Kale II. Illustrated by Karl Karalus.
This new edition is a major event for Florida birders. Each section of the book is updated, and 30 new species are added. Also added are range maps and color-coded guides to months when the bird is present and/or breeding in Florida. Color throughout.

Nature's Steward by Nick Penniman.
Chronicles the development of southwest Florida using the modern-day Conservancy of Southwest Florida as the lens through which to examine environmental history.

Myakka by Paula Benshoff.
Discover the story of the land of Myakka. This book takes you into shady hammocks of twisted oaks and up into aerial gardens, down the wild and scenic river, and across a variegated canvas of prairies, piney woods, and wetlands—all located in Myakka River State Park, the largest state park in Florida. Each adventure tells the story of a unique facet of this wilderness area and takes you into secret places it would take years to discover on your own.

The Trees of Florida, 2nd Edition, by Gil Nelson.
The only comprehensive guide to Florida's amazing variety of tree species, this book serves as both a reference and a field guide.

The Springs of Florida, 2nd Edition, by Doug Stamm.
Take a guided tour of Florida's fascinating springs in this beautiful book featuring detailed descriptions, maps, and rare underwater photography. Learn how to enjoy these natural wonders while swimming, diving, canoeing, and tubing.

St. Johns River Guidebook by Kevin M. McCarthy.
From any point of view—historical, commercial, or recreational—the St. Johns River is the most important river in Florida. This guide describes the history, major towns and cities along the way, wildlife, and personages associated with the river.

Suwannee River Guidebook by Kevin M. McCarthy.
A leisurely trip down one of the best-known and most beloved rivers in the country, from the Okefenokee Swamp in Georgia to the Gulf of Mexico in Florida.

Exploring Wild South Florida by Susan D. Jewell. Explore from West Palm Beach to Fort Myers and south through the Everglades and the Keys. For hikers, paddlers, bicyclists, bird and wildlife watchers, and campers.

Easygoing Guide to Natural Florida, Volume 1: South Florida by Douglas Waitley.
Easygoing Guide to Natural Florida, Volume 2: Central Florida by Douglas Waitley.
If you love nature but want to enjoy it with minimum effort, these are the books for you.

CPSIA information can be obtained
at www.ICGtesting.com
Printed in the USA
LVHW061257010721
691676LV00018B/304